Camera Culture

CAMERA CULTURE

Halla Beloff

Basil Blackwell

© Halla Beloff 1985

First published 1985

Basil Blackwell Ltd
108 Cowley Road, Oxford OX4 1JF, UK

Basil Blackwell Inc.
432 Park Avenue South, Suite 1505,
New York, NY 10016, USA

British Library Cataloguing in Publication Data
Beloff, Halla
 Camera culture.
 1. Photography
 I. Title
 770 TR145

 ISBN 0-631-13989-3

Library of Congress Cataloging in Publication Data
Beloff, Halla
 Camera culture.

 Bibliography:p.
 Includes index.
 1. Photography. I. Title.
TR183.B43 1986 770 85-6210
ISBN 0-631-13989-3

Typeset by Katerprint Co. Limited, Oxford
Origination of half-tones by OLP, Oxford
Printed in Great Britain by Billing and Sons Limited, Worcester

Contents

To **Zoe Beloff**, working in the other camera culture

Preface

My source of interest and stimulation in photography over the years will be all too clear to the cognoscenti. Not least come the writers within aesthetic criticism who have shown a fine understanding of the humanistic aspect of the medium. One must cite here especially Janet Malcolm, Marina Vaizey, Edward Lucie-Smith and Max Kozloff. I have taken my title from Susan Sontag.

At the beginning of the venture I got vital encouragement from Henri Tajfel, of happy memory. Professor Mick Billig and Dr Glynis Breakwell kept faith with the work and so added significantly to my perseverance. Bruno Beloff reported back from the field. John Beloff was patient. I thank them.

Halla Beloff
Edinburgh

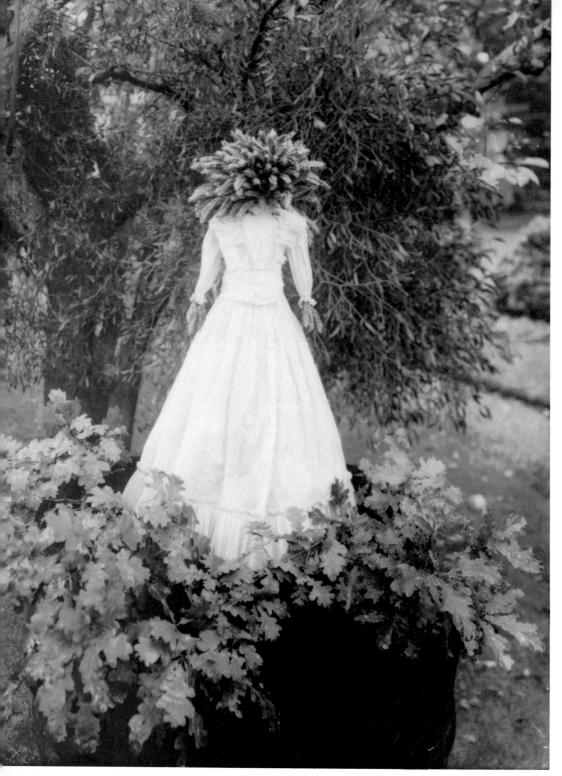

Sir Benjamin Stone *The Kern baby*

1 What is a photograph?

What is a photograph ?

If you ask a clever person, they say: it's something to do with physics and chemistry and time travel, and social issues and identification – people and things and what happened.

Rough and ready, but all true.

More formally, it is easy to see that photographs come in three kinds – art photography, documentary photography, personal photography. It's been said that photographs are about either information, aesthetics or emotion. But the fact is that the three elements are all present together in a good photograph. It is because of this amalgam that photographs are fascinating.

At its most concrete, a photograph is a piece of emulsified paper which represents in two dimensions the light pattern of a scene that was out there.

It is a representation that cannot possibly be made, or have been made, without *the presence* of the matter represented. You cannot photograph a dream. Perhaps that is why producing dreamlike photographs has always intrigued art photographers.

It is the camera's privileged relationship with reality that leads us to believe so strongly in its reporting, identifying and documenting functions, and all its other possibilities. The old adage that the camera cannot lie is illustrated by the use in races (between horses, dogs or people) of the 'photo-finish' to determine the outcome; and by the use of mug-shots of criminals which, however crude, are better than the best identikit drawings.

It is when we come to the photographic evidence for UFOs and for ghosts that we quickly see that we do not always believe the camera to be telling the truth. Then we need to know the exact circumstances of the production and processing of the image – because we know that human agency's interference may be paramount.

In one sense a photograph promises reality and truth and scientific precision. And in another it is in the domain of art. In yet another it holds magic and mystery. As Susan Sontag has reminded us (like all Freudian insights, we recognise it as true although we have never said it out loud ourselves), we are reluctant, almost afraid, to throw away a photograph of someone liked or loved, especially if they are far away or dead.

The camera is an invented eye.
Lucie-Smith, *The Invented Eye*, 1975

It is a brass-lidded eye of glass.
Théophile Gautier, 1858

It is an extension of our biology. A further stage in our evolution.
Stanley Milgram, *The Individual in a Social World*, 1975

Our lives have been significantly changed by the invention of the camera and the photograph. It is useful to start with a plain survey of the ways in which our ideas of the world and our place in it have been altered by the photographic possibilities of representing it and ourselves. If we start to list the functions that the camera can perform for us, we will begin to see how our common sense has been made richer and perhaps more rational.

The camera has enlarged our world in space and time. Since the middle of the last century it has been possible for us to see strange places and people in images that have a validity completely different from that of a drawing or a painting.

While itinerant medieval artists could peddle the same woodcut of a generic townscape to burghers anywhere, as depicting their own home, and while painters translated the setting and dress of historic figures and foreigners towards the understanding and expectation of their own period and place – because they knew no other – now, with the advent of photography, there was particular truth.

Explorers and travellers immediately appreciated the value of photographic records. One could see Italy without making the Grand Tour; the American Frontier was opened to stay-at-homes; Chinese and Maoris were seen in the West.

And the modern heirs to the early photographers of exotica are those independent workers who today document, with sympathy as well as accuracy, the retreating cultures and subcultures abroad and at home, which are not news in the general way.

War's look could now be conveyed to the home front. Painting had conventionally shown the romance of war. Photographs presented the dirt and the banality of battle and death. Matthew B. Brady did it in the American Civil War, and Don McCullin in our own time. It must be emphasised that this aspect of a campaign could now be shown *if* such was the decision of those people who controlled the means of communication, that is, the commanders in the field, the proprietors of newspapers and/or government.

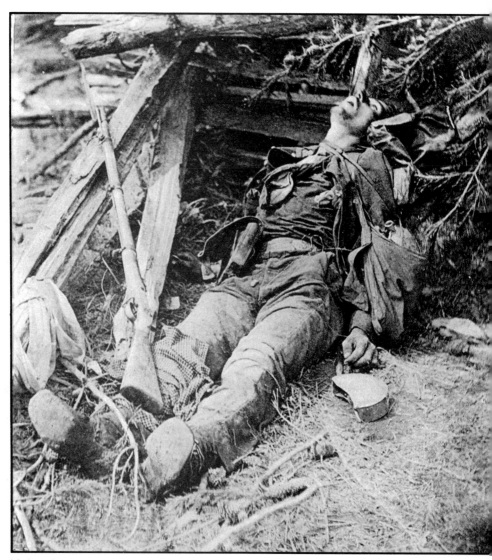

Mathew Brady *Dead soldier*

The famous, from monarchs to sex symbols, could be closely examined by all. Sometimes shown naturally, more often they are shown in a particularly stylised manner. Famous people could be bought via their photographs. They were brought near, and sometimes down.

And the camera brought with it a new kind of relationship between people – between the photographer and the photographed. As Diane Arbus said,

> The process has a kind of exactitude, a kind of scrutiny that we're not normally subject to. We're nicer to each other than the intervention of the camera is going to make us. It's a little bit cold, a little bit harsh.

The camera can enter the secret places of our civilisation. It can literally 'take', steal, the hidden scenes that are closed to our gaze.

Margaret Bourke-White's Midwestern secret society only raises a smile; but there is mystery and a kind of anguish in the genre depicting prostitutes and their clients, as Brassai shows in his *Secret Paris of the 30s*. Here the

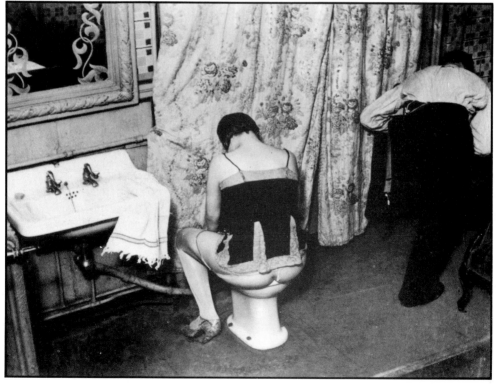

Brassai *Washing up in a brothel. Rue Quincampoix c.1932* Copyright BRASSAI

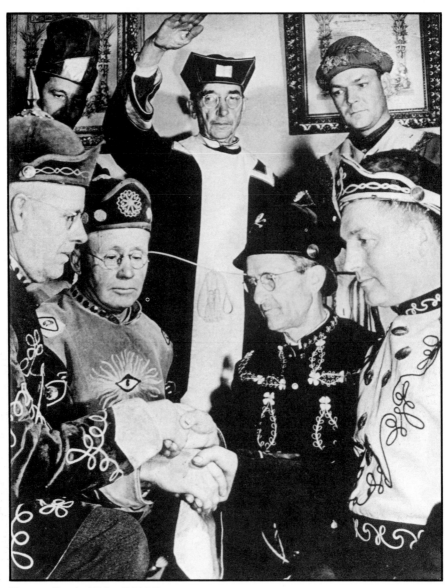

Margaret Bourke-White *Odd fellows*

photographer must have temerity indeed to invade the private moment – breaking the social and the camera rules, both – to show what we could never have seen otherwise. Even within the ordinary practice of science, Cartier-Bresson's picture of research in a laboratory with a monkey in an automatic test chamber shows us a scene that, at least in Britain, Home Office regulations legally forbid any ordinary citizen to witness with their own eyes.

Sometimes we have the chance to see what is all around us, but that we've never 'seen' because we've never looked at it. Amid the adaptation that we make to city life and its not-seeing, the new photographers like Robert Frank and Irwin Klein have stopped time, and fixed what must appear on our retina. We usually relegate those images to the constant flow of redundant information – to be ignored in order that we should not be hopelessly overloaded. They show the city to have a strange, fantastic meaning never appreciated before.

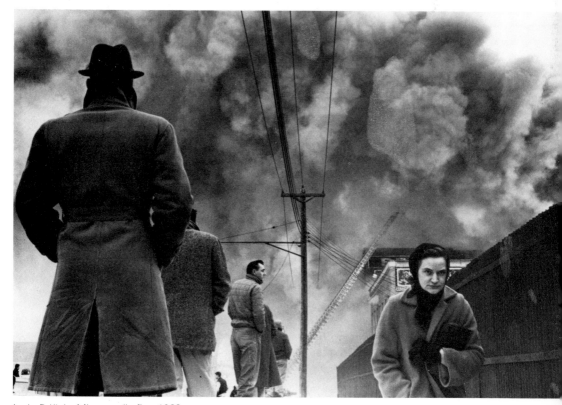

Irwin B Klein *Minneapolis fire, 1962*

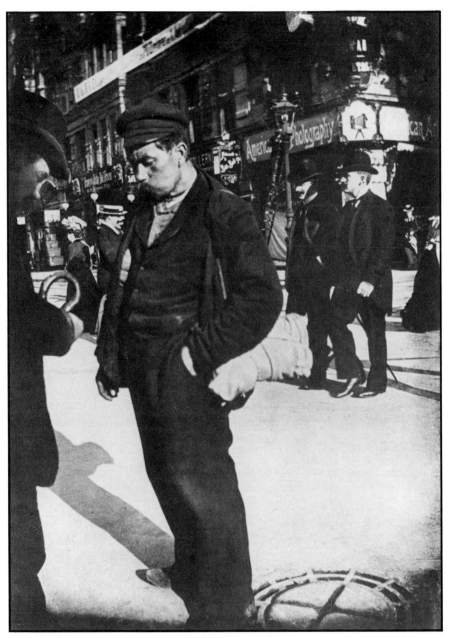

Heinrich Zille *At a crossing of Friedrichstrasse* Copyright Schirmer/Mosel Verlag GmbH

The camera is an extension of our perception. A photograph is an extension of our memory. It can replace the memory store. Before 1839 we experienced the world. We remembered those experiences, but they all decayed. Now we could have an indisputable trace. A sliver of time is preserved. We can possess a moment. And that moment can have a dreadful poignancy: see a man in Berlin in 1890 caught by Heinrich Zille searching his pocket for a coin – such a mundane gesture that all the world can identify with, and now he is rotted to dust.

> To photograph is to appropriate the thing photographed It feels like knowledge and therefore like power.
>
> Susan Sontag, *On Photography* (1977)

No wonder photography has fitted so snugly into the capitalist world. And into the democratic world. It seems the most egalitarian activity, and photographs an egalitarian phenomenon. Anybody can understand it. Anybody can even do it. And they do – witness the royal princes in Britain today.

Max Kozloff, the New York art critic, has listed in his book *Photography and Fascination* (1979) the subtle and protean functions of photography, including all the genres from reportage through art to family snapshots.

He sees the camera as a mirror with a memory, whose image gives us proof that we have not been hallucinating all our lives. Photographs are refugees from their moment. The camera drinks in the complex of things and happenings. Through photographs we have a radical fragment cut off from the unlimited flux. We can have alertness without mind. A perfection of looking without effort. If we had to do without photography now – we would be imprisoned in our immediate surroundings, we would be unmoored in time.

But on a simpler level, we must not forget that photography is a source of pleasure. Those pleasures vary widely.

On a personal level we need, and want to have and admire, pictures of our children and our loved ones and ourselves. They can be surrogates for the people involved, if they are far away, or grown up, or dead. They can be evidence of our success in being in any way related to such lovely and accomplished others.

On a social level, photography has brought us nearer to the important people in the world. We can all possess the icon. We can admire the famous more intimately, but we no longer need to stand in distant awe, if we don't want to.

Photography as used in advertising is the popular art form of today. Apart from the 'fine art' dimension in certain prestige magazine and newspaper advertisements, the Brobdingnagian products displayed on hoardings add a wonderful dimension of wit and ironic reality to contemporary streetscape.

Although it is admitted that prestige art galleries in London and New York deal in photographs as high-priced elite objects on a par with paintings, the aesthetic judgement on a 'good photograph' is one that everyone is willing and able to make and enjoy. Whatever the mechanical, electronic, laser or chemical substratum, the aesthetic element has always been salient.

George Hoyningen-Huene *Horst and model. Fashion Izod. 1930*

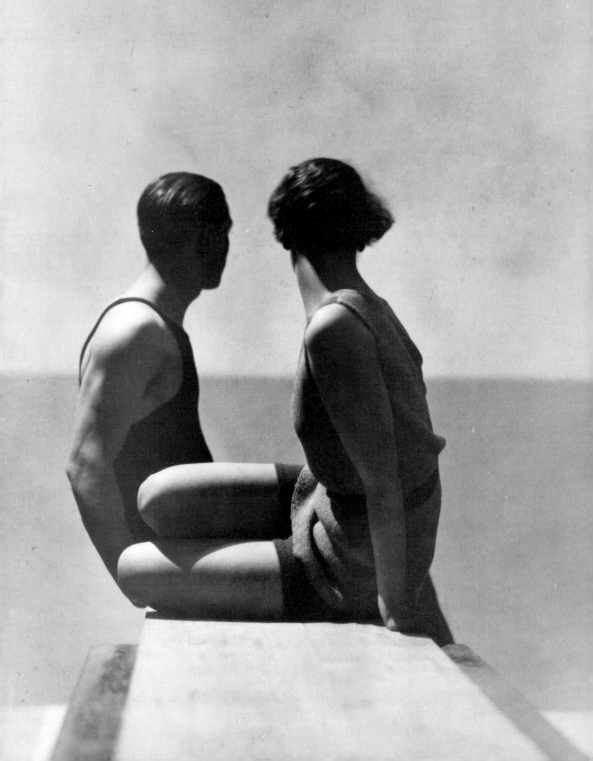

From the beginning, beauty has been a goal and also a by-product. Some-times when it has been a primary concern, it has escaped the artists, and has left them with only awkward fashion. Often it has come unobtrusively when the concern has been with mundane documentation. Sometimes beauty interferes with a colder message.

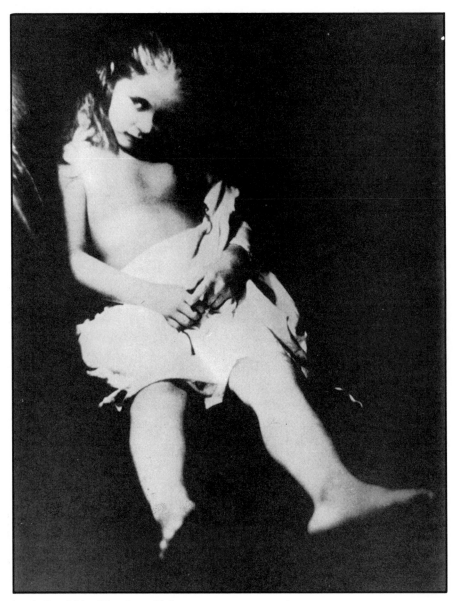

Lewis Carroll *Maud Constance Melbury*

From the first day it has been used for pornography.

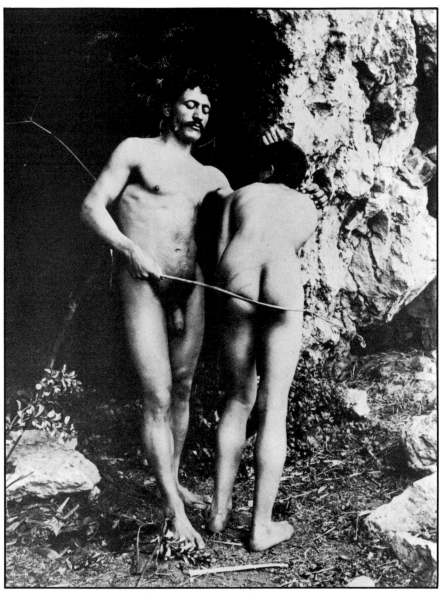

Wilhelm von Gloeden *Paternal chastisement*

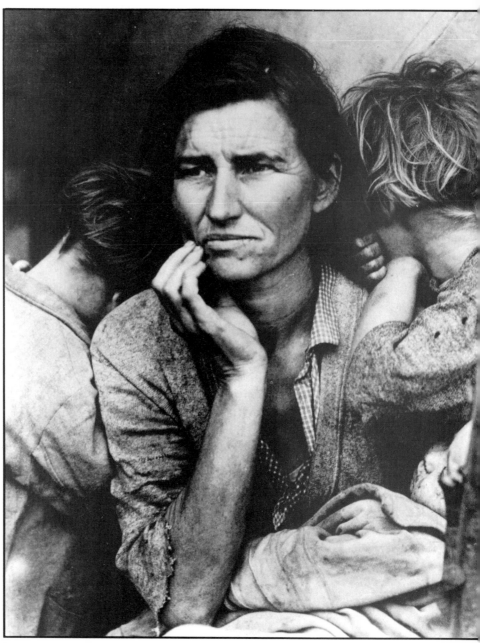

Dorothea Lange *Migrant mother, Nipomo, California, 1936*

Such is the power of the camera that we can easily think of photographs as having a kind of independent reality. Dorothea Lange's *Migrant mother* is a picture that has entered Western consciousness. She is not a mere representation.

However salient the information function of photography – it is more compact than verbal accounts, it seems a more reliable store, a more complete record – there is still the human agent who opens the shutter. The object is not just speaking for itself. There is always that mixture of information, accident, aesthetics and motive.

When William Fox Talbot moved on from his *camera lucida* – which could not record its images – to fix those images in the primitive version of true photography, he prettily called the invention 'the pencil of nature'. If it was a pencil, he thought the operator was simply a scribe.

But Alfred Stieglitz stood for three hours in a blizzard to go 'click' at a right moment for his *Fifth Avenue in winter*.

And reality drains away down many holes. Ostensibly recording, diagnosing, reporting, photographers have always known that while they were nothing, they were also everything. It is this paradox, or least complexity, that we shall have to remember at many points of our discussion, in every context.

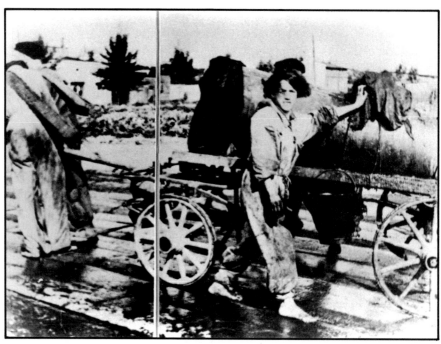

Mendel Grossman *Emptying the excrement containers into ditches on Franciszkanska Street*

From the beginning, photography has shown the world. That is a truism. Words can describe the world. The camera has the power to authenticate.

I know no better example of the power of authentication than that of Mendel Grossman's secret record of the Lodz ghetto.

Between 1940 and 1944 nearly two hundred thousand Jews and some gypsies were walled up there, including Grossman. He had been assigned to the German Department of Statistics, which was itself 'manufacturing' an official 'record'. At great personal risk to himself, and under the eyes of the Gestapo, he stole materials and took some thousand pictures showing every aspect of their grotesque existence.

He had to hide his camera from the guards, but the ghetto community was desperately anxious that he should make his pictures for the outside world and for the future. It was the only form of resistance possible to them. Their feeling was expressed by one ghetto member, Arieh Ben-Menahiem: 'Let him come in and photograph, let it become known to all who did not know, to those who otherwise would not believe.' A cry from the very heart of documentary work.

Grossman showed the suffering and degradation, but also the working hard to keep living. He knew he had to collect everything – children bloated with hunger, scavenging for food, public executions – but even he hesitated to take out his camera to take the 'faecalists', the people who collected the excrement in wagons. But the father of the family doing this asked him to photograph them, so that others should know how humiliated they were.

Grossman distributed negatives of his work to many people in the ghetto, because he sensed that this was the surest way that at least some of them might do their work. Single images in the care of single individuals would be his archive. He was right. He was not among the 887 survivors who were left at the liberation of the ghetto.

Why is a photograph so persuasive?

The argument must go something like this. We believe that we see reality. Therefore we believe what our eyes show us. But we don't simply see, and nor does the camera. We adulterate sensory information with our goals, needs, attitudes and expectations. We attend selectively to all the things around us. We notice those people, that facial expression, this poster, because they fit in with our present interest. What we see is 'coloured' by our state.

We don't see. We perceive. Yet ordinarily we ignore this point. By their very nature we accept our partialities as normal, natural, even universally valid.

We use a working model of naive empiricism. What we perceive is out there. What we don't perceive doesn't exist. As we take our own sight as evidence, so we take that of the camera.

But the photographic image shows the perception of a social agency, whether it is an advertising firm, a left-wing newspaper or a rock group promoter. Its partiality may be personal, economic, artistic or ideological. That social agency's expectations, aims, assumptions will have led to selection, highlighting, censorship, beautification, uglification, all these being part of the formal and informal stock-in-trade of the photographer.

It is possible to lengthen the neck of a film-star, to show poverty as noble rather than sordid, to denigrate or flatter a political leader. Like the computer, the camera is an instrument of a human intelligence.

Sometimes the element of persuasion may be openly planned and avowed, for example in product or party-political advertising campaigns. Then it may be rather simple for us to decode the message, and to understand that the picture is propaganda – although we may still agree to believe it and get pleasure from it.

What is more complicated to understand is that reportage and documentary works are also influenced, not to say contaminated, by the assumptions of the photographer and, further, by the context in which the work is shown. (What is the effect of showing the horrors of famine among advertisements for improved toasters and dog food in a colour supplement?) However straightforwardly they work, they cannot be just neutral messengers.

For the observer there can never be a pure image, as Victor Burgin has said in his essay 'Photography, Fantasy, Function' (1980). There is always language. We 'read' photographs. We bring to a picture a whole set of personal and social associations. It is these 'meanings' that are conjured up that make up the perception. We never merely see our retinal image.

We understand that this is what advertisers rely on. Their pictures must not only inject our consciousness with the simple content that is there, but also draw in motherhood, wealth, up-to-dateness, sexual arousal or what have you. Undoubtedly advertising still works, even though sophisticated members of the public see through its mystique. We grin, but we allow them their ploy.

What the radical analysts want to show is that such meanings and associations must perforce be included in *all* photographic images. We have not appreciated this, because we have essentially the same perspective as the photographers. We cannot see the mote.

All photographs, then, have a social–political vantage point. In the language of the photo-theorist:

> A major part of the political import of photographic signification is its constant confirmation and reduplication of subject-positions for the dominant discursive formations, as, for example, those which concern family-life, erotic encounters, competitiveness, and so on. (Burgin)

A photographer cannot be *hors de combat* in a war. Even a baked bean can be photographically-psychologically enhanced. Yet we continue to believe in

the straight veridicality of a photograph. It is a touching simplicity, but as reasoning people we can't continue to do so.

From the start, both practitioners and theorists of photography have understood that photographs could lie. It is working out why and when and how they do it, while at the same time seeing that they also show a truth, that is so difficult.

On the one hand the photograph has power in terms of what it can show. It is a conservative medium of realism. On the other, it has a freedom of form of representation. It can radically transform our idea of what is real.

We can try to tackle the task of emancipating ourselves from our naive assumptions about photography – the danger is complete cynicism and nihilism.

In so far as it is evidential, photography must also be *laissez-faire*. It appears to make contact for us. But we are not really party to the interaction.

The invention of photography and its continuous and rapid progress show a technology and a product ideally suited to the needs of that time and our own. The social dynamics of the Industrial Revolution, the death of romanticism in art, the advancement of science, meant that objectivity and the naturalism of the camera were entirely consonant with other cultural themes.

This, coupled with the rise of the middle classes – who wanted to have both the art images and the images of themselves which had previously been the prerogative of the gentry – provided a new class of avid consumer – for art reproductions and portraits.

The gentry's portraits had validated their importance, not to say grandeur. The bourgeoisie of the mid- and later nineteenth century wanted to show that they had the right to be taken seriously. Emerging from traditional society by their own effort, they wanted reinforcement for the point that the unique individual was now important. Photography and portrait photographs were ideal means for fulfilling that need.

Also, we must not forget that, compared with ourselves, the Victorians were prepared to be unashamedly emotional. They were not afraid of what we call, and tend to despise as, sentimentality. Aware of their mortality, as they had to be, the image of loved ones, especially children, could be sugared over. Photography could do all this just as well as painting – and more cheaply.

When life is flooding over us with new and strange experiences, when we are surrounded with myriads of strangers – as people were in the new city life of the nineteenth century – we want to possess images both to halt and to order the flood, even though in the end the mass of images doesn't help. Through photography we can hold people, events, places. But the images themselves become a flood.

Photographs may be evidence of personal existence and worth. They can give us the illusion of visual omniscience. But it is a counterfeit power.

At one level photographs are part of the communication industry and, like its other products, they are forgettable throw-aways, infinite in number and infinitely reproducible.

But we are equally convinced that photographs can have something about them that is the opposite of ephemeral.

A camera sidesteps the jumble of ordinary life. A good photographer austerely chooses the single moment when a happening is at its height. That is Cartier-Bresson's decisive moment. But the odd, random moments of modernists are in an inexplicable way also recognised as 'right'.

There are some photographs that each of us has in our minds for ever. Some are personal icons, some have entered our culture. They are important items in our mental furniture. The naked, burned girl running along the road in Vietnam, for example, is in the mind's eye for enough of us not to need to be reproduced here.

Photography is part of science, part of recording history; it is used for personal documentation, for providing social evidence outside our immediate environments, and not only for reproducing art, but as an art form to be appreciated in its own right. Evidence and art are conventionally considered the two central foci. But photography plays a role in all aspects of our culture. And like any of those aspects, photographs may be crude or delicate, diplomatic or rough, artful or direct, provoking positive emotion or its opposite. Photographs have strong persuasive powers. Politics/ideology is there knowingly or unknowingly.

As Cartier-Bresson writes – photography has not changed since its origins. It seems easy. It is ambiguous. It is a kind of recording with economic restraints.

And after the actual photographing there are many possibilities of selection, labelling and context that will add further 'error variance' to the plain copying function of the camera.

Consider the case history of the 'pictures of earth' part of the Voyager interstellar project. This most disinterested, pure-science venture, which would explore Jupiter and Saturn and then slowly leave our solar system and cruise for aeons through the realm of the other stars, carried pictures which were to record life on earth. John Lomberg has described in some detail in the Carl Sagan Voyager record, *Murmurs of Earth* (1978), the pictures of earth that were to be carried in the form of sound signals on a phonograph record (and which were in fact widely shown as a photographic exhibition). The technology need not concern us here, but we will be interested in the selection of the information images.

One hundred and eighteen pictures were finally selected (twenty in colour where this was critical – for flesh tones, seasonal changes in plants, fire etc.) which should give extra-terrestrials a view of our planet, plant and animal life, technology and social structure.

As a project which had in fact only the remotest chance of being decoded, one might have expected that our much vaunted scientific rationalism and value-freedom might have applied, and the widest possible range of phenomena been covered.

However, certain criteria for exclusion material were applied by project members themselves and by the NASA authority: 'We reached a consensus that we shouldn't present war, disease, crime, and poverty.' While agreeing that these might have affected more people on earth than string quartets (which were included) they decided that 'the worst of us needn't be sent across the galaxy.' Further they wished to avoid any political statement and concluded that a picture of Hiroshima or My Lai seemed more an ideological statement than an image of earth.

That left them with some pictures from *The National Geographic*, 'The Family of Man' (see exhibition p. 38), an Ansel Adams landscape, the Sydney Opera House, a production line – and a *diagram* of a nude man and pregnant woman, because NASA had vetoed the photograph of them taken from a medical text, which might have aroused an adverse public reaction.

In microcosm we have an example of scientific objectivity. The reality/partiality argument becomes more fraught.

What is plain is that we have to have a sociological perspective in the analysis. If we take the single genre of portrait photography, we can see that the social function of the work goes beyond the family album.

As Gisèle Freund pointed out in her book *Photography and Society* (1980),

> [photography] is the perfect means of expression for a goal-oriented, mechanised, and bureaucratic society founded on the belief that each person has his own place in a standardised hierarchy of professions.

The supposed objectivity of that social structure is then reflected in the supposed objective representations that the camera produces.

Analyses of the illusory nature of the camera's objectivity will be subversive of the social structure too. It is an attractive proposition, one that radical commentators all entertain.

In general terms, the radical critics have shown that every kind of distortion of reality is possible, and even easy. A photographer can express his or her own vision, or the demands of the patron, or the values of a dominant social class. This refers to the production of the image itself.

There are always partnerships and often contradictions. Photography is the antithesis of art, yet it is an art form. It is crucially shaped by our ideas, influenced by our behaviour, defined by our beliefs about community. In turn it influences our ideas and our behaviour, and defines our society. It is a large industry controlled by multinational corporations, because we use it ubiquitously to express our individuality.

As social life becomes more fragmented and anonymous, we express ourselves in a photograph. The more fragile our identity, the more we need to reinforce it. To show that we exist. To show that we can create something, in a photograph.

We treat the camera as a creative tool, analogous to a paintbrush. But it is a machine, whether mechanical, electronic or laser, and it 'takes' what is put in front of it. It captures its subject without further judgement. If we were to be anthropomorphic – and that is never difficult – I think we would say that it takes the scene into its maw. It reaches out and swallows it.

Certainly pre-literate as well as highly literate people (like Flaubert) have believed that the act of being photographed removes some essence or layer from us. That it is a dangerous activity. Their superstitious metaphor may be truer than we think as we laugh. Consider the victim of complete media coverage.

(Continuing the paradoxes, though – some pre-literate people are reported to sport their photographs tied on their foreheads as a support for their selfhood.)

The various arguments raised so far in this discussion seem to centre on the scientific versus the humanistic and artistic claims of photography, and on the problem of truth-telling.

The goal, the attitude, the personality of the photographer can emphasise the possibilities of machine precision or the eye-like aspect of the camera.

On the science side one would place the early and the later ethnographers, and such creative objective surveyors of social hierarchy as August Sander.

At the humanistic end the candidates would surely be the 'concerned' photographers who were working in the thirties both in Europe and in the USA.

Objectivity leads to the pre-eminence of intellect. Diane Arbus must be a prime example. While the heart or the emotions inform the work of Cartier-Bresson.

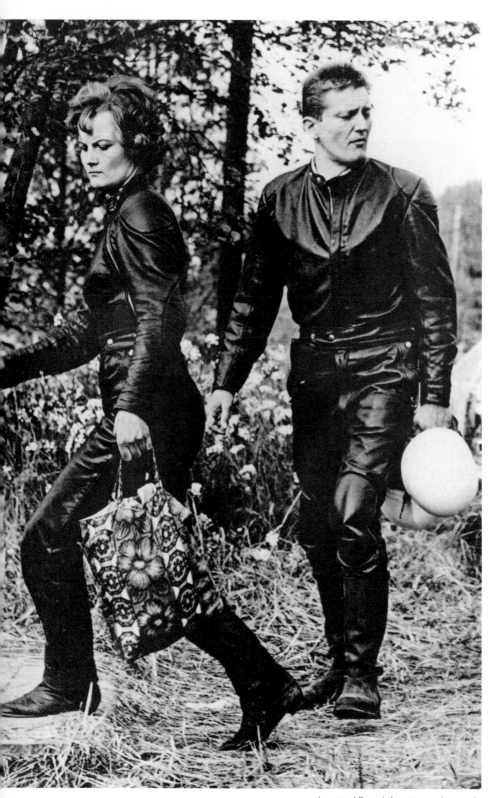

Leonard Freed *A motorcycle couple*

A separation between the roles and positions of the subject and the photographer accompanies the objective mode, in which the prey is stalked and 'shot' by the camera. Leonard Freed, at least in his German work, seems to exemplify this. While at the other end, Jane Bown's *The Gentle Eye* (1980) succeeds because she makes her subjects her friends.

The scientific bent may treat nature, including people, as a kind of still life. In his *Worlds in a Small Room* Irving Penn succeeds in this with people everywhere while Nadar, in a pre-1900 studio and before the the possibilities of modern technology, could bring Réjane's little daughter popping right out of her frame.

There have been masters and mistresses of each mode. There are the possibilities of the extremes, but also of steps between, and complex intermixtures.

Photography is an expresssion of its technics and of the individual photographer.

The camera is at the same time an instrument of science and of art, of personal motive, and of the collective vision.

2 The role of the photographer

Is it a job like any other ?
Is it a hobby just like stamp-collecting ?
What is the 'image' of the photographer ?
What is the social status ?
How far is it defined by each photographer ?
How is the professional different from the amateur ?
How far is it defined by the particular genre ?
How far is the photographer different from an on-looker ?
Has the photographer a right to record what is there anyway ?
Is a photographer reinforcing the *status quo* as a servant of the establish-
ment ?
How do photographers themselves understand their role ?
Does a camera give a voyeur's licence ?

In discussing what photography is, we have already hinted at some of the answers. But it is worth developing further the meaning of the job that photographers do – from their own perspective and from that of the people who are the object of the image. And we should consider also the focus of the buyers and consumers of the pictures.

We may straightforwardly follow the initial statement that we accepted about photography being art/information/emotion. Then surely different photographers, in their specific work, simply exemplify to different degrees the role of artist, reporter, and in some sense psychologist. Some may even bend the rules.

But perhaps it is good to get back to an even simpler starting-point, to see what is happening when a photograph is being taken.

Photographing as social interaction

The great variety of modes of interaction can be considered under many logical headings, for example:
1 The social context of the taking
2 The relationship in status between the photographer and the subjects
3 The use to which the product/photograph is to be put
4 The contract made between the parties
5 The number of parties involved, particularly when it is more than just the photographer and subject

Sometimes the interaction is clearly defined in ways that are acceptable to all concerned. Sometimes it is similar to other, familiar interactions. Sometimes the function of the work is abstracted from worldly considerations. Sometimes it is none of these. Let us consider a range.

In the studio portrait there is the most open and explicit contract, the narrowest specification of context, use, status and number of parties involved. A client makes a contract with a professional to have a certain service done, which will result in a product which will be paid for. The photograph produced belongs to the client, but they may agree between them that it be used in a display window or even the local newspaper.

A friend or relation may perform a similar service without fee. But we can begin to see some role strain when, for example, they take a candid snap, and then create amusement by showing the result to family and friends. From the point of view of the subject, this is social chaos. We believe that we have a righteous claim to veto such a process at various stages – at the time of taking, after the printing, in the choice of who is to be party to the showing.

Similarly, the photographing of strangers will involve variations in the rights and obligations of the photographer and the kind of contract that is involved, explicitly or implicitly.

Consider the tartan-trousered ex-soldier who is photographed by tourists at Edinburgh Castle. He poses good-naturedly, if stiffly. He sees it as part of his job, but more than that, as one of its perks – to be proved important and decorative enough to find an eventual place in so many albums and so many slide-projectors in so many countries.

The down-and-out, who is photographed by the more sophisticated amateurs below in the Grassmarket, is caught in a different interaction. He is 'collected' not just as another colourful character, but as a suitably dramatic visual example of stigmatised man, and of the Scottish stereotype incarnate. In the ordinary way with him, we pass by on the other side, or at least avert our gaze, so that we do not distress ourselves, and do not distress him with the acknowledgement of his shame.

The photographer, then, must not gaze either, that is, steal his shot secretly by appearing to be photographing sometimes else; or ask permission to photograph formally; and/or balance the interaction by justifying his intrusion with money payment or by citing investigative reporting, for example; or break social rules and photograph openly and without permission.

The photographer's performance can be carefully categorised. Impression leads one to believe that Europeans have still a sense of propriety; they do not often shoot the winos 'shamelessly'. It is the young North American who comes right up and focuses with full ritual of knee-bend and torso-cant.

The responses of the subjects are finely graded too. There may be vigorous objection. Or a kind of jocular-seeming posing – even with the raising of the can or bottle to the photographer – which is also a kind of sending him up. Give him what he wants. The stereotype is good enough for him. No reaction at all from the man in the street is a sign of degradation indeed.

And on another level consider the professional news photographer and the work of photo-journalism.

We are the object of that camera when we have achieved something. It may be a new job, in which case a posed picture of an accountant, even, may appear in the pages of a newspaper. This is part of the accolade. It may be that we have won a lottery. In that case, too, we may be delighted at the extra kudos – but may regret it later, when we are recognised in the street as the possessor of much money.

The rich and famous will be caught by the roving photographer, or even by full-blown *paparazzi* at a newly fashionable or *louche* setting. They presumably feel a delicately mixed gratification and shame in such presentations. The ordinary public are supposed to enjoy the experiences of high life vicariously through such photographs, while at the same time allowing themselves the possibility of denigrating such meretricious lives. The recent *Private Pictures* by Daniel Angeli and Jean-Paul Dousset was aimed at just such *Schadenfreude*.

Or it may be that we are taken as a victim or the relative of a victim of an accident or other misfortune, in which case too our image will be snatched from us. It will be used and propagated to sell newspapers. Our identity and our plight become public property. The simple justification for this work of the photographer is that such an image is news. The public's right to information covers all contracts.

The public also has the right to know the criminal, and even the alleged criminal. That is part of their punishment.

So we see from these few examples that the role of photographer ranges from that of the service professional, through that of the collector of images, to that of the psychologist. Loyalties may lie with the client-subject of the picture, with the abstract idea of taking a 'good photograph', with an outsider who pays for it, or with the national public who has the 'right to know'. The subjects reciprocally will range in status from employer and controller, through object of display, to actual victim of the camera.

But then, interesting as this sort of analysis may be, one can still ask the question – is a photographer essentially different, in his work, from a word-smith ?

Verbal descriptions can flatter and collude, investigate and invade. A reporter in any medium can be objective or subjective. A report can be made with or without the knowledge and agreement of the people involved.

There are similarities between the two. But a photograph represents a scene, an event, a person – with peculiar particularity. It leads to an identi-fication that is qualitatively different. The taking of our image invades our privacy, especially. A photograph promises a reality.

Interaction in photography accepts the power of the photographer's status. That status always has an edge over that of the subject. We are a little afraid of even the high-street photographer. We view with trepidation a friend with a camera. We know that the person with the camera has control over our appearance: how we will look, where we will be seen, who will see us.

But on the other hand, that extra power can also enable the photographer to please us. We are glad to have this moment in our life preserved. We are flattered to be chosen.

We have so far concentrated on the reporting functions of photography, but we must not forget our earlier discussion of the range of subjectivity that is not only possible, but always involved.

In particular, it may be provocative to enlarge on that metaphor of photographer as scientist-artist, and the other roles or professions that come to mind as metaphors or analogies of photography. This can be played as a kind of parlour game where you list famous photographers who can be slotted into the metaphors. But it is perhaps more than a game, and may help us to set out the range of role definitions that succeed in photography. In each case we will have to see how far the analogy holds, and how far it adds to our understanding of what it is that a photographer is doing.

First, the photographer within the domain of *science* and objectivity:

The anatomist – August Sander

August Sander collected a sample of people in various status positions, to show their surface appearance but also their preferred presentations. He saw his role as merely giving them a chance to display themselves. They thought that their appearance was all that was at stake. But Sander knew it must be more. His pictures would be expressive of psychology, sociology, politics, morality.

Otherwise it would all have been for the fashion archive.

The zoologist – Bill Owens

In his *Suburbia and Our Kind of People* (1975) he too surveys, but in the genre of the candid photograph (unposed and unbeknown) or the casual (the posed candid), in social settings.

August Sander
Court bailiff, Köln, 1931

Again, the subjects know there is a photographer there. Appearance is at stake. But Owens is also interested in social etiquette. Ordinary people in mundane settings are chosen. The interest of the work comes from the very fact that the subjects have not previously been celebrated beyond the focus of the family album or the local newspaper. Further, his work documents the rules of camera culture in poses that are *de rigueur*. After all, in the domain of photographing there are rules, and etiquette and courtesies, as there are in any activity. There may be conformity or deviation, serious or joking. With Bill Owens there are both ethological information and social finesse.

The pathologist – Diane Arbus

Arbus intended to go below surface appearance; to show that below the appearance of health there is hidden canker; to demonstrate that although we keep up appearances, there is every kind of horror all around us. She exposed the illusion of youth, of harmony, of well-being, of *soigné* social skills, of gender identity, of innocence. And she did that by simply looking straight ahead with her camera. She did not need to engage in technical manipulation. She saw, showed, and made us see the misery, the loneliness, the anomie, the gimcrack of urban American life. Although her pictures were not taken surreptitiously, she surely did not show them to her subjects. What would have been their response ?

The surgeon – Richard Avedon

His brand of objectivity in portraits has been different from that of Arbus, because although he also exposes and unmasks, he does so in a more active way. It is he himself who draws back the veil. Working as a formal commercial portrait photographer, he contracts to photograph clients as he sees fit; to show them as they are, seen by him. The subjects must agree to this, and they do – to be shown in all manner of unattractive ways, because he is a *famous* photographer. It's been suggested that perhaps he believes that they can learn sometimes new and good and improving from his vision of themselves.

Do they ? Or is it just the price (to be shown bemused, vulnerable, crass or cross) to pay, when the reward is that one is important enough to be operated on by Avedon ?

At the other extreme are the artists with their ostensibly subjective vision and aim:

The painterly artist – Cecil Beaton

Beaton came to portray people and their actions and settings in a way that is itself beautiful, and revealing of their visual charm. The painter is an active agent. He chooses his subjects with scrupulous care. If their social status is not high, their beauty must be so. If they can command his services by reason of their social status, then he is bound to create their image of the required level of beauty. Beaton worked in other genres too. For example, during the Second World War he reported on the London blitz and the North African campaign. But whether the subject was the little girl with the head bandage sitting up in hospital or the wreck of a tank in the desert, he always conveyed his message with an element of beauty. This made his images highly acceptable and therefore powerfully persuasive too. His subjects would always have accepted his pictures of them.

The camera artist – Jacques Henri Lartigue

Lartigue shows how people and things and actions really look, as we never see them. He shows the possibilities of the camera, and captures therefore – spontaneously, informally, unexpectedly – people and life. The temperament of the photographer will influence the vision both of his natural and of his glass eye. He is part of the ubiquity of camera culture. But he will not steal secretly. He will capture on film what is publicly available, in the street, at the beach, in the garden. His subjects could not object – that is how they were; and anyway his view of them is so innocent that they are seen as innocent too. His aim is to show what the camera can do, in a fresh, poetic, happy way.

And in between the poles of science and art is another set of analogies for photography, which are based on the social sciences and the humanist tradition:

Jacques Henri Lartigue *The beach at Villerville*

The psychologist – Edward Steichen and 'The Family of Man'

(See also chapter 4)

The photographer as psychologist also wants to show what people are like, but to go further than the zoologist, in making a statement that goes beyond empiricism. While ostensibly following the value-free model, psychologists generally illustrate with their empirical research a certain message and a certain assumption. In 1952 Steichen arranged the most famous photographic exhibition of all time. In this collection he showed pictures of people from all over the world, demonstrating through the juxtaposition of pink and brown and yellow people acting out the common human life stages, showing that we are indeed sisters and brothers under the skin, that our lives are *essentially* all the same. That was what it meant then. Thirty years later we are more clear-sighted, and we see it rather as an exercise in Western/ Northern self-congratulation. Photographers are able to show some version of the world. It can never be the whole reality, and all we can hope to do is to be aware of this and be constantly on our guard against complacency.

Family of Man *Family of Man*

Japan, Unosuke Gamou

O wonderful,

wonderful,

and most wonderful wonderful!

and yet again wonderful . . .

William Shakespeare

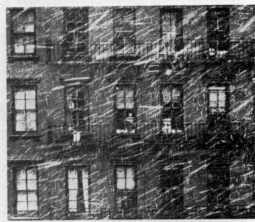

U.S.A. Paul Himmel

U.S.A. Allan Grant Life

Java, Henri Cartier-Bresson Magnum

The political agent – Margaret Bourke-White

Bourke-White's aim was to show what America was like. She was highly skilled in picturing a version of America that reinforced the themes of opportunity, equality, the protestant ethic and amelioration. (Now we can easily see it as a kind of capitalist–realist style.) Photographers within the context of the great picture magazines like *Life* are now seen as agents or at least fellow-travellers of the dominant, materialistic, political establishment ethos of their owners. As visual politicians they showed life as it was seen by the dominant culture. They showed which was good and what could be improved. They provided the cultural models that were to be emulated, either in achievement or in appearance, and preferably in both. Whatever was in such magazines had to be true. They were news magazines, not fiction. (Although the photoplay style of *True Romances* should have given pause.)

The fame, the success, and also the staidness of such magazines confirmed automatically the role of the photographer as a kind of recording angel. One cannot imagine oneself refusing to be photographed for them. True worthiness would be bestowed. And yet they were tools of their advertisers (see also chapter 4).

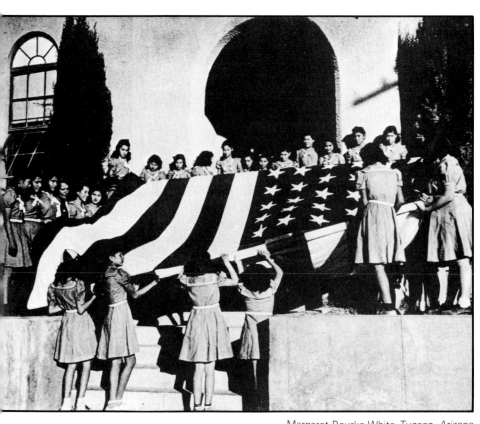

Margaret Bourke-White *Tucson, Arizona*

The reformer – Lewis Hine

Photographers from early times have seen themselves as crusaders, or, as we would now say, investigative reporters. It is they who can venture into the lower depths of our own or others' societies and bring back accounts of the real conditions there. As we noted before, such pictures command attention through their authenticity. They cannot be turned away from. Their function is to move hearts and minds. And once they have been seen, something will be done. One cannot go on living comfortably with the memory of them. That is why the American Child Labour Committee commissioned Lewis Hine to show the exploitation of children.

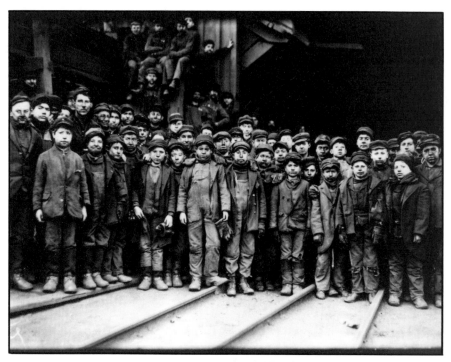

Lewis Hine *Coal breakers, Pennsylvania, 1911*

The photographer's job is to find the dramatically horrendous locales, the most pathetic derelicts. This mission is sufficient justification for taking the pictures. The means are justified by the ends. However ashamed are the people of their condition, they cannot, will not, refuse to be shown. They are not on trial, they are victims. Responsibility for their condition lies with the landlords, the employers, the market forces. Those are on trial.

In fact, the reforming role of the photographer is easily and widely understood and accepted, even by the people whose shame is to be exposed (see McCullin p. 220). This role gives the photographer much power, a power documented *vis-à-vis* the subjects photographed. It is the power of effectiveness of the crusade that is harder to prove.

The psychotherapist – not to say friend and helpmeet – Roslyn Banish

There is a new breed of photographer who is in some sense in a particular relationship of alliance with his or her subjects. These photographers collect people 'respectfully', with the aim of allowing them to show themselves in natural 'bloom'. Their own personality falls modestly into the shadows. They have a humanistic belief in the positive qualities of human nature, and simply supply the means by which a person or a family is 'enabled' to show itself and become immortal. (It is intriguing to know that these photographers are sometimes financed by arts foundations.) When they offer their services, they are nearly always accepted. They are seen as harmless. In the flattery of being chosen, the problem of what 'the point' of the whole venture is is washed away. (One can only speculate whether someone who came to *ask questions* about what one's living room looked like and how many people one was living with, would be accepted as happily.)

Subjects such as Banish's clearly enjoyed themselves, were happy to justify their life and surroundings to her, and had their self-esteem enhanced in a wholly innocent way by the process.

Roslyn Banish *Kathleen and Robert Osborn, children Ronald, Graham, David, Susan*

If the role of photographer has so many analogies, can we make any general statement at all ?

Photographers look at the world and capture some residue of their looking. We can see what they saw. Their look depends on their temperament and personal experience, but more importantly on the purpose for which they take the picture. The photographer is an agent.

Sometimes he is an agent of the subject – the millions of amateurs taking snapshots of their friends and family belong here. The genre of personal photography (see chapter 7) is involved with recording the identities and the events of the informal social circle in such a way that the members will not only have a historical document, but be seen in a positive light.

Sometimes the photographer is the agent of the media of communication – and here again the range of possible aims and goals is very wide.

The aim may be to enhance the market value of a product in advertising, either directly or by association, or to report the identity of a person. That person is seen as either good or bad, in command or perplexed, like us or very unlike us. Or the aim may be to bring to our breakfast tables a scene of obscene horror, done in our name on the other side of the world – either to raise our political consciousness or to sell newspapers, or both.

Sometimes the photographer may be an independent visionary – although this independence will not always be complete. Some of the most wilful artistic photographers like Avedon have links with *Vogue* magazine, and their work may be interpreted as providing a crucial *frisson* for the jaded palates of its readers. While within a political programme like the New Deal, people such as Walker Evans carried out their most individual and private work, and at *Picture Post* Bill Brandt's own interpretation of British working-class life is now seen in high aesthetic terms, the very fact that independent photo-graphers can now command high prices in the elite art galleries, as well as staging exhibitions in museums, suggests that their independence is also open to erosion.

Photography is ubiquitous. We cannot imagine life without it any more. The powerless can't refuse to be photographed, but neither can the powerful. Photographs are preserving, reporting, reforming, titillating, selling, giving us beauty.

The institution of the role

Historically, photography grew out of the interests and needs of artists. Consonant with the scientific-technological-industrial revolution, they wanted to mechanise sketching. They enrolled scientists to help with the physics and the chemistry. The invention of the apparatus of camera and plate, and the chemical fixing of the image, was a joint *ad hoc* venture.

Perforce the early photographers were self-taught. For a while professional entrepreneurs and amateurs worked side by side. An amateur like Julia Margaret Cameron turned herself imperceptibly into a respected professional. Lewis Carroll, for whom photography remained a hobby, vies technically and aesthetically with any of his contemporary professionals.

The distinction between professional and amateur eventually became widest when the development of the cheap box camera enabled 'everyone' to take a snapshot. Then the domains separated.

Within the social circles of family and friends, people could take their own pictures of informal occasions, for informal, personal use. Professional work was needed for the reporting of formal events (weddings, graduations), which needed a more serious record. And photography has become part of the ceremony.

Similarly the technical limitations of amateur equipment removed it far from the range of professional possibilities in terms of light–dark, near–far, depth of field, clarity of image – to put it most crudely. But the pro could take a photograph anywhere. The pro could make a photograph of anything he or she wanted.

Still the vast army of photographers is largely amateur. And it is the development of sophisticated cameras, that are at the same time simple to operate, that has led to the ever-rising standards that amateurs can easily attain. (Fast film and reliable techniques for home processing have also played their part.)

In fact, technical developments have supported the amateur to the extent of leading to the gradual demise of the high street photographic studio. That, and the way in which the commercial photographer has continued (however unknowingly) the tradition of the painterly role, have made him unacceptable to modern taste. It was the stiffness, the touching-up, the removal from the picture of the natural style that we cultivate, that combined to make a studio picture distasteful.

And while television, for complex reasons, has killed the picture news magazine (see pp. 114–15) and largely closed that market for still photography, the trend has been for advertising to move from graphic work to photographs. Both the goods themselves and the ambiances that provide the positive associations for them can be more persuasively enhanced by colour photography.

The market for professional photographic work is changing, but certainly not shrinking. However large that market might be, it could still not possibly absorb the numbers of young people who now graduate from formal courses in photography (practice and theory) as potential professionals. In Britain courses are provided in polytechnics and colleges of art. These are highly over-subscribed and have anyway burgeoned with the growth of this higher education sector in the years 1960–80. It is in the United States that the figures suggest a social movement, not a vocational training.

And the image of the photographer is that of a fascinating creator, since he (the image is always masculine) came into the foreground of public consciousness as a crucial member of the Swinging Sixties culture. In 1969 David Bailey showed clearly in his book *Goodbye Baby and Amen: A Sarabande for the Sixties* that the photographer was a person who was able to exemplify many ideals and many ideal activities.

It would appear that a photographer roved around, being a part of every 'scene', relating in an intimate but not 'draggy' way with the talented and famous, having the power to elect those chosen for immortality and the power to show them in a style decided by him: having the power to create and destroy, therefore. And being paid for doing what others would pay to do.

The role has elements of glamour, easy achievement, social interaction, constant change and novelty, intimacy, even – no arduous, long and lonely effort. In short it was interesting and not boring!

The photographer was seen to be making beautiful things. His pictures had power. He made his subjects famous and they made him famous in their turn. That this was a dream more often than a reality was not so obvious. In fact, in Bailey's *Sarabande for the Sixties*, eighteen photographers appeared among the pop singers, actors, restaurateurs, etc. who make up the cast of characters. It is about the same numbers as fashion models, and they seemed as ephemeral.

This is clearly an account that takes up the most frivolous position possible. But it is not entirely an unfair parody.

The other side of the image is that of the sharp, cynical, tough war photographer with the heart of gold. He also roves, but he relates in some abstract way to the victims of ghastly horrors that he must document and report back to us. Don McCullin carries this image, and certainly he is identified by many as the original of Tom Stoppard's George Guthrie in the play *Night and Day*. What Max Kozloff in his book (1979) has called the brutality of the compassion of the concerned photographer has another kind of appeal to the ambivalent macho mind.

If these are the caricatures, more seriously there is fascination inherent in photography – as an ideal modern medium that potentially allows one to combine art and technics and humanism – that is deservedly attracting people to its ranks. And the serious conclusion must be that in future photographers and their analysts will all be formally qualified and professionalised. Is an increase in formality and bureaucracy not always the outcome of the sheer expansion of an activity ? If so, then the element of the haphazard and the private obsession is likely to be lost. It was surely the previous informality that made all kinds of possibilities easily available to all kinds of people. Consider, for example, the place of women in photography.

Women in photography

Compared with other fields of art, craft, technology and communication – wherever you want to put photography – women have played a stronger part than in those other fields. At the present time, when the documentation of women in painting is of considerable interest and when the interpretation of their particular aims and contribution is being minutely discussed, it is useful to make some comparative comments.

In fine art it was, of course, the academics and their definition of necessary and formal training that simply and rigidly excluded women from the practice and commerce of the visual arts, unless they could find some informal, illicit entrée.

The absence of the academic stranglehold at the beginnings of photography (when women would still have been debarred from art schools even if the nude had not been involved), left the field open. On the other hand, the complexities and indeed dangers of the crude chemistry involved, the smells and the staining, should have deterred them. In the wet-collodion process used by Mrs Cameron, for example, potassium iodide had to be poured over a glass plate which was tilted to coat it evenly, then bathed in a silver nitrate solution. Exposed by the camera while wet, the plate had to be developed immediately with pyrogallic acid (1,2,3-trihydroxybenzine) or ferrous sulphate, and fixed with sodium hyposulphite or potassium cyanide. And all this after a sitting in which the subject had to be persuaded to be still for up to ten minutes. The technological aspects and the expense should have been a formidable barrier.

In the event, from the middle of the nineteenth century onwards women were involved both in the making of photographs and in explicating the process and results. Initially the only proviso was that they should come from the affluent classes.

Julia Margaret Cameron, working in the 1860s, was truly a pioneer of portraiture. Lady Eastlake in the 1850s had published some of the first critical analyses of photography.

Related to and a forerunner of 'the tribe of Bloomsbury', she was by any lights a wonderful English eccentric. A bold, creative person, she was given a present of a camera and a wet-collodion kit by her daughter, and simply got on with it. She was passionately fascinated by people, and it was the possibility of picturing faces that was the lure for her. By lonely trial and error (she made her first successful picture in 1864 at the age of forty-nine), she discovered both the technical and the aesthetic principles that she could work by.

On the one hand she was entirely 'masculine' in her single-mindedness. She got the local builder to punch a new window in her spare room one afternoon, in order to capture her neighbour Lord Tennyson in appropriate light. On the other, she was conventional and 'feminine', as revealed in the Schwärmerei of her very 'poetic' portraits of the poets.

She practised by taking pictures of the servants' children – who could be cajoled to sit still – initially with little hope of any successful outcome. Even after she had become a mistress of technique, she used her servants in the narrative pictures as models for the kings and queens she needed. She took the opportunities that were to hand.

It is this flexibility within the domain, making a virtue of necessity, that has stood creative women in good stead.

Julia Margaret Cameron *Julia Cameron*

Aspects of Imogen Cunningham's long life (1883–1976) are described in fictional terms in Paul Theroux's *Picture Palace* (1978). She worked as a portraitist to make a living, and in various art genres. When she had small children (in the 1910s and 1920s) and was confined to the domestic world, she turned herself into an eminent photographer of plant life, using her own garden. She kept up such *ad hoc* activity into her nineties, when she used her sympathy for old people in her book, *After Ninety*.

Imogen Cunningham *Portrait of August Sander: 'I took this famous European photographer at his house in Germany'*

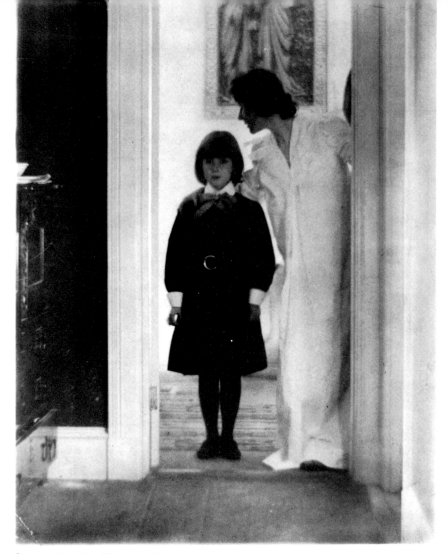

Gertrude Käsebier *Blessed art thou among women*

Within the traditional expectations of women's concerns one could sub-
sume the interest in portraits, and the possibility of finding beauty in mun-
dane things. The camera can easily be a humanistic tool.

The very concreteness of its subject matter, its lack of abstractness, appeal
to the supposed 'feminine' disposition. And indeed Gertrude Käsebier
(1852–1934) romantically extolled the role of motherhood in her softly
unfocused images of white-dressed women and beautiful children.

Doris Ulmann (1884–1934) documented the poor lives of Appalachian farm
families before this became a routine activity.

But in fact women have played a prominent part in every genre except fashion photography, and have by no means remained in the ghetto of the stereotypes.

In the 1860s Lady Hawarden (1822–65) produced her mysterious and erotic pictures which, though influenced by the Pre-Raphaelites, were brilliantly her own. She is paid the ultimate compliment by Cecil Beaton and Gail Buckland in their biographical encyclopaedia, *The Magic Image*:

> With such bold attack, uncluttered line and obliteration of all extraneous detail, her work might be that of a man.

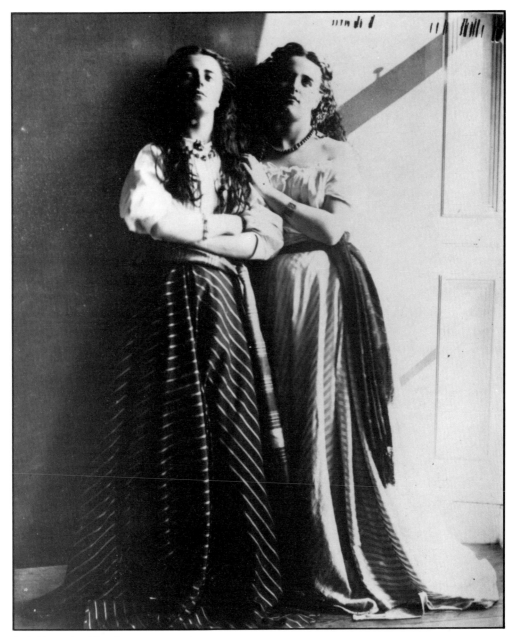

Lady Hawarden *The sisters*

Berenice Abbott has demonstrated protean skills and talents. As a pioneer of high-speed photography in scientific investigation, she invented the necessary technology from first principles. In her book *Vanishing New York*, she showed the importance of photographs in documenting the changing architecture and life of cities.

She contributed to the mainstream of art photography and portraiture. She was a partner in the recognition of the genius of Eugène Atget's work. It was she who searched him out in his Paris garret and took a picture of him, terrible in its mortality – when she came to show him the print, he was dead.

Dorothea Lange (1895–1965) created in *Migrant mother* (1936) (see p. 14) one of the most powerful images in photography. Her series of reports for the Farm Security Administration project helped to make its photography project the highly successful visual propaganda arm of Franklin Roosevelt's New Deal.

Margaret Bourke-White (1904–71), before and during her years as an editor of *Life* magazine, worked in providing both the New Deal with images of hope and the American war effort during the Second World War with images of home that were worth fighting for. She became a war photographer herself, and produced some of the pictures of the liberation of Buchenwald that we have all seen and remembered.

Berenice Abbot *Eugène Atget*

Eve Arnold was a journalist who also worked for *Life*, and has become more than a journalist in her recent work in China.

And among the independents, none have been more outstanding nor further from the establishment than, say, Diane Arbus and Nancy Rexroth (see chapter 5 and chapter 3). Perhaps because they found themselves so far from the conventional mould personally, they could also find their way out of the accepted ideas in their work. But such instant psychological interpretation is unnecessary. What matters is the work.

With total insouciance Rexroth has recently been making pictures with a toy camera (which retails at $1.50), and called a number of bluffs.

Eve Arnold *Joan Crawford*

Arbus, from a privileged background and with all the attendant social con-
straints, worked as an individual visionary. Without presuming to make a
personal analysis, it is appropriate to say that genteel women who are
taught, over-taught, to be skilled in the social mores, are likely to be espec-
ially sensitive to the breaking of those customs. They are fascinated by the
leakage behind a social presentation. So one can understand her preoccupa-
tion with freaks and others whose facework doesn't work. She understood
that maquillage doesn't hide everything. Alienation is understood.

The analysis of photography and women's part in it can be drawn from many
contexts.

Gisèle Freund, in what was later published as *Photography and Society*,
presented in the 1970s the first doctoral thesis on photography accepted at
the Sorbonne. Lisette Model was an earlier theorist, especially of portraiture,
in Germany, and later a teacher in the United States. And the cause of
photography as a serious intellectual activity and photographs as serious
documents has been strongly advanced recently by the collections of essays
of Susan Sontag (*On Photography*) and of Janet Malcolm (*Diana and Nikon*).

Jo Spence has been crucial in the British movement, in deconstructing the
apparent but unreal, honesty of the image behind the lens. The fact that she
has a special interest in personal photography and the representation of
people in the media can be interpreted as another kind of 'feminine' perspec-
tive, but more importantly it is a humanistic one.

While this topic could obviously be explored in depth, it may be sufficient here to say that in a medium which does not carry the burden of age-old traditions, where entry has not been hedged by the institution of an academy, where no great capital expenditure is involved, and where the individual working alone may achieve something – women will find themselves successfully operating, as people.

It is difficult to find statistical analyses on the matter. However, a simple-minded demography can be compiled from Beaton and Buckland's chronological encyclopaedia of photographers from 1839 to 1975. It lists forty women among the 294 entries.

A plausible comparison for painters would be the same time span from the *Penguin Dictionary of Art and Artists*, where thirteen women appear among the 273 nominees.

Children as photographers

There is an argument that studying the development of a gift or skill throws particular light on it. It may be worth a diversion in the seemingly improbable direction of children taking photographs. It may even be useful to consider why it is thought an improbable tack.

It is certainly a useful approach to consider the question of talent versus the application of skill, in any *métier*. After all, we learn a lot about musical talent when we know that both composition and performance are the field of child prodigies. In the visual arts of painting and drawing there have certainly been famous artists who performed prodigies as children. One can list them all the way, in every sense, from Dürer through to Sir John Millais to Pablo Picasso. Further, all children given a free and positive setting and appropriate material will produce pictures and designs that we appreciate for their aesthetic qualities as well as for their psychological characteristics of freshness and humour. In fact, of course, the comment that 'a child of six could do it' is a compliment, not an insult.

Was Stanley Milgram right, then, when he said in *The Individual in a Social World* that in contrast, children cannot take photographs ?

Children *want* to take them. They too want to catch and keep their favourite bits of the world. They want to photograph their house, certainly their pet, and also their mother. The trouble is that their enthusiasm is initially, at least, unselective, as is much else of their appetite.

As many parents who have given a child a camera find out, this is an expensive business. Few children therefore have the chance to attain the skills to take successful pictures, and to learn for themselves the technique behind them. (A Polaroid camera is, of course, one ideal learning tool with quick feedback, but it is particularly expensive.) On that score the high-cost technics are the barrrier.

What we do know is that a number of eminent professional photographers were given cameras as children, and were aware immediately that this was the life *métier* for them. They have written and spoken about that experience, demonstrating that it was a turning point in their lives.

Alvin Langdon Coburn (1882–1966) was given a 4 × 5 Kodak on his eighth birthday. At the age of fifteen he had his own studio at home where he would hang his pictures. At seventeen he was teaching processing to F. Holland Day. And by the time he was eighteen he exhibited with The New School of American Pictorial Photography at the Royal Photographic Society, and in the avant-garde London Salon of Photography organised by the Linked Ring group.

Paul Strand (1890–1976) was given a Brownie at twelve, and at the New York Ethical Cultural School was taught by the photographer-sociologist Lewis Hine. Hine taught science in the curriculum and camera work (including the how of an open-flashpan of magnesium powder for indoor photography) outside it.

Cecil Beaton (1904–80) became involved at the age of eight or nine. His must have been a fine nursery. He was 'taught to do things properly' by his sisters' nurse, and used his own nanny to help process his work in the bathroom. His earliest pictures of his sisters are not naive – faux-sophisticated one must call them. They are unmistakably Beatons.

Brett Weston, as the son of the influential photographer Edward Weston, is a special case. And it is perhaps not surprising that he took up serious photographing when he was twelve. Pictures taken when he was fourteen were reproduced in the German magazine *Photo Eye*. And twenty pictures of that vintage were shown in the Stuttgart exhibition, 'Film und Foto', where the American section scored a particular success.

Henri Cartier-Bresson, as he himself has said, 'burst into the world of photography with a Box Brownie' as a schoolboy.

But it is Jacques Henri Lartigue who is clearly the exceptional case as far as child photography is concerned. Born in 1896 into an affluent and creative French family, he was fascinated to see his father producing images on his photographic plates in the dark-room. (Is that why at the age of five he jokingly suspected that his father might be the Good Lord in disguise ?) Given a camera at that age, he was not only smaller than the tripod, but recognised immediately that the camera was a necessary extension of his body and his life.

At six, he wrote in his diary:

> Now I will be able to make portraits of everything . . . *everything*. And now I won't feel sad any more when I have to return to Paris: I can take all my photographs of the country back to Paris with me . . . the ones I want to take of my Courbevoie-paradise; ones of the beach, of the woods in Pont-de-l'Arche . . . and photos of my garden . . . of all the flowers and plants I've grown to love so much . . . and last but not least, pictures of all the people I see and like and love.

A fine analysis of the function of personal photography, but more importantly even, he produced beautiful and innovative pictures from the beginning.

In fact, some of his most famous and most exciting pictures, such as *The beach at Villerville* (see p. 37), *Bichonnade in flight* and *Zissou in his tyreboat* were taken when he was around ten years old. And this was at a time when he could 'compose' the image only on an inverting viewfinder.

So it would seem that the admixture of technology and money is a barrier to the easy and informal opportunity for ordinary children to take up photography.

When they have such a chance, they can use it.

What photographers say

But perhaps outsiders are both arrogant and partial in making interpretations of what photographers are doing. The most direct approach is to see what photographers themselves have said about what they do. Certainly famous photographers, in learned monographs and in recent books of interviews, have given us a lot of evidence.

Paul Strand (1890–1976), the American art photographer who was also a serious thinker, said very clearly in his memoir *Sixty Years of Photographs*,

> I've always wanted to be aware of what's going on around me, and I've wanted to use photography as an instrument of research into and reporting on the life of my own time.

Because he understood that the *raison d'être* of photography as an art form lies in its unique and absolute objectivity, he realised that the photographer must hold 'a real respect for the thing in front of him'.

He saw the photographer as engaging in a kind of battle with his camera. Like other serious American photographers he was looking towards the powerful Edward Stieglitz, whose work for Strand crystallised the 'unqualified subjugation of a machine to the single purpose of expression.'

The machine's objectivity would lead to a kind of cold and meaningless empiricism. But the infinite possibilities of subject-matter out in the world can be tamed by a visual intelligence, and at the height of its power express entirely the vision of the photographer.

Similarly, Henri Cartier-Bresson, like any scientist, has written:

> Subjects do not consist of a collection of facts, for facts in themselves offer little of interest. Through facts, however, we can reach an understanding of the laws that govern them, and be better able to select the essential ones which communicate reality.

Then we must believe that in his 'decisive moment', when he sees the 'strongest' picture in the set, he is showing us an example of such laws.

But again the scientific quality of the work is tempered by an essential humanism. While he is looking for 'things-as-they-are', he also tells us that:

> You must be alert with the brain, the eye, the heart; and have a suppleness of body.

Reality is filtered through his brain, eye and heart. Then as in any other human activity, the relative power of the brain, eye and heart varies.

Richard Avedon (see chapter 6) is clearly working with the intellect. For him, photography is a 'mental medium', more like mathematics and chess than like painting and drawing.

Linda McCartney is wonderfully open in her account about the component of 'heart' in her pictures. When discussing why she takes photographs, she writes:

> If you see something that moves you, and then snap it, you keep a moment.
>
> Most people if I like their music, I can get good pictures.
>
> There's the the feeling, and the right reading – that's all you really need to know; the right light and the feeling.

Others want to withdraw altogether.

Garry Winogrand has said laconically that the process of photography is perception (seeing) and description (operating the camera to make a record) of the seeing.

And Winogrand's own work is an attempt to remove his own personality and his decision-making process. His pictures are not supposed to comment, simply to describe. The paradox then is that we can't accept that. Selection is intrinsic in any aspect of photography. The arbitrariness of a seemingly random selection must itself give us some message about the arbitrariness of life. His coolness must say something about the 'warmth' or the 'heat' of others.

Winogrand is not alone in wanting to abrogate the role of active agent, or artist, or reformer. Don McCullin (whose ideas and work will be considered in several contexts later), the most powerful serious photographer working in Britain today, is clearly shy of accepting such terms. In his monograph *Homecoming* (1979) he has written in detail about his motives as well as his method of working.

> I'm really a communication platform, manoeuvring images, raw material, from one place to another.

And even more at odds with his images of misery and destruction and death:

> I only use the camera like I use a toothbrush. It does the job.

In fact other photographers who may be expected to give a complex psychological background to their work, in that they have shown strong and beautiful evidence of their sensibility and creativity, are surprisingly coy, not to say cynical, about their work and their role.

Imogen Cunningham, when asked about what she felt when she pressed the shutter, replied:

> 'Couldn't possibly imagine.'

Then:

> 'Is it a blank ?'

> 'No, I always think I've got it! I don't punch until I know I've got it, but even then I don't always get it.'

And Elliot Erwitt, whose work has clearly gone beyond the narrower confines of photo-journalism, has been at pains in his interviews with Danziger and Conrad to refute any real involvement:

> 'How do you approach an assignment like Ten Tyres Typical of the American West ?'

> 'I rent a car and drive to the place and take the pictures. There's no great mystique. A lot of photographers like to put their hand to their forehead and tell you how they suffered. It's really very simple. If you're told what the problem is, you go out and do it. It's no big deal.'

> 'What do you think of the photographer in romantic imagination today ?'

> 'It's OK because it keeps the prices up.'

And when pressed . . .

> 'Did you ever see the movie *Blow-Up ?'*

> 'Yea. It's OK. It had nothing to do with me.'

But Thomas, the photographer in Antonioni's *Blow-Up*, was not only a version of the romantic image – and we must test now the interpretation of photographer as voyeur.

All this discussion – the examples, the analogies, the voices of the photographers, the images, the roots in childhood, the enormous attraction that the profession has – does it lead to any clear conclusions ?

Could it really be that the only constant within the role is that of voyeur ?

This is certainly the conclusion of some of the vociferous theorists, especially of the neo-Freudian–Marxist persuasion.

Is it acceptable on more humble grounds ?

Is photography fundamentally just a psychodynamically ill-concealed form of voyeurism ?

What are the *prima facie* arguments for this shocking possibility ?

Certainly a photographer looks. We must admit that he peers, even. He sees what others do not see. A photographer may easily steal what is private. He can keep it for his later delectation.

Lucie-Smith has suggested in his book *The Invented Eye* that the subconscious of the photographer will be revealed in his pictures:

> the camera responds with perfect obedience to the subconscious mind of the man who uses it and brings any obsessional element in the personality of the photographer to the surface.

Then how much more clearly must the taking up of a camera in the first place be psychodynamically motivated – obeying a need to look ?

We remember the crucial point that with high speed film, people could be 'taken' unbeknown. The candid camera can make us all voyeurs and the object of voyeurism. To continue the argument, as we look at some photographs, we may vicariously experience the pleasure, relatively innocently or relatively fraught, of the voyeur. And this extends far beyond the confines of pornography.

Paul Strand's *Blind woman*, taken in New York in 1916, has often been discussed from the point of view of the tension created by the fact that we look at her but she cannot look at us. The contradictions, the invasions, the inequalities inherent in photography, and its excitement, are critically contained in this image. We might take it here as the most terrible symptom of our condition.

Professionals writing about their work have not been unaware of the interpretations of it. And Diane Arbus has perhaps expressed it most simply:

> I always thought of photography as a naughty thing to do. That was one of my favourite things about it, and when I first did it I felt very perverse.

But it is the movies that have found still photographers a fine subject for visual and psychological commentary.

In their screenplay for *Blow-Up* (1971) Antonioni and Guerra showed Thomas not only in the 'swinging' image, but more particularly exemplifying two aspects of voyeurism – sexual arousal and obsessive looking at a secret sight.

In his commercial work, Thomas clearly uses sexual arousal to get good pictures – principally and cynically in his female models, who must be 'turned on' by him in order that they may communicate the right 'availability' in the images. The audience then makes, at some level, the further association to his private concern with the chance picture he made in the park, which may lead to the discovery of a murder and the identity of the murderer – if only it can be blown up enough. The denouement – that no crime could ever have been committed – serves to underline the phantasy quality of the nature of his calling.

Paul Strand *Blind woman, New York, 1916*

Blow-Up

Michelangelo Antonioni

Antonioni *Blow-Up*

Similarly, Hitchcock's *Rear Window* is always interpreted as an essay in the experience, the aims and the dangers of voyeurism. When a broken leg removes James Stewart from his mundane job of news-photographer, he resorts to observing the neighbours with his camera. He no longer takes part in real life, he can enter it only vicariously. Here, in true Freudian spirit, the interest and meaning of actions lie in their symbolic values; what he sees is terrible, criminal and dangerous to himself. He makes the interpretation that there has been a wife murder. It is the primal scene.

More recently, in *The Eyes of Laura Mars*, Faye Dunaway tempts the gods in further peculiarly camera crimes. She sets up metaphorical photographic simulations of the horrors of crashes and fires and urban violence. They make smart settings for fashion plates. She is punished by seeing the future in her own photographs. The gods say, if you want to pretend horror, we will create it for you.

Photographer as voyeur is a metaphor that provides an attractive *frisson*; it appeals to those of us who know that nothing is what it seems.

It says that those within the *métier*, professional or amateur, are expressing a form of abnormality. That their work is invisibly determined or at best constrained. That their activity has at least an element of irrationality, that they are fulfilling extraneous motives.

If all this is so, it would clearly be emancipatory for us to know about it, to bring it into the open, and at least intellectually to analyse it. But before we accept the argument, it is necessary to check back to the original psychoanalysts to see what they really meant by the term 'voyeurism' and what it implied for them.

Karl Abraham's paper, originally published in 1913, with the formidable title 'Restrictions and Transformations of Scoptophilia in Psycho-neurotics; with Remarks on Analogous Phenomena in Folk-Psychology', is the fullest account of the question of looking. From this and Freud's own introduction to *Instincts and their Vicissitudes* (1915), and further elucidation in *The Libido Theory* (1923), we may test the value of taking this complex luggage on board.

Abraham cites as a natural component of the sexual instinct the desire to look at the naked human body, and the primary and secondary sexual characteristics. Like all other instincts this will be modified during socialisation and maturation. The source, the object and the aim will be influenced during repression and sublimation.

When the early and direct gratification of the instinct is blocked, neurotic transformations will take place. However, even in an ideal development, change will cause a move away from direct expression. The change is destructive, of course, in the neurotic adjustment, but constructive in the personal and social adjustment of the fulfilled individual.

If the blocking of the initial impulses in early life is extreme, this can lead either to an abnormally acute interest in looking (scoptophilia), or to disorders of vision of a psychosomatic kind (scoptophobia). In either case they are substitutions for sexual interest. They have an obsessional quality, whose source is libidinal. Their aim will be narrow, in that they serve to assuage anxiety surrounding sexual activity. Both voyeurism and the not-looking are after all something else.

The sexual component instinct may become 'lust of the eye', and the technical perversion of voyeurism results. This distortion of the quality of sexual striving is surrounded by conflict, because super-ego and ego continue the battle with the id. In a voyeur the interest in looking will take specific forms – both in terms of what is looked at and in the means of looking. In order that gratification will result, the activity of this special looking will be accompanied by complex inhibitions and ritualised practices.

We can see, then, that photography can become a form of voyeurism. It can provide a fine vehicle for the neurotic scoptophiliac. In the active role, the men who join certain 'camera clubs' have access to nude models, and can play their role in an institutionalised setting. Their bonus is that they have a permanent memento of their looking session. This will allow them to play the passive version of the role, as do, of course, all consumers of pornographic photographs. The limited and indeed secret nature of their activity is an intrinsic and rewarding aspect of their obsession.

However, as we have stressed, even in normal, healthy development social-isation will demand a constraint on initial impulses and direct expression of the instinct of pleasurable looking at the naked body, as it does on every other instinct, from feeding to defecating.

The child will willingly accede to this, if sufficient initial gratification is allowed. Then scoptophilia will be sublimated – by which the psychoanalysts mean, fundamentally, that a substitution of socially approved forms will be learned, which are not attended by insoluble conflicts.

That the source or motive power of the new form of the component (the desire to look at the naked *human body* still lies with the original instinct – that is, that visual pleasure has its roots in the sexual instinct – is simply a fact of psychodynamic life. After all, we have only the choice between eros and thanatos.

The result of this positive manoeuvre is aptly described by Abraham:

> Some of the important psychological phenomena which owe their origin in a great part to this [sublimation] are the desire for knowledge (in a general sense), the impulse towards investigation, interest in the observation of Nature, pleasure in travel, and the impulse towards artistic treatment of things perceived by the eye (for example painting).

Photography was outside the scope of cultural activity when he was writing this in 1913.

Owe their origin – yes.

However, it is simply not sensible to suggest that we can explain the whole spectrum of photography – technics, creativity, humanism – as a form or a symptom of the perversion of scoptophilia.

We can understand it as a basic pleasurable human activity, but we knew that all along.

3 The problem of beauty

Why are all photographs beautiful ? This is not a wilfully silly question. There is a beauty in any photograph to which we pay serious attention. And it comes from a whole series of paradoxes which abound in the very nature of photography. It is the tension, the contradiction and the conflict that draw us into feeling the magic.

A photograph is so absolutely still and yet it is produced by what is alive and lively. The most tranquil, lonely landscape is completely dynamic compared with the photograph of it.

A photograph that we look at now is a picture of the past, of what has gone. The people are old or dead; the places have changed or disappeared. And yet, here in the picture this was so important and seemed to secure. Photographs are inextricably linked with nostalgia.

The camera and the film link a photograph concretely with a machine, and yet we understand that a human intelligence, and sensitivity, and a human need have made us that picture.

All these provocative paradoxes not only give a photograph a special kind of human appeal, but they also give us the experience of a kind of beauty.

Yet there is a further, crowning paradox that we shall have to take into account — that the most beautiful photographs are not always those where the photographer has been most directly aiming for aesthetic achievement. The history of photography abounds with the risible products of old 'art' photographers — that is, risible now.

On the contrary, it is adventitiously that some of the highest peaks of beauty have been achieved: in plain recording, in documentary photography, even in photo-journalism.

In fact, it is the confounding and the confusing of messages by the by-product of beauty that leads us to talk about the 'problem of beauty'. It may divert attention from the photograph's social purpose.

As we have seen, within photography it has been taken for granted that photographs have an art or aesthetic form. To produce beautiful objects in their own right was the avowed aim of photographers like Stieglitz, Weston and Strand — to name an American trio. Using camera and film they wanted to make images that would have in their composition the appearance of a formal work of art.

However, the fine art establishment was not easy to conquer. Essentially the crusade has succeeded, but one suspects that within the university courses on the history of art not many lectures are devoted to Cameron, Strand and Brandt. Certainly the pictures of Eugène Atget languished in the files of 'Architectural Details' in the Victoria and Albert Museum for many years. Even now it is as applied art and craft that photographs are collected by the Victoria and Albert, while Peter Blake's reconstituted village shop is among the high-culture art treasures of the Tate Gallery.

This is not simply a problem of status rivalry, but has serious implications for our evaluation of photography as a 'truthful' medium, and for our under-standing of the message that a photograph contains.

Certainly since Helmut and Alison Gernsheim's exhibition of Victorian photographs at the Victoria and Albert Museum in 1951, photographs – at least old ones – have been valued not only as records but for their beauty, even in Britain. Janet Malcolm is right when she says in her book *Diana and Nikon* that galleries which previously would have shown pot-holders as soon as photographs, now see there is a commercial–artistic market for them.

The irony, then, lies in the fact that it is the clever amateur who continues the tradition of fine composition. This is seen most saliently in the exhibitions of competition entries, and in the magazines promoted for amateurs by camera manufacturers.

Eugène Atget *L'Aqueduc – Acueil*

The aesthetic of photography has moved inexorably on, step by step, with the mainstream of art itself. And that means that the independent photographers who are the avant-garde have moved on to artlessness.

For example, in one stream who partner each other in minimalist and conceptual art, there is a throwing-away of technique, a knowing absence of form and craft-like skill. The innocent eye and the simple use of the medium are valued. A sparse note about what is basic to the conception is all that is needed. The *idea* is prominent.

Nancy Rexroth *My mother, Pennsylvania, Ohio, 1970*

Who is the most artless artist in photography ? Nancy Rexroth has made one intrepid excursion into elementalism. As mentioned earlier she takes pictures with a camera called a Diana which retails for $1.50 – 'The company make a cheaper model which squirts water.' She sometimes shuts her eyes

when she shoots. And she matters because her results have an interest, not just a naive charm, and because they give us a vivid idea of what camera work is about. It is even another kind of realism, of technique and of style.

It is this relationship between photographic and other art movements that establishes photography's place within aesthetic domains, as well as in communication technology, family history, psychology and everything else.

Photography Democracy Art

One of the earliest functions of photography was to present and reproduce works of art. It replaced engraving as the form in which painting, sculpture and architecture could be available for study and entertainment in the comfort and convenience of the library or the home. At its simplest, it helped to democratise aesthetic pleasure and appreciation. First in black and white versions, latterly in colour.

John Berger, in his *Ways of Seeing* (1972), has pointed out the various ways in which cheap postcard reproductions allow and encourage us to manipulate and re-see the hallowed 'great paintings' of European civilisation – for example, in the multiple display of one picture. And it is, of course, Andy Warhol who has taken the de-mystifying technique of presenting multiples of the same image from the pin-board into High Art: in his matrix of 4 × 6 screen-prints in one – twenty-four Marilyns. His most intimate or intrinsic debt to photography comes, though, in his 1981 Joseph Beuys series, where it is a *negative* that is printed, most finely, in white and black plus glitter.

And the inevitable way in which photography changes the scale of a work need not be a drawback. On the one hand a large thing becomes more intimate to use when made small; on the other, a tiny artefact may take on a wholly new power when it fills the photographic plate.

The cavalier way in which Warhol has combined photographs and crude colour infill in his portrait silk-screens (e.g. in *Portraits of the 70s*) demonstrates very directly that a photograph is only another basis for the arbitrary decision of the artist.

Within the aesthetic genre there was, of course, a hope that a beautiful photograph would provide a widely available, cheap source of 'stimulus' for the masses. This has not come about. Art photography of this kind has become almost completely assimilated into the elite art market. Some photographers in fact destroy their negatives after a certain number of prints have been made, aping the engraver. Others continue to print, apparently without limit, but have entered the price range of the traditional fine arts.

The common man and woman meet the art dimension of photography in advertising — and that is often beautiful, elegant, witty, innovative and without pretensions.

Painting and photography

It may still be enlightening for us to see how far photography, drawing and painting have in fact been connected, since Fox Talbot referred to his first 'real' camera as the 'pencil of nature', and to note that influence has gone in both directions — from painting to photography, but quickly also from photography back to painting.

This to-and-fro movement is a problem within the analysis of the visual arts and of aesthetics, but will help us here to study further the question of machine versus the individual eye and vision. Here, too, is the matter of culturally conventional taste and perception, as well as of the particular motives and aims of photographers.

Much has been written about the early emulation of painting by photographers. Some indeed were bastard painters. The best, we now see, found in the camera a specific instrument which could show qualities of informality, directness and honesty that are its own. The pictures of David Octavius Hill and Robert Adamson from the 1840s are always quoted here. And even the solemn Mrs Cameron in her child portraits departs from the contemporary mould of showing children in paintings as sugar and spice, towards something much more down to earth and believable.

No, it is the artists who understood the underbelly of photography. They saw that this realistic medium could lie. They produced the illegitimate offspring of the camera and the brush.

The most earnest and hard-working of these was D. G. Reijlander (1813–75), who would use up to thirty separate negative plates to produce one panoramic allegory for the uplifting of Victorian sensibility to further heights. His titles like *The Two Ways of Life* (as can be imagined, one spiritual and the other carnal) of 1875 reinforced the popular self-righteousness and the taste for the real.

But the most dramatically terrible of them, both aesthetically and logically, must be Fred Holland Day, who posed himself for his series depicting the last days of Christ, ending with his dieted body on the cross itself.

In a narrower focus, Fernando Tempesti, writing about the portraits of the Alinari Studio in Florence in the 1870s, describes how the Alinari brothers had devised a pose that would be reasonably comfortable for the long exposures required at the time. The sitter was made comfortable with the chin resting on the hand, which pose was then fixed with the dreaded head-rest, or rather, neck-clamp. This perforce gave a languid, rather pensive look, and also some element of intimacy and informality. In fact, the technique was taken up by contemporary painters, who obviously had the same problem of stillness with their sitters.

The Impressionists were photographers without a camera. It is not hard to discern the dialogue that a painter like Degas had with the camera. And the Impressionists' influence can surely be traced to those photographers who have concentrated on showing the vision of the moment. Cartier-Bresson, Lartigue, and Brassai follow on from them.

The amalgam of painting and camera work does not confine itself to the painters of perceptions. The Surrealists recognise their kinship with the realist medium – or at least with some practitioners within it. And what is interesting is not that they appreciated the faithfulness of representation in terms of technique, but that they saw the content of some photographs to be of the right fantastic, unreal, dreamlike quality.

Fred Holland Day *The crucifixion, 1898*

In 1900 Eugène Atget (1857–1927), a failed actor and painter, settled to 'collecting' the old Paris and its gardens in a series of photographs. Ostensibly these were documentary records of architectural details, formal gardens, baroque statuary, for museum archives. But Atget could not help making individual works of fine art, expressing his personal vision. Searching out the right light and shade in the early empty hours, he gave us images which are now acknowledged as part of the myth of Paris. His unknowingness, his lack of formal qualifications, his remoteness from the art scene, of course, endeared him particularly to Man Ray and the Surrealists. It demonstrated perfectly that it was indeed Atget's unconscious that was behind his pictures. Atget was smoothly assimilated into the art movement of Surrealism.

However, as we have already seen, artists have also used photography within their own painting.

We know from the extensive documentation of Marina Vaizey's *The Artist as Photographer* book that Eugène Delacroix used photographs as the basis of paintings as early as 1857. While Edgar Degas made paintings that give the immediate, fleeting, cut-off quality of a photograph, especially in his racecourse pictures. He did this in order to produce his conception of our actual experience of seeing. Walter Sickert in his late work used ordinary newspaper photographs as blueprints for large paintings. The pity was that he did not have the courage to announce this formally at the time. He must have feared the accusation of some sort of cheating.

SLRs and the SX-70 have become aids, as the camera obscura was in the days of Dürer – full circle indeed.

Picasso painted from snapshots in the twenties, although he would critically change the scale of the final image. For him the snap was just an *aide-mémoire*. He did not use the vision of the camera.

Ben Shahn, one of the American Farm Security Administration photographers, went on to use photographs (usually reversed) as exact blueprints or patterns for his most famous, moving and characteristic paintings. His photographs, therefore, were already full-blown Shahns.

Eugène Atget *Boulevard de Strasbourg, corsets*

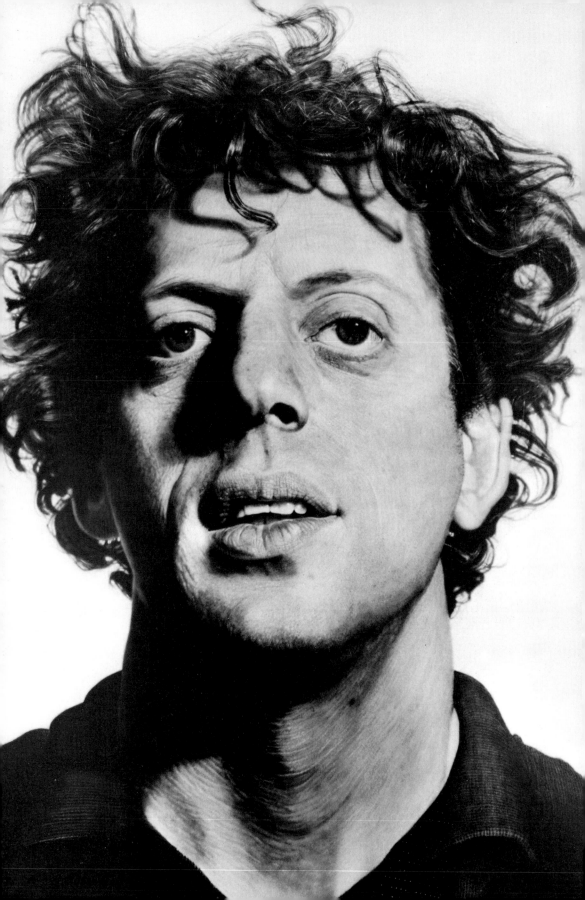

While it is contemporaries like David Hockney who have made it entirely unremarkable to use Polaroids as the basis, not only of portraits, but of large scale landscape and city paintings, there has been an entire movement in painting that has taken photography as its goal.

The super-realists have set themselves the engaging aim of reproducing, with acrylic paint and brush, as near as possible a reproduction of a colour, and even sometimes of a black and white, photograph. This is done by projecting a slide on to canvas and painting on top of the light image.

The fun and fascination of the result is, of course, that it is so skilful an imitation photograph, yet on a scale and of a solidity that we cannot link with photography. Although the movement is rejected by traditional connoisseurs as heresy, it is a logical extension of the relationship betwen painting and photography. Previously photography copied painters; now the process is reversed. And it is more than a *tour de force*, for Chuck Close and his colleagues have extended our vision. His large black and white painted photographs are intended to grab our attention in highly sophisticated ways. While, ordinarily, big modern paintings increase the size of the composite brush strokes proportionately, Chuck Close's 7 ft × 9 ft *Robert* consists of 160,000 identical sprayed round ink dots. The 'inarticulate' dots (one cannot tell whether one will end up as hair or lip), Close knows, would produce a clear image for us at fifty feet, but then suck us in close so that we can also experience a relationship with minutiae. We can now 'see' in still another way, and that is what the visual arts have always been about.

It is here that one must include the recent work of David Hockney. And, as often, Hockney enters the scene to tease, to extend our way of seeing, and at the same time to make a serious statement about our taken-for-granted concepts and the logic behind them.

Starting by providing patterns for paintings — one-to-ones, as Mark Haworth-Booth in his catalogue essay has called them — photography was useful. But Hockney could see that these lacked the layers of time that a painting must include, and they had necessarily to be 'one-eyed', of a single perspective.

Chuck Close *Philip Glass*

David Hockney *George, Blanche, Celia, Albert and Percy, London, January 1983*

The element of time and the increased richness of complex points of view came in two stages. The 'joiners' of 1982, a kind of simple geometric patchwork of perhaps 10 × 18 Polaroid SX-70s, would piece together a domestic conversation between Robert Lawson and Wayne Sleep, by dint of Hockney catching each element from his constant stance but different point of focus eighteen hundred times. We are told that this could take four to six hours. Time was thus incorporated. These ventures not only developed a new art form, although Chuck Close had produced joiner portraits in 1980, but the use of a popular amateur's camera, ordinary light and quick commercial processing had the right modish element of throw-away technique as a background for the painstaking work of the taking; while the logically necessary presence of the photographer – Hockney himself in the mirror – is included too. What more could we want ?

The process of perceiving comes more richly into the second stage of free collages, where an ungeometric collection of pictures (now taken with a Pentax 110) show the kind of free but motivated visual search which our eyes engage in when we cover any interesting scene. George and Albert play with Blanche and Percy, and Celia turns to look at them each in turn. Here in the visual and the temporal data we have not only the 'display', but the relations within it acted out in time. There for our delectation in front of us, having the qualities of a moving image, and yet with the permanence of a still.

But perhaps the closest symbiosis between art and the camera can be encountered in the production of works of art which cannot possibly be seen, let alone studied, without the aid of photographic documents of them.

One thinks here of the wrapped-up buildings, connections with rope, and curtains across canyons manufactured by Christo. Although in theory it is possible to go to Biscayne Bay to view his work for the days it is up, his art is essentially propagated in reproduction. The ephemeral reality finds lasting fame in photographs.

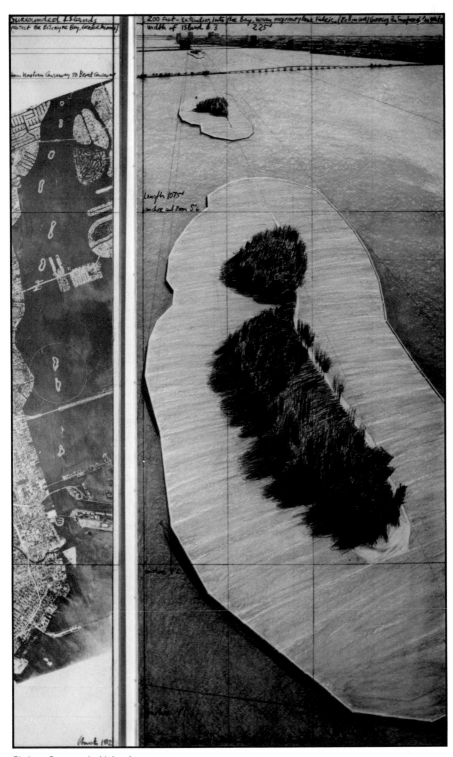

Christo *Surrounded islands*

The same applies to 'performance' art works, and certainly to much 'land' art, which combines parts of Ordnance Survey maps, samples of sand and water, and photographs of terrain (on a broad scale and in detail).

Here the argument could be that photography is the strongest partner in these ventures. Artists set up happenings to photograph them. The art is produced to be photographed.

Confounding the message

If we are right in the idea that photographs have an inevitable possibility of fascination and beauty, and that the best of them mix information, emotion and beauty, this must mean that it is difficult to be single-minded in using a photograph to carry only the function of information. The question of this kind of purity arises most strikingly when one considers reporting and 'concerned' documentary work (see chapter 4).

A good photographer will take, and then further select, pictures that convey in the image the particular message of happiness, malaise, dominance, defeat, modernity or tradition that is appropriate to his or her view. In order that the image should be powerful as well as clear, it seems that principles of good composition are always used, naturally and, perhaps, unknowingly. For the picture to look 'good', therefore, the aesthetic component is included. And the problem of the admixture of aesthetic 'goodness' continues, because the person looking at the picture will, at some level, again appreciate the beauty. And that beauty waylays us. The message will be not necessarily enhanced, and often blunted. It is the positive that is enhanced, the negative blunted.

When we see photographs of Bill Brandt's from the old *Picture Post* – the miner pushing his coal gleanings up the hill on the bicycle, the young girl dancing in the street in her poor clothes – the solemn beauty and the lively charm divert us from the understanding of the degradation. We see the poverty as a kind of austere elegance, just as Millet did, and certainly having in that sense a value that the bourgeoisie can never attain. But is that the right effect and the right conclusion ?

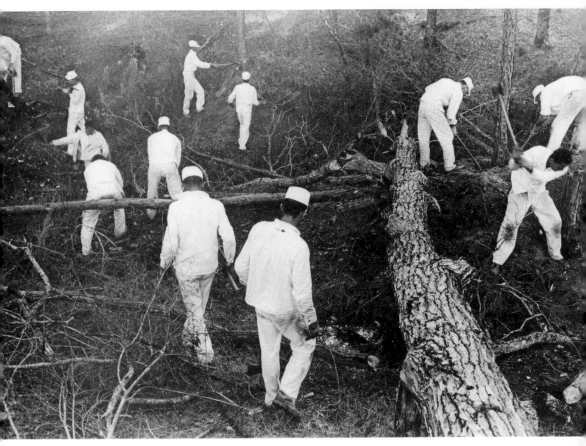

Danny Lyon *Clearing land*

Similarly, the overtly propagandist work of Danny Lyon about the prisons of Texas shows a clarity of surface light and texture, a sharpness of focus, as well as a composition of forms, that add a distinctive sheen both to the actual images and to the figures of the prisoners, giving us a direct visual pleasure. That pleasure must distract and detract from our empathy with the frustrations and indignities that he is trying to show.

The crux of this 'problem' occurs most notably in the work of Don McCullin, whose pictures of the deepest terror are always wonderful compositions of form and light. One must marvel at the sureness of his eye under circumstances of great personal hazard, but also wonder at the dissonance between the random ugliness of the matter and the fineness of the art.

Colour bad, Black and white good – Or vice versa ?

As anyone who has ever thought at all about photography will have noticed, popular photographs are in colour, serious photographs are in black and white. Why is there this strange divide and why are there so few exceptions ?

The founders of photography hoped for colour. That would bring them even nearer nature and reality, and closer to the other visual artists. They saw black and white as a stage, a limitation that would be overcome. It has been overcome, and yet colour has not been accepted by art photographers in general, nor certainly by those engaged in serious reportage.

Colour technically gives more information. It is up to date. And beyond commodity realism, psychologically it has associations of a rich emotional kind. Colour can be warm or cold. It can easily suggest lushness and richness, either with enhanced colour or with that chiaroscuro which suggests Rembrandt and fine taste. It is opulent. All of these characteristics make it ideally useful for what is called mercantile photography, which, put bluntly, is advertising and other forms of making people happy.

Food in black and white simply isn't food. Food in colour and on any scale is good. A tomato in a luscious red with highlights, and two feet in diameter, is a desirable tomato indeed. High life and jet-setting must be shown in 'rich' colour.

Even nostalgia, so strong an element in some promotions, can be easily created by the 'warm' glow of remembered sunsets and open fires. Landscape and nature is also heightened with colour, in terms of either grandeur or friendliness. It is only with colour that the sun is warm.

It must be agreed that amateur, informal, personal and family photography is virtually all in colour now, and the film manufacturers have clearly judged their market right. (It is significantly more expensive and takes longer to have black and white film processed commercially.) Colour in this genre enhances pleasure. The children, the family and the settings look more cheerful. They look more like they are. They conform to pictures in the popular magazines.

Why then is its use so circumscribed in the proudest domain of the independent photographers ?

Certainly 'serious' photographers have not only avoided, but despised, colour. Max Kozloff interprets their feelings in vituperative terms. For them, he suggests, colour is 'a bogus lushness'. The cheaper and more kitschy the content, the more likely it is that colour will be needed and used. Terms like 'the most vulgar visual lusts of the mass audience' are used.

It is worth considering in some detail the arguments against colour and for black and white. This will lead us to understand further what it is that photographers with serious intent are trying to do, both aesthetically and psychologically.

Technics

At least until now, photographers have been able to say, rightly, that the colour of film is far removed from the colour of paint. It is a dye that has no body or texture or density. People like Paul Strand, then, presumably believed that the comparison with painting would nonetheless be made, especially when photography relates itself to it on the further dimension of colour.

More directly, photographers have felt that they do not have the personal control over colour that they have over the optic values in black and white. Both in the camera and especially during processing, the freedom of the photographer is restricted by the more complex chemistry involved.

Naturalism/realism

A colour picture can suggest *naturalism* — the direct representation of the object depicted. It is a more faithful translation from the three to the two dimensions. But serious photographers have essentially wanted to ally themselves with the task of *realistically* presenting the world. That is, to go beyond and behind simple description, and to show a truer essence. And that is done logically more easily by removing the surface gloss of colour and using light–dark to denote the meaning of what is really there. It has abstracted reality/truth.

History and association

It is a fact that the founders used black and white. The medium therefore has the stamp of history. We know what the great photographs look like – shades of black and white.

Colour pictures first appeared in magazines like *Vogue* and *Woman* and in travel brochures, including *The National Geographic*. For these colour was good. However, the association with the meretriciously chic, the bogusly sunny and exotic, and the domestically blissful hardly attracted the photographer who wanted to be taken seriously. Was there also an element of snobbery here ?

'Psychology'

Related to the last point, there is the plain matter that the immediate response to colour, unless it is finely and subtly 'washed' (and that is just what was so hard to achieve technically), is a sense of good cheer and the mundane world. The mood is not serious and the link is to ordinariness.

News photographs *could* now be in colour. But that would significantly change the quality of news. They would inevitably look less stark, less businesslike and more jolly.

Time magazine first used colour for advertisements. It entered the editorial pages unsurprisingly in the 'People' section (an unembarrassing way for serious people to get some gossip), was used further at 'the back of the book', and is only now sliding into the serious pages.

But in order for a visual object to be made interesting and challenging it must remove itself from the mundane and present an element of translation or codification. Black and white can do this. It has an austerity, an abstractness – even, it has been suggested, a literary quality – that means we take notice of it in a particular way.

Historically and logically we understand that the message will be to our mind, and not only to the eye. There will be no easy sentimentality. The message is spoken to the sophisticated, who do not 'need' the bribe of colour. Sober businesses need sober suits.

David Duncan photographed Picasso in colour — but never a war.

> It violates too many of the decencies and the great privacy of the battlefield. In
> the photograph of war I can in a way dominate you through control of black and
> white. I can take the mood down to something so terrible that you don't realise
> the work is not in colour. It is colour in your heart but not in your eye.

The new colour photography

If previously colour has been rejected by the elite of photographers —
because it is both jolly and pretty — that attitude has not deterred a new set
of 'serious' art photographers.

They do not want to see themselves as elitist. They do not make a god of
austerity. They have no message which will make us 'concerned' with the
plight of the wretched of the earth. They do not want to remove themselves
from contemporary technical developments, or from the rest of the photog-
raphers of the world. Colour is there. Why not accept the technology,
imperfect as it may be ? Make colour pictures. See what happens. Their
pictures are openly 'snatched' from the flux of the everyday. They are little
removed from it.

They don't have the quality of immortality. There is no dream magic. There is
little form. There is no claim to persuade us of anything. There is no repining.
There is the valuing of the random moment and the acknowledgement of
the mass-produced.

This puts them in the mainstream of current anti-art. And in this we can see
that they are making one kind of significant statement about modern life.
Their work is not about meaningful images, about aesthetic principles, about
noble suffering. It is about random juxtapositions, ambiguous meanings and
fraught relationships, mysterious entities. They may be interpreted as sinis-
ter, or mundane, or need not be interpreted at all.

Photography's own genre — street photography

It is not by chance that the latter group of photographers have worked
systematically in the milieu of the street. If one had to choose one domain
that photography has made its own within the conventions of art, it must be
that — the street and the life on it.

Other genres and functions existed before, and continue to exist in painting, landscape, portrait, story-telling. But it is the quickness of the camera that allows it to *show* the street in its essential quality. With the aid of photography we have seen the street perhaps for the first time. For as Milgram, among others, has demonstrated, it is the street that provides us with the most concentrated kinds of environmental overload in its constant flux, both visual and aural, and it is there that we work hardest to reduce our perceptions. We can't see it all, we don't want to experience it all.

And yet, as Desmond Morris has said, it is the quintessentially modern experience and the arena in which the customs and mores of a modern culture are enacted.

A photograph arrests the flux, it can select a moment and lock it in the frame. What we then see is a sample from an infinite time frame, which represents a culture, living out there, but which is itself an example of that culture and its values and practices.

In Europe commentators on photography have found grace and discretion, while in America grasp and boldness have been the style. In their two ways they have a traditional and a more modern, tense beauty.

Atget has been mentioned so often, and he must reappear here. His streets may be empty and dreamlike, but when peopled they have an order and an atmosphere of purpose. The street musicians are performing a formal act; the children work hard at digging in the sand; the crowd have come together to enjoy, socially, looking at the eclipse through smoked glass, their postures choreographed; only the whores look boldly back at the photographer; the corset shop is but a further index of control.

Atget in Paris; Heinrich Zille in Berlin similarly caught the small trader, the skilled housewife, the folk art of the shop-front, the irony of the deserted fair.

And with him it is particularly interesting to be able to compare his graphic work of the same scenes and the same people. Zille worked for a variety of newspapers producing comic drawings of working-class life in the tenement courtyards. These were certainly skilled and amusing, although we see them now as highly stylised, stereotyped, entirely conforming to the conventions of the graphic style of the time for the presentation of the poorer classes, ragged but having a good time.

Zille's photographs show sometimes different. Although many of them were taken just to serve as mechanical sketches for the architectural backgrounds, they show a much more delicate, modest, and humanistic vision. There are women pushing big loads of sticks for firewood, the isolation of down-and-outs, and some of the tentativeness of big city life that he would not have dared to put in his drawings — it would not have fitted with the newspaper's ideology. It was his drawings that were mechanical, his photographs that were personal and creative.

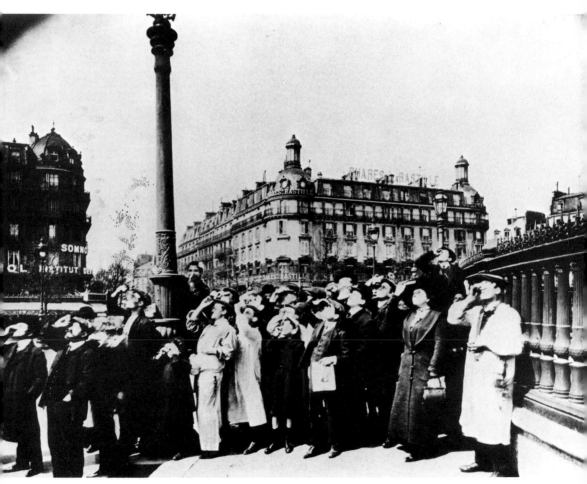

Eugène Atget

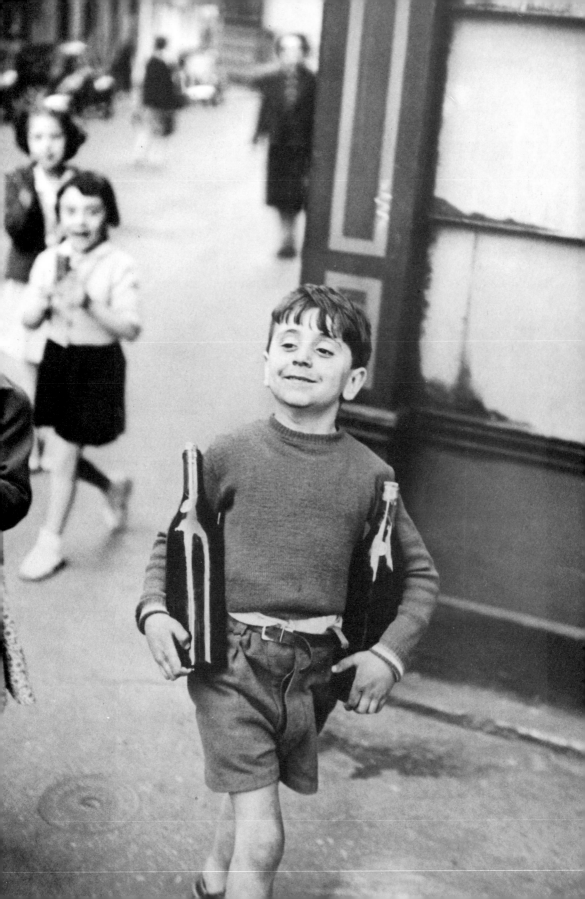

And the European tradition was brought to its apogee by the discreetly caught moment of Cartier-Bresson. It is the 'decisive moment', of course, that Cartier-Bresson presents to give us the maximum of meaning, but we do not feel that we intrude. It has been there for everyone. It is just that he was there, and his picture then transcends the moment. Sometimes the moment is very public: the boy with the wine bottles 'plays up' his role; sometimes a street event, a street juxtaposition, has a private mystery, a resonance that we can't altogether understand. Neither of these pictures would have had the same effect as paintings. They would have been kitsch, both of them. Because they would have lost the authenticity, the truth value.

It is the truth value of the American street photographs, too, that gives them their special artistic and psychological interest. Their style and their subject matter in a state of consonance, they randomly sample their subject-matter. They show fragments, *randomly* set out, *arbitrarily* cut off, with *bizarre* juxtapositions, and these epithets invite us to move from the photograph to the culture and the people in them.

Robert Frank, a Swiss immigrant to the United States, made a profound impression on American photographers with his work collected in *The Americans* (1978). And when Jack Kerouac in his essay on the work said 'To Robert Frank I now give this message: You got eyes', the implication must be more than personal: it took a stranger to see what was going on in the American street and highway, and to understand that he must make his medium marry the message.

That tradition which brings a kind of anarchy to style, which changes the conventions of photography towards the changed conventions of life, is further elaborated by the new colour photographers.

If Europe is discreet, and maybe has grace, and America is indeed bold and grasping, we may see this (index this) in the way in which the photographers in the United States catch their subjects head-on; in the way they don't merely exchange a glance but, in the technical sense, gaze. People are not caught at their best. The moment is critically indecisive and transitional. There is confusion rather than mystery. There is tension. We have the impression that the picture has been stolen rather than taken.

But we will have to consider the delicate matter of the act of photographing later.

Henri Cartier-Bresson *Sunday morning errand, rue Mouffetard, Paris, 1958*

4 Photography as truth and lies

I wanted to show the things that had to be corrected: I wanted to show the things that had to be appreciated.

Lewis Hine

Documentary photography has always been one of the most important genres. Documentary photographers have always been the most respected members of the profession. They do what photography can uniquely do – tell us what the world is really like.

Documentary photographers do more than simply show reality. By custom the term has been applied to a particular kind of 'showing' – what in general we don't want to see, the bad things in life.

As we see how things are, inevitably we see that they will have to change. Intrinsic in the documentary photographer's role is the element of reform.

Documentation is more than reporting. It is propaganda. And although that term is fraught with conflict to many ears, Tom Hopkinson himself, the editor of *Picture Post*, has said, 'Propaganda can be noble when it is applied in a cause and employs good emotions.'

This is a crude account of the basic argument that has been the receive, background to documentary photography. We will consider the argument in further detail. The positive points will be presented, but we will also have to consider the negative ones, which have become more prominent in the last decade.

It will become clear that there are three elements in the process of propaganda. The photographer is, of course, one of them, but there is also the medium for the propagation of the picture, and the 'reader' or consumer of it. The role and interests of each will be of importance.

Why was documentary photography so important ?

It seemed a job that the camera could do perfectly. Photographers of high talent applied themselves to it. It has political and media support. Documentary photographs have a special fascination for the reader. They put us in touch with 'reality'. They raise our consciousness in a good way.

But was the propaganda truly effective ? What reality was shown ? What version did photographers find most apt for showing ? Whose consciousness was raised ? How were some of the effects defused ? Are there ways of doing things better ?

The image of a photograph does represent something out in the world. It has great face validity. However sophisticated we are about the construction of social realities, we must intuitively acknowledge the authenticity of a photograph. We believe it. It is real and alive, in a way that the cleverest drawing in the old *Illustrated London News* was ambiguous and dead.

And here the fact that the camera is a machine, a simple mechanical tool, is at a premium. We believe that it allows the state of a person or a situation simply to show itself. Put a camera in front of people or a happening, and they will appear on the negative and that's that.

That power of reporting was soon appreciated. Within three years of the invention of the camera, news photographs were being taken. (The trouble was that they had to wait for the invention of the halftone block to make them usefully reproducible. The *Daily Mirror* printed the first photograph in 1904.)

Mendel Grossman *Victims of the great round-up in September 1942*

Anonymous *Communards in their coffins, May 1871*

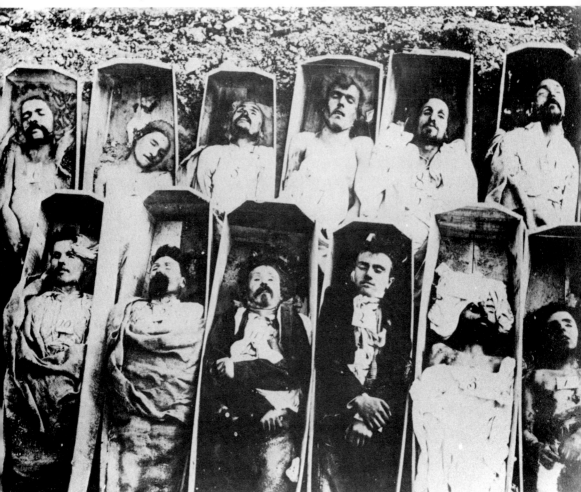

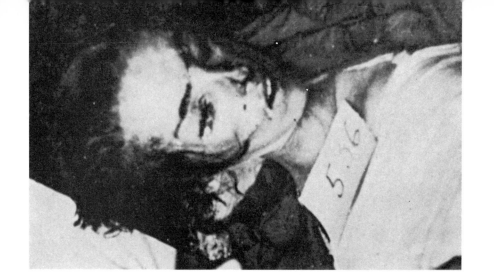

It was photo-journalism that brought readers into a kind of new contact with the world over the horizon. Tom Hopkinson, for one, considers the change revolutionary, when he says that readers were no longer members of the excluded mass. They now shared the excitement and the entertainment value of things going on all over the world. They shared also, though, the horrors and the suffering of earthquakes, wars, epidemics; and the poverty, not only of the other side of the world, but of their own community. These were shown in serious 'documentary photography'. For all the genius of Goya or Picasso, the painting cannot match up. Nor can a moving image. Again, Tom Hopkinson puts it succinctly:

> A newsreel has movement, but the still photograph has permanence. It is a moment of time frozen. The famous picture of the South Vietnam general shooting a terrorist with his own hand in a Saigon street would have meant little flashing by on television screens. As a still picture it stands forever – an accusation of mankind.

An investigative reporter has to find the subject. The camera does the rest.

We have already considered a direct and simple illustration of the function of documentation in the work of Mendel Grossman in the Lodz ghetto. His picture of the three dead children is an echo of another famous image in the history of photography, the dead Communards. The terrible conflicts within the genre were already present in 1871.

Pictures of the Paris Communards at their barricades are among the earliest news photographs. The supporters of the Commune were apparently more than willing to allow themselves to be pictured. It was only proper that these historic moments, and their part in them, should be recorded. We see here a sharp example of the matter of worthiness. Photography already then set the seal of importance.

Tragically, these photographs were used immediately after the fall of the short-lived Commune, as evidence of identification, the proof of identity as an insurgent then leading to summary execution. But the role of photography does not end there. Photographs were also taken of their dead bodies in their makeshift coffins. It is these pictures that have become their powerful memorials. They are monuments to their free spirit, and monuments also to the cruelty of their executioners. The reports have come full circle. The propaganda message has turned around. We shall return to these kinds of paradoxes.

The documentarists

It is usual to begin a discussion of documentary photographers with an account of the work of Jacob Riis, who as a Danish immigrant had himself lived initially in great poverty, and later in the 1880s, as a police reporter for the *New York Tribune*, had perforce to remain in the lower depths of the East Side of the city. He published two exposés of life in the tenements, sweatshops and lodging houses, and under the bridges. In *How the Other Half Lives* (1890) he describes the wages, rents, population densities, social relations and ethnic customs. It was intended to be a cry for reform and was appreciated as such.

He took many photographs, which unfortunately could only work as *aides-mémoires* for undistinguished and sanitised small drawings which illustrated the first edition. It is only now that we have the possibility of seeing his book in the way he planned it. We can see that his work had indeed an artless genius, which makes his pictures more powerful than a more polished performance would have been.

Opinions differ about the effect that the work actually had on slum clearance. Theodore Roosevelt, then Governor of New York, called Riis 'the most useful citizen of New York'; but others suggest that the house shown in the Baxter Street alley, which featured in one of his most interesting photographs, was one of the very few that were demolished as the result of his work.

It is clear that he is indeed an early documentary photographer in spirit, even if he cannot be counted as one in fact.

Lewis Hine (1874–1940) is an example of the reformer, who chose eventually to work within the institution of the groups whose interests he wanted to advance. He was formally a servant of 'labour'.

Jacob A. Riis *Baxter Street Alley in Mulberry Bend, New York, 1888*

A teacher of science (albeit at the Ethical Culture School) in New York, he was an amateur photographer still when he published his series on immigrants arriving at Ellis Island. His work for the magazine *Charities and Commons* and *Survey* culminated in his appointment as photographer for the National Child Labour Committee. For them he documented the living and, more importantly, the working conditions of the children who helped in 'home work', but more dramatically in coalmines and textile mills.

His pictures were used in publications, posters and handbills. They clearly helped to bring the conditions of children to the attention of the affluent community. And it is interesting for us to see that his message did not involve sentimentality or any other kind of pleading.

We are simply shown the dangerous machinery which a small girl must stand on a box to reach to operate. In another photograph, the bleak-faced 'breakerboys' (*Coal breakers, Pennsylvania, 1911*) are upright and seem proud of their positions: some grin, all have a fine insouciance. They are not to be pitied. It is their position which is wrong, and does not allow them to partake of the American Way of Life to the full.

Lewis Hine *Child labour*

This, the relationship between his employment by the union and his vision of the subjects, is perhaps an important point to consider.

Not all documentary photographers have a clear crusade as a motive force behind their work. Some choose simply to show the life around them, believing that they have no particular propaganda function. It seems difficult to keep up this kind of neutral and disinterested stance. The observer sees a comment as well as a report.

Horace W. Nicholls (1867–1941), a photographer long forgotten and recently brought again to the fore, worked for the Department of Information during the First World War. He produced a set of pictures, *Women at War*, which demonstrate with panache the range of work in factories, on the roads, in bakeries and everywhere else that women had taken over and were performing effectively and with evident enjoyment. Here he clearly took a stand. It was a 'good thing' to show this happening, in the circumstances.

Payment for the right to photograph It is not only the visual anthropologists and sociologists who follow the dictum that one must pay for the right to photograph. Eminent photo-journalists have often taken the role of humanistic participant rather than sharp-eyed in-and-out observer.

W. Eugene Smith (1918–78) is perhaps the finest example of one who felt the responsibility he had, not only to show his subjects in a way that was true for them, but to enter their role. But he knew that such knowledge takes time to acquire. He was on the side of his subjects in many contexts. To achieve perhaps his most famous photo-essay, *The Spanish Village*, he lived in the location for a year. His war pictures were taken side by side with the fighting soldiers. (Later he was wounded in Okinawa.)

But the project that he himself considered most seriously took three years of his life, and in some sense cost his life.

Minamata, words and photographs by Smith and his wife Aileen M. Smith, describes and forms part of the battle for compensation and legislation that the people of the village of Minamata waged against the Chisso chemical factory, which had massively polluted the sea nearby with methyl mercury, leading to illness and death from brain damage.

Horace Nicholls *Woman tram driver c. 1918*

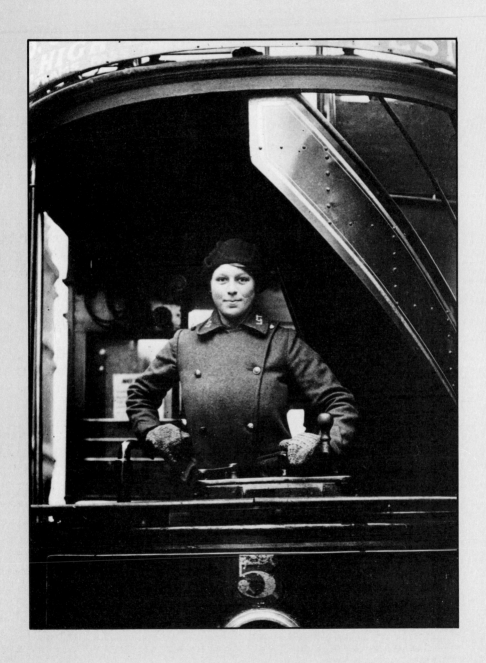

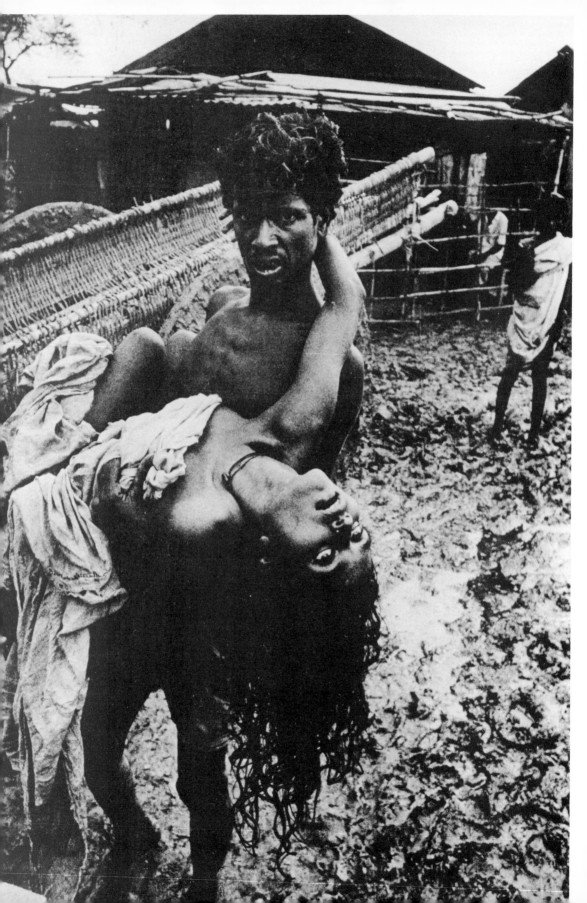

The Smiths lived in Minamata for three years. Not only were they harrassed by the agents of the Chisso Company, but Eugene Smith was attacked in the street and suffered, among other injuries, several crushed vertebrae. The company clearly believed that his pictures would be powerful – enough to try and prevent them being taken, with violence. In fact they have provided a lesson for everyone who wants evidence about the effects of pollution and the battles that must be fought against the polluters.

Don McCullin is the photographer who today exemplifies most clearly all the virtues of the serious documentary mode, and happens also to be the most celebrated photographer in Britain today. He was twice won the Photographer of the Year Award, has been the subject of essays by both John Berger and John le Carré, and has had a retrospective exhibition at the Victoria and Albert Museum.

We remember his:

> I only use a camera like I use a toothbrush. It does the job.

A laconic remark – but 'the job' is in fact not a simple one. He wants us to miss nothing that is going on anywhere in the world. His pictures are communiqués about what politics mean in people terms; how democracy is enacting its principles; what 'limited losses' amount to; and how well welfare is doing in our state.

We hate to look at his pictures, but we have to. 'McCullin is the eye we cannot shut,' as John Berger has said. The fascination is compounded by revulsion, but we still look.

What we see certainly illustrates the claim that photography can show what we never see otherwise.

Again, more powerfully than in moving film, we have to think about the cholera deaths in Bangladesh and what it must feel like to carry your dying child to what is just another source of polluted water; or to find your husband killed on the floor of your house in the Cyprus war of 1964.

His pictures are the only thing that we 'know' about such conflicts and horrors. They are certainly in our minds the way the political accounts and analyses can't be.

Don McCullin *Man carrying sick wife suspected of having cholera to makeshift hospital, 1971*

Happenings in the world we know as distant, fleeting and unconnected with ourselves. It is their shadows that have substance, that become part of our lives, that influence us . . . when they have been caught by McCullin. His pictures are documents of human lives. And his work must be a form of victimology, because the victims are the element that the political pundits exclude from their calculations and conclusions, and because we can only understand what (natural) disasters mean when we see them.

His pictures illustrate political theory, as Berger has put it. We have to draw the new political conclusions ourselves, by including his evidence with the abstractions that the Secretary of State or the local demagogues, or our unthinking indifference, have lived with up to now. And it is painful to look at his pictures. They stop the casual, clever chitchat when they're shown at exhibitions.

It is perhaps not difficult to generate the correct moral indignation against the cynical 'super powers', the ineffectiveness of the UN agencies, and even against human nature itself when it continues to ridicule the albino boy at death's door in the Biafra famine. The pictures raise our attitudes to new heights.

But what's that ? Does that do anything ? Does it help ? For many of us the process stops at hearts and minds. They are improved, for our own edification.

The problem is acute in McCullin's documents about life in Britain. In Bradford, with 'war pictures taken in peace-time', as John le Carré has called them, he proves to us that people live in a squalor that compares exactly with that which Riis found in the 1880s; that Disraeli's two nations still exist side by side; and that men can die on the pavements of Bradford as well as in Calcutta.

Awareness is an important part of political thinking, which lies at the back of action. Long-term results may come in the greater acknowledgement of our responsibility for others – both our own responsibility and that expected of politicians. Or does McCullin's work just emphasise for us, if we think about it beyond moral pain, our distance and helplessness with respect to politics ?

Institutional support

The way in which photographs can vividly report the happenings of our time has made them part of various institutions. For a start, they are an integral feature of newspapers. (The almost photoless Swiss paper, *Neue Zürcher Zeitung*, signals its high political intent dramatically by this lack.)

Documenting photography as photo-journalism was the basis of the editorial matter of the picture magazines like *Life* and *Picture Post*. This tradition is in some sense maintained by the colour supplements of the Sunday news-papers. The political purpose of such work was given its most significant recognition in the setting-up of the so-called Historical Unit of the Farm Security Administration (FSA) of Roosevelt's New Deal. Here photographers had the plain job of showing and explaining the white rural poor to the rest of American society.

The social assumptions behind these 'institutions' are worth exploring and may help us to begin to see what the tacit, as well as the ostensible, messages were.

It was Henry Luce and *Life's* editors, *par excellence*, who were going to show all human life, as seen by American eyes: single pictures of particular importance and photo-essays that could be about what was good in life, what bad, comic, elegant, sexy, tragic or exalted. All mixed together, it was a survey that would both entertain and enlighten the reader. The generosity of its vision was in one sense a clear sign of the munificence of America itself. Even within the American ideal it held particularly to the optimistic position.

Most things are good. What is not good now, is improvable. Further than that, no political analyses were made. Neither individuals nor aspects of the system could be indicted, neither directly nor even obliquely, unless they were foreign.

As Gisèle Freund has pointed out, the simple juxtaposition of pictures of poverty and wealth which can make such a pointed comment was used in respect to England, where the beflounced little Princesses Elizabeth and Margaret Rose were shown opposite the barefoot children of depressed towns. Such comparisons were not made for America.

Freund has further scotched the argument that *Life* was killed because its readers moved to the television for their picture of life. No, it was the advertisers who moved and thus withdrew their financial subsidies of the low price of the magazine. The crucial role of advertising revenue obviously provides a further clue to understanding the basic role of the journal. To put it crudely, the editorial matter provided the justification for the consumer propaganda. One might go on to say that the serious photo-journalism justifies the sweeter material on the editorial pages. Here was a commercial business with some room for manoeuvre, but little possibility of stepping outside the dominant political stance of free enterprise and opportunity and the survival of the fittest.

The priority of values at *Life* magazine is nicely encapsulated in Eve Arnold's account in *Flashback! The 50's* of the fate of her photo-essay on Malcolm X and the Black Muslims, on which she had worked for some months in 1959 and which had cost $10,000. After much persuasion on her part and several editorial conferences, because it seemed such an obscure subject, a ten-page layout was agreed on. In the event, the story ended with a horizontal double-page picture of Elijah Muhammad's family at prayer. The double-spread advertisement below was for Oreos, the chocolate biscuits, with the caption: 'The greatest chocolate cookie of them all.' Arnold says, '*Life* didn't pull the ad; they pulled my story, and we never mentioned it again.'

The more modest *Picture Post* in Britain emulated *Life's* red logo but its political position stemmed from the continent. Stefan Lorant and some of his creative photographers (for example, Felix H. Man (*né* Hans Baumann) and K. Hutton (*né* Kurt Hubschmann) were refugees from Hitler, and the magazine was started to fill a media void. In the autumn of 1938 the establishment had supported Appeasement, and yet many people were against it. *Picture Post* was to be their voice.

As Lorant recognised, the technical possibility of candid photography in all contexts would not only make the paper attractively 'modern', but could display in style the populist and iconoclastic political position of the paper. We now find some of the early essays in political 'education' risible and, more importantly, risible in their directness. (In 1938, the feature 'Back to the Middle Ages', contrasts the ugly and ignorant Hitler and Göring with a series of Nobel Prize-winning Jewish men.)

Bert Hardy's Gorbals pictures and Bill Brandt's West Ham and northern town surveys remain milestones among strong and honest pictures of working-class ways of living.

Though *Picture Post* must have been underwritten by its advertisers to some extent, it was not enthralled by them, nor were its editors politically naive. Its photographs and their commentary informed the concerned public about what was going on in what seemed a sophisticated manner. Unfortunately such fine independence from the establishment position is hard to maintain. By the time of the Korean War, Bert Hardy's pictures of prisoners being ill-treated by South Korean forces were rejected by the proprietor, and Hardy resigned from the paper. Not long after, it too fell to the advertising power of television.

The FSA chapter: a case history

From many points of view one of the high-water marks in the history of photography comes in its association with the New Deal and the Farm Security Administration. There its power to authenticate and to persuade was recognised and appreciated. Especially if we consider that one of the reasons for their existence here was simply to make work for photographers, it is a fascinating story, photographically, psychologically and politically.

It is said that the ethos of the Historical Unit was popular, pushing, optimistic. Its job was to show the wretchedness, waste, chaos, despair – the denial of the American Dream – among the smallholders and itinerant workers, so that the influential urban middle classes would agree to their betterment. The straits of the white rural poor were to be shown, so that opinion would again admit that they mattered. Demonstrate, deplore, and fix up – in good American style.

The amazing thing is that the job seems to have been done by a group of people who were often highly sophisticated, arty, introverted, upper-class in background. They produced a body of work that contains many of the 'great' images in the history of photography. From the very practical purpose of the project comes, understandably, their dramatic human empathy. But they are also highpoints in the aesthetic canon.

Stryker chose a varied group, including Ben Shahn, the painter, for his humanism:

> I was taken by Ben's photos because they were so compassionate. Ben's were warm. Ben had the juices of human beings and their troubles and all those human things. You sensed all those things.

Dorothea Lange (1895–1965) worked with a more knowing stance. In photographing poor people 'Here's what these people are like now', she believed that she showed not only the people dispossessed, but also, in some sense, society – then quite invisible. Walker Evans, another member of the group, has suggested that an important attraction was the opportunity to show the truth – away from the pressures of bosses and bureaucrats.

Ben Shahn *Ozark mountaineer family, Arkansas, 1935*

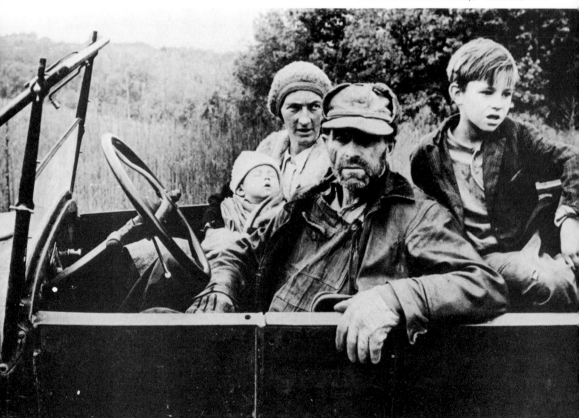

They and others – Arthur Rothstein, Caryl Mydans, Russell Lee – tried to accept their moral purpose with purity: . . . no angle shots, no filters, no mattes, nothing but glossy paper' (Ben Shahn). Frontality of subject matter and flatness of space.

> We tried to present the ordinary in an extraordinary manner. But that's the paradox because the only thing extraordinary about it was that it was so ordinary. Nobody had ever done it before, deliberately. Now it's called documentary, which I suppose is all right . . . We just took pictures that cried out to be taken.
>
> Ben Shahn.

Although Shahn is now remembered as a painter, he had been working as an unobtrusive street photographer and had certainly painted direct 'copies' of some of his photos. He had crucially, though, the humanistic perspective that Stryker was looking for.

Walker Evans, on the other hand, has been desribed as being concerned with purifying experience rather than institutions. He could almost be said to be brother to Andy Warhol in his interest in style, in so far as he wanted his subjects to demonstrate to him the whole of their lives, whatever they were, of achievement or failure, goodness or badness in portraits.

Dorothea Lange's aim was to make a picture that we would look at with attention. It was her earlier work in collaboration with the text of Paul Schuster Taylor, a University of California economics professor, carried out in 1934 and published in *An American Exodus: A Record of Human Erosion* (1939), which had stimulated the setting up of the whole photographic unit. She had already had practice in the role of 'explainer'. A picture could explain, if we would stop and look: 'She felt that the glance was enemy of the look, of understanding, of humanity even.'

At the simplest level of evaluation, one must say that the FSA photographic project demonstrated that the support of a government agency for a particular job need not deaden creativity. Propaganda can have a kind of nobility. Photographs can directly and honestly, we feel, move us and influence our thinking. All of the workers in the group wanted in their own way to show us facts. They wanted to be factual, not sentimental or sloppy, or arty.

The trouble is that we as observers can easily fall into the trap of becoming preoccupied with the finesse of our responses, confuse our reaction with anything more useful, become satisfied with our aesthetic appreciation.

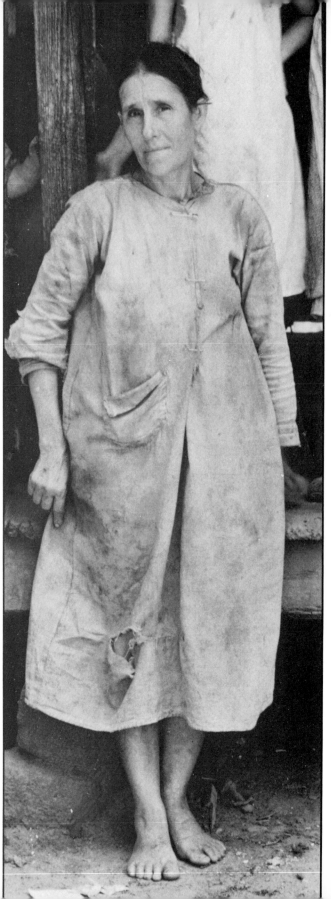

Walker Evans
*Sharecropper's wife,
Hale County, Alabama, 1936*

Dorothea Lange

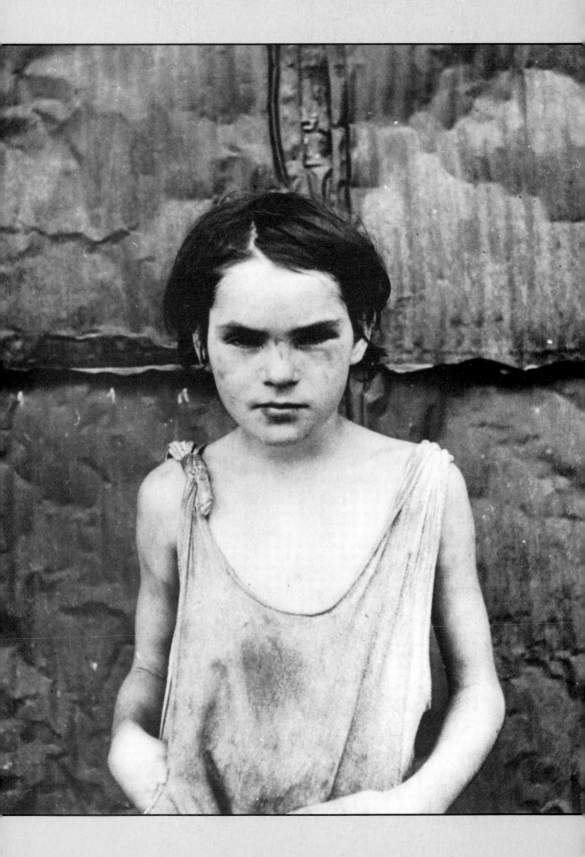

The fascination of beauty

It is perhaps the work of Dorothea Lange that illustrates most finely how, whatever the ostensible purpose, a good photograph will include the element of beauty. If whe wanted to have her pictures looked at with attention, she has, of course, succeeded most dramatically with her *Migrant mother.*

It has rightly been said, this is one of the few photographs in the world that leads a life of its own. It has a trick of grace – it, rather than the photographer.

The woman is anxious and stressed but she has a simplicity, an austerity and a strength that we in our affluence and comfort don't have. She is noble in her poverty; we are meretricious in our affluence.

In her bad situation she is a good person; in our better situation we are worse people. She will survive, however hard her circumstances. We might not; we couldn't change places with her.

We metaphorically suffer with her. We admire her. We find her spirit, and even the simplicity of her image, beautiful. We attend to it, we can even contemplate it, and as with any beautiful thing we can gain serenity from it. But should we ? Is that how society is to be exposed and improved ?

Do these pictures raise consciousness in a good way ?

Throughout this discussion we have been concerned with the way in which photographic images might and can affect us.

They can inform us about things in the social world which we have been ignorant of. They can embody ideas which we may have toyed with in the abstract. They can move us emotionally, even to tears, if we give them attention. They can help us to rearrange our opinions and attitudes.

Susan Sontag has convinced us, though, that photographs cannot be expected to create right thinking. They can perhaps become kinds of ethical reference points. For me I can see the small boy in the dreadfully big cap, coming out of the Warsaw ghetto with his hands up under the Nazi rifles.

But as we have suggested, every reader will have his or her own. In our imagination they retain their power. One suspects that actually looking at copies of them would make their effect wear off, like pornography's arousal.

Surely we are proud to have these ethical reference points. Proud even of the pain they arouse. With them we are nearer the ideal of empathic humanism. We want to have a repertory of the right ideas and attitudes. We believe that if we think right, feel right, somehow things become better, even if we do nothing. Our high purpose is to know the truth. And the knowing provides its own kind of virtue.

If concern is a significant improvement on unconcern, photographs are a good provocation. If action is the criterion, though, they are not such a good starting-point.

The arguments against the power of documentary photographs

Photographs seem to show us reality. But the genre of documentation is as fraught with ambiguity as any other kind of photography, and as any other kind of evidence. Riis, Evans, Brandt and even McCullin have produced straightforward ammunition for 'the good'. They have shown a version of the real.

It is easy for us to see the partiality in those whose ideology is different from our own. Early Soviet artists, like Rodchenko, tried to change not only the content but also the form of Russian photography, so that the New Soviet Man could be shown in a new visual perspective which rejected the old bourgeois naturalism of the mirror form of pictures. But his futurism was seen by the Soviet establishment as formalist deviation. All that was acceptable was a simple optimistic vision of good people (in the front of the frame) working towards a future which would be even better. And that look was also favoured by capitalism.

The look is only one element in the interaction with ideology. Who/what is worth photographing ? How is it to be shot ? How is it to be shown ? How is it to be labelled ?

One does not need to go to exotic locations to find startling examples of cutting and re-labelling. In the very domain we have been discussing there are demonstrations of the fragility of the document and of the vulnerability of the meaning of camera evidence.

Let us consider the fate of Dorothea Lange's *Plantation overseer and his field hands*, taken in the Mississippi Delta in 1936. In its original version this showed the bloated boss, foot possessively placed on his motor car, spatially dominating his black underlings. As George P. Elliott has interpreted it in his catalogue commentary, it shows the ruler and the ruled. However, another version of this picture was published in 1938 in *The Land of the Free*, as an illustration to Archibald MacLeish's hymn to the American

Dorothea Lange *Plantation overseer and his field hands, Mississippi Delta, 1936*

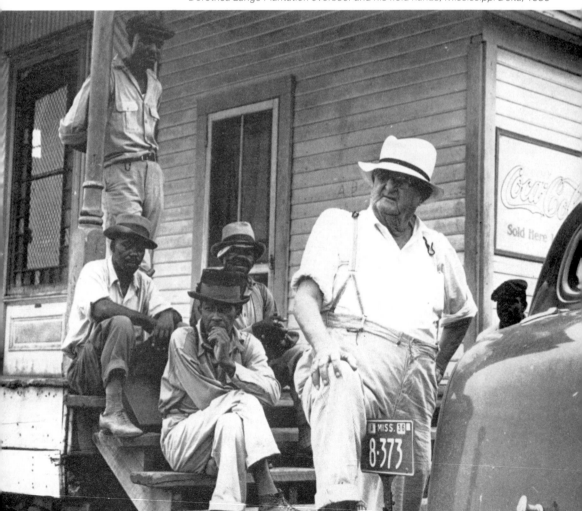

Dream. This time the black men have virtually vanished, the white man is shown alone, and with this accompanying blank verse:

We told ourselves we were free because we were free.
We were free because we were that kind.
We were Americans.

We were free because of the Battle of Bunker Hill
and the constitution adopted at Philadelphia.

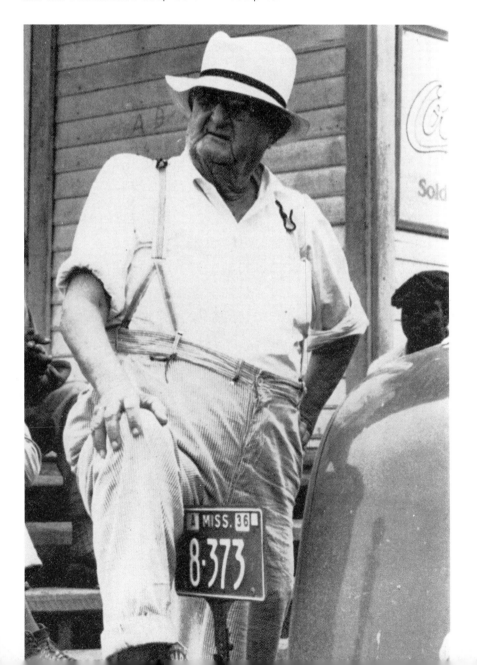

An oppressor of the helpless poor turns into a doughty freedom fighter.

The original sparse title enables us to draw our own conclusions, which are presented by the content and form of the picture. The MacLeish verse juxtaposed with it would have been ironic, to say the least. With the cropped image, we have a straight nationalistic message.

Does this mean that Roosevelt's New Deal and the Farm Security Administration had done their job of improving America? No more need to grumble, everything was OK again ? Or, at least, it was not politic to continue the campaign of social change ? It is tantalising that Elliott does not reveal what Lange's own views about the transmogrification were.

Further, it is worth analysing a particular photographic production after the passage of time, to see how the taken-for-granted quality of humanism may be open to more complex interpretation. We have already mentioned 'The Family of Man' exhibition and the book accompanying it, which The Museum of Modern Art in New York called 'the greatest photographic exhibition of all time'. It certainly interested, pleased and did not disturb all those people who saw it in the 1950s.

In those images of birth, childhood, marriage, work and death – the same for all of us – no political, economic considerations intruded. We could come away from it with that up-beat conclusion, better people.

But birth and motherhood, work and social identity are very different at subsistence level from in sophisticated wealth. We are not members of one family. Some of us suffer from deficiency diseases and some from diseases of affluence. Misery and anger and hopelessness were not shown, nor were the meretricious pleasures and pains of British northern communities.

The pictures were taken by famous photographers from their perspective and without the partnership of their subjects. They illustrated not the family of man, but a utopian vision, or a story of a paradise that does not exist, never has, and was manufactured for the comfort and edification of a public that was weary of the Second World War and the Cold War, and wanted to believe that we could now all return to a private existence, because at heart we were all the same, all basically happy and all of goodwill.

124

It was easy for Steichen to mount the exhibition from the portfolios of photographers. Without specific instructions on his part, the vision already existed. Collected together in a travelling display it carried a coercive message, which we didn't need to be coerced to accept. It is time passing that has drawn back the veil.

A victimology

In the tradition of Western liberal humanism the convention has been that it is the victim that must be shown. The photographic form has then expressed the ethos of the political structure, and has in its own way interpreted the ideology of reform. You have to show what is bad.

Photographers showed us the noble losers in society. The pictures have come to form a kind of shorthand or code, which we use to embody our ideas about the poor, migrants, child labourers, the unemployed and the victims of war. These are wonderful images. But their very beauty and sometimes even 'charm' leads to a kind of passivity in the readers.

Documentary photographers have tended to become trapped in their own cultural milieu. In *Life* and the Sunday colour supplements, which are consumer catalogues with some editorial makeweight, they are drowned. If this is the context in which they have to find themselves, the beauty is allied with other kinds of glamour; and the reader readily become peeping Toms. They can see the 'unbelievable' things that go on in the world in the comfort of their own homes.

At the 1980 Don McCullin retrospective exhibition, the context of his work was highlighted, and de-mystified. As well as his fine prints, there was the presentation of a complete issue of the *Sunday Times* supplement so that we could see this work properly among the sports cars, filter-tip cigarettes and continental quilt covers. It is when we remember that all this took place within the Victorian baroque finery of the Victoria and Albert Museum that the paradox is redoubled.

Bill Brandt *Coal searcher going home to Jarrow*

The images of authenticity are no more potent than all other kinds of evidence. The so-called directness of the visual image is as weak as other kinds of evidence in stimulating reforming action.

We can see that in the appearance of the same message in the work of Bill Brandt and in that of Don McCullin. The sixties man recapitulates exactly the degradation of the thirties one.

Whether the message is of pity or of anger, it is not enough. Does all this mean that a radical photography is not possible ?

5 Radical photography

If photographers are so closely enmeshed in the dominant values of their society, if their pictures are so readily assimilated into comfortable conventions in thinking, if documentary photography just works to further isolate the poor and suffering outside the community of those who see their images – is radical photography possible?

We will consider here a variety of strategies that have been applied, especially the German experiments of the thirties, as well as their successors in Britain and elsewhere.

We will try to see how far independent 'outsiders' among photographers could escape the traps of the class perspective, and evaluate the effect of presenting the whole power nexus, rather than just the victims. It will be worth studying some examples of 'giving photography away' in worker and community projects

It is a cliché that Britain and America are countries in which politics do not feature as an issue in discussion among cultured people. In Britain this is because it is taken for granted that we are all people of goodwill and therefore don't need politics in the form of ideology; and in the United States, the American Dream is shared by all and its attainment by all can sooner or later be fixed up.

On the continent of Europe we will find the open discussion of ends and means, as they obtain within the different class-related ideologies. And it was in Germany that was found the most sophisticated and refined understanding of what the new technical possibilities of the camera could bring both to social exploration and to subversion of the status quo.

While examining radical possibilities in Germany, one must remember that in the thirties the influence of German culture was remarkably strong in Britain. David Mellor in his recent history, *Germany: The New Photography 1927–1933*, discusses the imperatives of the new German photography at one end of the spectrum and the Weimar mythology of sun-bathing, athletics, bare flesh and high technology at the other.

It will be useful to consider also two serious German photographers, August Sander and Erich Salomon, who in their own right and through their successors initiated two kinds of documentary photography which avoid the pitfalls discussed in the previous chapter. They were radical not only because they were totally independent, but because they defined their roles as photographers in ways which cleansed them of the past in art and in emotion. Thus disinfected, they looked about them. Their critique of the social scene, of society, was oblique, but all the stronger for that, especially to Anglo-Saxon tastes.

Radical form

> Photography has become an outstanding and indispensable means of propaganda in the revolutionary class struggle.
>
> Willi Muenzenberg in *Arbeiter-Fotograf*, 1931.

Muenzenberg was one of those brilliant German intellectuals who could be a theorist of communism, the founder of the Young Communist movement, and concern himself with the structure of photography. He understood both the way in which photography could be exploited by the existing institutions and the way it might be captured and functionally transformed by those who needed to change society.

Pictures are intrinsically attractive and easy to read, Muenzenberg tells us:

> Photography works upon the human eye: what is seen is reflected in the brain without the need for complicated thought. In this way the bourgeoisie takes advantage of the mental indolence of the masses and does good business as well.

Muenzenberg and his German colleagues were ready with two tactics for the necessary transformation of photography, and we shall consider them in some detail.

First, the eye of the photographer must be politically educated. Style and form, and not only content, must reflect the new goals. A specific form of realism must be achieved. Here we are clearly part of the wider German art movement of *Die Neue Sachlichkeit*, the New Objectivity. It was not just a way of applying photography in a way that would serve the proletariat rather than the bourgeoisie, but a new way of understanding what photography could be about. This meant that the camera would be used as a mechanical instrument for a realistic information process, as well as a resource for a new visionary perspective.

Second, it was their principle to 'give photography away'. By this the German Left accepted as axiomatic that the professional, the expert, the dominant agent must abrogate their role and teach the people who had hitherto been only objects of their pictures to use, develop and control the means of their presentation.

The victims were to become the masters. The workers must take over the means of production and the distribution of photographs. *The Arbeiter-Fotograf* was born. This was a photographic magazine which published pictures made by worker amateurs, who worked in co-operatives under the guidance of experts. More than a journal, the movement organised a national conference in Erfurt in 1927, established the Association of Worker Photographers and held the first exhibition of proletarian photographs. International conferences took place in the early thirties, and the concept was seriously appreciated by the continental left trade union movement.

While the resulting pictures, which we can study in issues of *Arbeiter-Fotograf*, are properly provocative, the movement was hardly to be remembered as a crucial factor in the political turmoil of the thirties. It is worth considering for the rightness of the logic of its programme, though. The camera, just as any other kind of political force or weapon, must be in the hands of the people whose interests are at stake. We shall return to the argument.

August Sander (1876–1964)

We have already met him as the anatomist photographer of the Weimar Republic. He was one kind of document-maker, one kind of political commentator, one kind of radical, who 'wrote' sociology without writing. And all this happened while his ostensible purpose was to do *exact* photography, nothing more. He achieved his goal, for we are entirely persuaded by his pictures that he was objective and therefore accurate. His success contradicts all the pundits who have convinced us so far that no such thing was possible.

He wanted to be true to nature, to tell the truth about people in his era. The truth-telling was a political action, and the subversion that lurks behind his modest exactitude was recognized by no less an authority than the National Socialist Party.

The complexities within Sander's work constitute another of the big photographic paradoxes. He worked in Cologne from about 1910 to the thirties. Starting as a straightforward high street 'identity photographer', he began to realise that the camera could extend that. He would produce an identity survey of his people in his time. His plan became greatly ambitious, and in a proper Teutonic way he called it, Man of the Twentieth Century. Sander begins with the peasants and goes up through each level, up to the highest members of the bureaucratic, academic, artistic and military establishments, but does not let us forget the idiots.

August Sander *Pastry cook*

August Sander *Unemployed man*

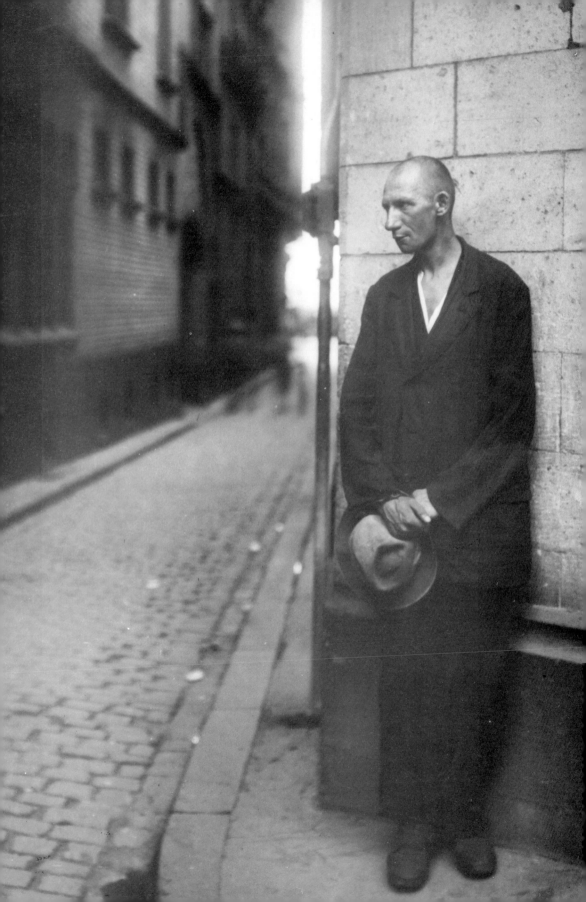

In the group portrait of the German nation, which his portfolios were to produce (who would even attempt to do such a thing today ?), there is no aura, no aesthetic, but a clean factual image.

His method was simple. Based at his home in Cologne, he surveyed the city and its environs by bicycle, to find people – adults and children – who would be representative of their class, their occupation, their setting, and asked to be allowed to photograph them. He looked at the whole population, no sub-sample of underlings. As is clear to us today, the pictures were taken in a very ordinary way. The camera was not hidden. People arranged themselves in a good pose. They are shown in their natural setting, at home, at their place of work, in the street or in the countryside. They always seem to show themselves in a serious mood. Full length, they are not tense or pretending. They must have trusted him in a very direct way.

Sander wanted to record the look of the social hierarchy of German society, at the end of centuries of stable evolution of that stratified community. For history it was important to show the appearance – the last appearance – of people who knew their place and acted out their status in the social order, whatever their personal qualities. He did not give the names of the subjects, only their *métiers*. He succeeded, as John Berger said, because 'they looked into the lens, and using a strange historical tense, say – I looked like this'.

The appearance was symbolic, though. Berger has analysed *the suit* in Sander's images as presenting the security of the middle-class man, contrasting its pathetic aping in its 'deformed' versions. (Its meaning as an index of status, aspired to and attained, may be compared with James Agee's interpretation of the metaphor of the bib and braces for the tenant farmers of Kentucky, in Walker Evans' FSA pictures, which he saw as the harness of the human.)

Sander's success with appearance is partnered with his even greater success behind appearance, in psychology and political analysis. He seemed preoccupied with roles, as were his subjects. However, when we look at the pictures now, removed in time and place, we see 'the face', the created persona, but we can also see where there is hiding behind the mask. In some cases society seemed to give too much importance to status, and in others too little to 'front'.

To our reading, the presentations seem naive. The most elevated show their arrogance, the young show delight in their sophistication, the older workers do not hide their endurance, the children are already classified. We see the surface, but also the individual. It is the interaction between role and person that tempts us to make the moral judgements that we can't avoid when we study his people.

Unpretentiously he said:

> I never made a person look bad. They do that themselves. The portrait is your mirror. It's you.

It is the tension between the sitters' belief in their own performance and our disbelief that holds the fascination that Sander's work continues to exert. Max Kozloff refers to 'the imperturbable chaste ridiculousness' of the sitters, but there is more to it than that.

Sander's record of archetypes is radical because it shows the truth and nothing else. In fact, at the time he exhibited and published some preview samples of his work — sixty pictures in 1929 — they aroused little interest. Only intellectuals recognised his vision then. It was the Nazis who felt the danger of it. He did not present the Aryan master race, only the crumpled suits of the peasants, the stiffness of the evangelist, the play-acting of the student duellist, and, in the sample, the National Socialists were just as lumpy as everyone else. On the pretext of his son Ernst's socialism, the Gestapo destroyed his plates and stopped any further portrait work.

By his immediate, accurate observation, he allowed the good and the bad to show itself. Simply to show the Germans as they were, not as a special creation, violated and conflicted with the state view. His pictures condemned him.

Diane Arbus (1927–71)

The natural successor to the anatomist Sander is generally acknowledged to be Arbus, the pathologist. That progression in style may be an index of the terribleness of the times, or of the degree of extra drama that is necessary to evoke the same response from our jaundiced eyes. On the other hand, it may be that the quality of American life threw up a photographer whose acidity was consonant with its own degree of extremity.

Like Sander, Arbus quite blatantly confronted her subjects with the camera. They too were invited to show themselves, to appear in their own settings – apartments, public parks on holidays, private views, parades. She followed Sander in presenting the rich and the poor, both; and even more notaby in including in her survey circus people and people in asylums.

She too had in mind to produce a picture of mankind, and saw the enormity of the task:

> There are an awful lot of people in the world and it's going to be terribly hard to photograph all of them . . . It was my teacher Lisette Model who finally made it clear to me that the more specific you are, the more general it will be.

Arbus, compared with Sander, was both more active and more specific. In the flux of America, that was essential. She would make her point by showing us a sub-set of the North American urban population, who demonstrate in actuality the quality of the American Dream. She did this by seeking out the transvestites, the wrinkled blondes, the murderous child, the isolated nationalist; and by photographing them with great exactitude. Then we would see what the American Way of Life was really like. By her account the optimistic materialism is accompanied by sham, by grotesque falseness, by fantastic delusion, to say the least.

Her people have no place or status: they come from the cracks in American society. They are not outcasts, though, but, as Kozloff has labelled them, peacocks of subcultures – albeit subcultures of which the earnest readers of Arbus' pictures do not feel any membership. Our identities are not spoiled, our face-work is not so crude. She would have included us all, though. Speaking like a sociologist, she said:

> Our whole guise is like giving a sign to the world to think of us in a certain way, but there's a point between what you want people to know about you and what you can't help people knowing about you. And that has to do with what I've always called the gap between intention and effect.

That gap is ignored in the politeness of the co-operative management of reasonable impressions. Our eye turns away from the frailties of failed presentations and leakage. She confronts spoilage head-on, and must have been right when she said, I really believe there are things which nobody could see unless I photographed them.

Apart from its psychological account, her work makes a social–political point. If a community can be described in Arbus' terms, there must be something wrong with it. And her message is more potent because the people she shows don't know that. They believe that their identities are in working order, that their life is manageable. We know that neither is true. It is the dramatic irony that makes her work radical.

Erich Salomon (1886-1944)

The camera may also present a more openly subversive message, and the origins of specifically photographic investigative journalism also have their origins in Weimar Germany. The term 'candid camera' was coined to describe Erich Salomon's work, and it was applied to his 'unrepresentative' images.

The traditional political news picture has been the formal line-up of politicians after the meeting, or at least the 'weight of the world on my shoulders' portrait at the office desk. In such images, the portentous responsibility and power of the agencies of government were reinforced in a manner convenient to those in power. Salomon, who was by training a lawyer, picked up a camera to provide some evidence for contract-breaking in a court case and quickly realised that, even in 1928, small cameras would allow one, with a bit of ingenuity, to catch pictures unobtrusively without flash. So was introduced true *Bild Journalismus* (picture journalism) into the powerful Ullstein empire of newspapers and picture magazines.

Erich Salomon *'Ah, le voilà: the King of indiscretion:' Aristide Briand spots the photographer Erich Salomon*

His features didn't just illustrate a verbal text, they told their story in pictures. His photographs caught the plain reality of the political events of the twenties and thirties. Inside the myriad of peace conferences, League of Nations negotiations, pacts and manoeuvres, Salomon infiltrated himself and his camera to show what it was *really* like. He captured his candid shots by use of his Ermanox, and later his Leica, usually concealed in a bowler hat that he carried, in an attaché case, in a book, or behind a bowl of flowers. He was certainly not averse to cheating, therefore, and with his educated demeanour (he always dressed to match his quarry) and his superb aplomb, he calmly infiltrated the corridors of power. Tall and short stories of his disguises abound – everything from his camera in a bagpipe at a Scottish shooting party, to hiring a team of decorators and ladders to shoot from a window outside a meeting, although his favoured entrée was in the entourage of a great person.

He described his technique as simply waiting for the moment at which one person had reached the apogee of his performance and his companions hanging on his words: then would come the moment of stillness, which allowed the vital shot. His collection *Berühmte Zeitgenossen in Unbewachten Augenblicken* (Famous Contemporaries in Unguarded Moments) showed that. But they were not only hanging on every word. On the contrary, the statesmen were shown laughing, drinking, gossiping, yawning, dozing. Their game of highmindedness was exposed. He showed them for what they were, elderly men who spent a lot of time in conferences and hotels, and whose characteristics and behaviour seemed not so different from businessmen or anyone else of their class.

It is said that pictures like *Conference at The Hague: Briand, Lord Cushendun, Müller, Scialoja, Hymans and von Schubert 1929,* changed Europe's view of politics and politicians at a single stroke. The camera, among other technological marvels, has brought us far along the road to cynicism since then.

Salomon himself became famous among politicians. They eventually welcomed him openly to their meetings, which without him could not be considered important occassions. Briand called him Dr Mephistopheles. But he did not manipulate situations. It was enough to show things, to show them up.

His colleagues on the *Berliner Illustrierte* and the *Münchner Illustrierte Presse* eventually came to England and formed the nucleus, under their old editor, Stefan Lorant, of the *Picture Post* team. There perhaps the simplest and most dramatic example of such investigative work was Felix Man's feature on a day with Mussolini. Showing for the first time Mussolini's giant office, the feature allowed him to make himself ludicrous.

In the snow-storm of images, some pictures did make their mark. In 1929 Salomon's plain picture was recognised as saying something about the world. Some of his pictures do not show received views. The version of the world that they select was stimulating and was used in speculating about new ideas.

In 1932 he fled Germany, but only to Holland. In 1944 he was killed in Auschwitz.

The practitioners of these forms of documentation or journalism – there can't be a hard line between the two – were themselves autonomous outsiders. They had either a personal or a social ideology that provided a perspective for their 'objectivity' we see another world.

Giving photography away – a case history

No camera without a proletarian eye behind it.

That was the motto of the Union of Worker–Photographers (*Die Vereinigung der Arbeiter-Fotografen*) in 1930. Their aim in radical photography was to involve the active partnership of all people in the business of photography. Photography was not to be done *to* people, nor *for* them, but *by* all groups.

The programme of the German worker–photographers' movement was founded on two good ideas. First, that special interest determines the view and the understanding that we have. A bourgeois cannot see the world of the worker. For that reason, the world of the worker has not been shown so far. Second, even the worker's eye (or natural camera, as it was dubbed) has not been given the chance to perceive what matters to him or her. They have been alienated from their own visual environment. They do not have the essential psychological vision that links the image on the retina with its meaning.

Arbeiter-Fotograf, Photographer F. P. Breslau
Cover of *Arbeiter-Fotograf* journal, Berlin, 1931

The practice of photography by the workers would develop visual and social consciousness and would propagate the true picture. No longer then would photographic content reflect the cult of leisure and idleness, which are the basic preoccupations of the bourgeoisie. The facts of life at the survival line would take their place.

> If the bourgeoisie depicts proletarians and their world of suffering, it is only to provide a contrast, a dark background to set off the glories of bourgeois 'culture', 'humanity', 'arts and sciences' and so forth, so that sensitive folk can enjoy a feeling of sympathy and 'compassion' or else take pride in the consciousness of their own superiority.
>
> Edwin Hörule, a leader of the movement in 1930.

The subject-matter of the new photography would be different. What is invisible to the people at the top must be made visible. In fact, from the volumes of the movement's publication *Der Arbeiter-Fotograf*, we can see the unpretentious mixture of information and discussion that occupied the members, coupled with a stronger element of Marxist agitation than some commentators imply.

Technical know-how is presented, with a clear appreciation of the simplicity of means available to the readers. (There is a picture of a dark-room set up in a lavatory.) Readers could enter photo competitions, and pictures sent in received technical and aesthetic adjudication. Aesthetic values were always tempered with the facts of political realities. Where there was ugliness, there must be no veils, no retouching.

The class war and the raising of consciousness, as we would now call it, of the proletariat for the better waging of the battle, was the main preoccupation. *Das Bild – eine Waffe im Klassenkampf* ('The Picture – a Weapon in the Class War') was carefully analysed. It could be represented in terms of homelessness, unemployment, soup-kitchens, wages below the poverty line. Farm workers were shown bent over the earth under the watchful eye of the upright landowner. Sharp contrasts were drawn between the lives of the children of workers and those of the gentry. Comparing it with other publications, one is struck by the amount of space given to women's lives, at work and in the family. Pregnant women are photographed, and the stress of large families is discussed.

The propaganda message is given most clearly in the policing-the-police function which the magazine took up. The action of the Prussian police against street meetings and demonstrations is shown from the view of the masses. The camera against the rubber truncheon, and the camera as an alternative truncheon, are vividly presented.

The movement was killed by National Socialism. It has no direct successor, but not because its lessons have been learned. In Britain it was perhaps translated into Mass Observation, but in an etiolated form. The photographers here, although imbued with the right democratic ideals, were hardly members of the proletariat themselves. Now, perhaps, the final remnants of the *Arbeiter* principles are to be found the in community arts movement. They may find new life there, albeit crucially handicapped by the fact that financial support comes from official agencies rather than from the community itself.

Mass Observation

Humphrey Spender, the principal photographer with Mass Observation, has described and exposed its aims, motives and practices with honesty and wit in his book *Worktown People*. Photography was a weapon there in a peculiarly English style.

Mass Observation called itself an independent, scientific, fact-finding body. But the matter was more complicated than that. Tom Harrisson, newly returned from an ethnographic trip to Borneo, in partnership with Charles Madge, set out to document the culture and mores of working-class England, with a particular sampling of Bolton, or Worktown, as they called it. Flanked by varying groups of upper- and middle-class helpers, they were to collect, squirrel-like, evidence of all aspects of the appearance and practices of Boltonians, the meaning of which might have to be interpreted at some future time.

Humphrey Spender was commissioned to photograph, as unobtrusively as possible, the customs – hats and coats on Blackpool beach; little boys widdling on waste ground; the collectivities of the dog-track; work and electioneering.

Humphrey Spender *Three smart girls came by*

The work was powered by the guilt that Harrisson and his colleagues felt about the harshness of Bolton life, although contradictions have been pointed out within Harrisson's own assumptions – the poor do not mind being poor, they are used to it – he has been quoted as saying. And although Spender characterises himself as a a spy from another planet, and tells how his language and accent divorced him from the people, there seems no 'distance' or patronage in his pictures.

The Bolton men and women and children are shown as serious and shrewd, hard-working and friendly. There are no 'madonnas of the cotton-mills' and no patient suffering. They are getting on with the job of surviving with respectability – hard work at the time. It left few smiles on faces.

Spender has discussed at some length the tactics he used to remain 'invisible' to get the real, unposed image of how people moved and looked. He would pretend, for example, to be photographing children playing, and when the neighbouring adults had accepted that, quickly turn his camera through 90 degrees and catch them. The ends of the work justified the means. The publication of the pictures at the time would reveal to the elite of the south, the hidden life of the north of England. And it would all have a place in the archive for history, as indeed it now has. He was good at hiding, but says he found it distasteful in the long run.

What is most important to our interest here, is that worthy as the motives were, this was entirely a venture in which good-hearted people at the top came to help and organise those at the bottom. (Informants were canvassed to keep diaries and describe capsule experiences, but they had no control over the group's work.) Further, the amateurish style, the volunteer status of the members, the lack of formal organisation or official backing, were entirely British. British, too, was the non-ideological quality of the programme, and the plain and simple descriptive outcome.

146

Spender's *Worktown People* seems, as far as we can judge, to the in the best sense a simple survey of the look of working-class life in that place at that time. It could have had a propaganda purpose, but not an emancipatory one for the people themselves. In fact, it seems that it is only in the recent study of the archive that a 'native', Mr Harry Gordon, has been recruited to read the pictures accurately. He can now explicate the subtle nuances of class dress, and comment on the meaning of social groupings and on the social rules surrounding wives and husbands drinking in the lounges and saloons of pubs. Mass Observation did not 'give away' the work or the power of showing, selecting, understanding and using that culture.

Beyond the victim

If we follow through the argument of the last chapter concerning the noble victims who have been presented so often as the objects of our finer feelings, then we must search for new possibilities to do with the showing of the whole social nexus surrounding the conditions that had to be corrected. They exist.

We may take as an example *A Matter of Colour*, the publication which recorded the mid-sixties state of the struggle for racial equality in the United States, and note the difference in its style and content from the persuasion of the mid-thirties and the FSA.

With a minimal caption text by the black writer Lorraine Hansberry, it is a series of photographs that show the personalities, the fighting and demonstrating, the deprivation and some of the achievements, of the Civil Rights Movement. What is important is that suffering in the sense of enduring plays no part. The activitiy of the struggle is shown, and full emphasis is given to white authority and dominance and the way in which they are used. We look at the people of power and at their actions, and our response is very different from the one we made to the silent and still madonna of California and Alabama (see pp. 14 and 118). Empathy is still there, but now we are

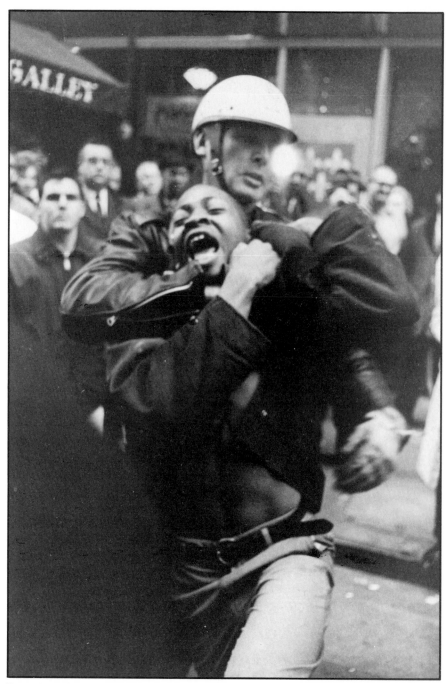

Danny Lyon *The arrest of militant teenager, Taylor Washington, in Atlanta, Georgia*

148

aroused to anger and to shame. These aren't pictures that can be viewed with any kind of pleasure. They have no beauty; there is no bonus in contemplation. The action of repression is before us and so is the fighting-back by the righteously angry black women and men. They have at least the potential of spurring us to action too. That was not part of the message before.

Community Arts

In community arts projects, cultural activities are to be brought to the people; extracted from the old elitist palaces called museums and galleries and concert halls. At the same time they are concerned to involve the working-class community in the arts themselves, either as practitioners or at least as partners in some locally relevant venture. Photography would seem to be an ideal medium for such ventures. It is easy to understand, it seems easy to do, it could cover all areas of people's lives.

The Newport Survey (1980) is an example of one such community-oriented photographic album. Students of documentary photography at Gwent College of Higher Education are producing a series of reports of the people of Newport, with their active cooperation. (It is edited, though, by Sir Tom Hopkinson, the doyen editor of *Picture Post*.) The very fact that the photographers are young students reduces their status or power as camera-holders, and should lead to a more balanced relationship with the subjects (even if they are not taking the pictures themselves).

The first part, 'The Family', has obviously been made with tact and ingenuity and much goodwill between all the parties concerned. It goes into shops and factories, schools and pubs, as well as into kitchens and backyards. We see harmony and good cheer, smiling faces and patient application to all the jobs at hand. Is that the whole story ? It is a wider version of life in Newport than that found in any single family album, but wider only in terms of the settings included. It is hardly the whole of life. There are still rigid censors at work, and in this case it would seem to be the censorship of tact. The reader is not persuaded that psychological or political insights have been given. The social veil remains in place. The general rules of camera culture have been strictly obeyed. We are still within the convention of what is traditionally showable. Etiquette and social identity are maintained. So there is nothing very interesting to see.

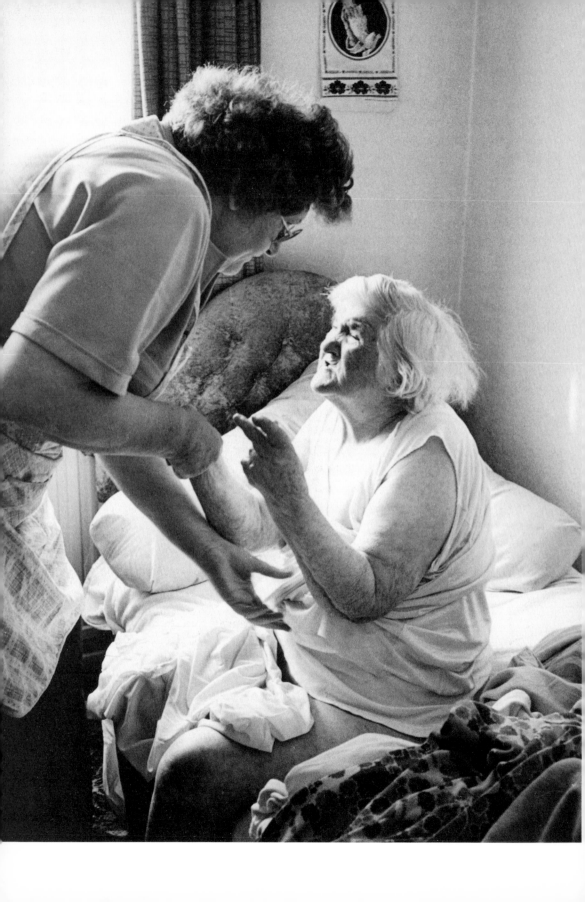

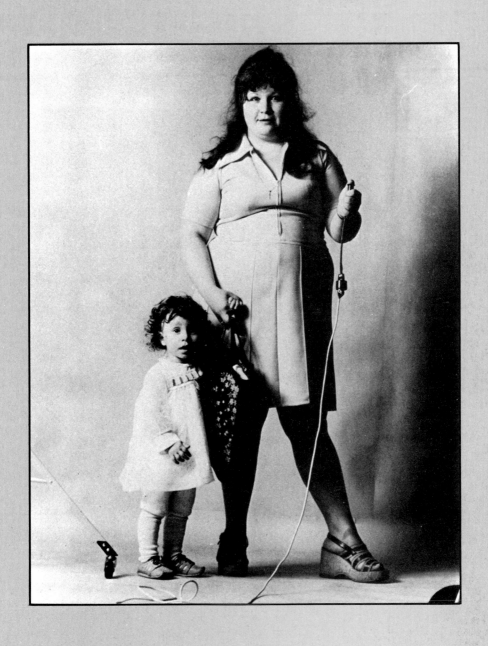

David Attie *Russian self-portrait*

John Charity and Ron McCormick *Getting dressed in the morning is a joint effort*

We must rejoice that Newport life is possible at this level of dignity and well-being, but the best planned families have their quarrels and depressions and private moments of withdrawal. Here there is just life sunny side up. Reportage must not become fashionable pictorial clichés – but there are also unfashionable pictorial clichés.

Self-portraits

The logic of giving photography away is finely exemplified by the concept of the self-portrait. If we want fairness and if we want to know what people are like, it is surely proper that we should ask them, themselves, to show us. Then we will break down the barriers between the photographer and the camera and its subject. Then the subject will not be manipulated or exploited. He or she will control the picture.

One of the most unusual examples of this idea has been published in David Attie's *Russian Self-Portraits* (1978), and, as we can imagine, it is an exercise not devoid of political undertones.

The United States Information Agency, as part of its propaganda mission into the communist bloc, has staged regular exhibitions of American consumer technology. David Attie had participated in previous photographic exhibitions and knew that involving visitors in picture-making enhanced their interest. In Kiev in 1976 he set up an elaborate 'studio' to that end.

Visitors were faced with a full-length mirror (brought in from Vienna) and a positive-negative Polaroid camera. In the mirror they could assume whatever stance and expression they considered most suitable and appealing for their pose, press the bulb, and take their own photo. Thus in one action the West could see Russians as they really were, and the Russians could experience the Western informal democratic spirit at first hand.

His published portfolio is certainly full of charming and amusing pictures. His Russians have to our eyes a seriousness and a directness that we seem to have lost. On the other hand, we have no exact comparison. No Russian photographer has performed a similar investigation at an Ideal Home Exhibition in a provincial city, which would perhaps be the nearest equivalent.

Attie is open about the actual circumstances of the work. Several layers of selection come between us and the simple survey data. International camera culture has exerted its influence, and for the visitors to his studio the process of photographing was quite complex. First, the selection of demeanour and pose. This having been assumed, the studio was darkened, the subjects decided (in the dark) when they were ready, the camera shutter opened and they pushed the button to activate the strobe light and close the shutter. The sitter got an instant print. However, the Polaroid camera did not give a perfect negative. In order to retain a perfect one for his own ends, Attie had to have another camera. But that was not the end. 'To make it more fun, I later installed a battery of four cameras, all recording simultaneously, but each from a different vantage point.'

359,726 people visited the exhibition. The queue of models was enormous. This could hardly have been conducive to a relaxed frame of mind. Attie tells us that the images tended to be static and repetitive. He and his young assistants worked hard to bring some action into them.

So we have an attempt at democracy in action that ends up as a pleasing set of ninety images of people who present themselves at some sort of ingratiating 'best' telling us perhaps that Russians are not unlike us in that respect – and never forgetting that Attie himself must also have had his eye on producing a provocative publication for Western taste.

A similar experiment has been carried out by community photographers in the Handsworth district of Birmingham. As an extension of the graphic design and photography office of the Handsworth Project, Derek Bishton and his partners set up a portrait stall in Grove Lane, just outside their office, on four Saturdays, and invited people to take their own pictures. Five hundred took the opportunity and each got a 10" × 7" print a week later.

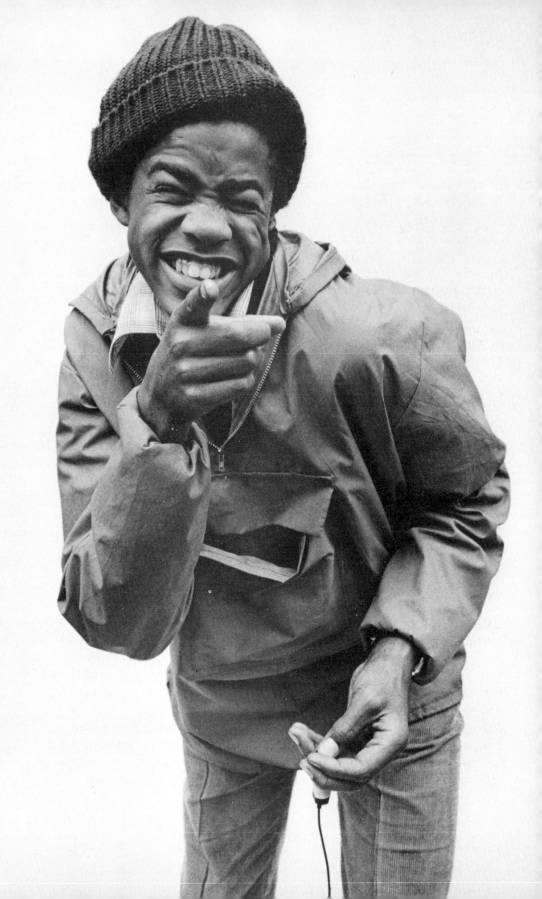

Again, some of the results are stiff and posed in a routine way, while others are fresh and lively. There is the interaction between a new opportunity offering itself, and the old rules of the pose; and the fear, or at least embarrassment, that we feel in exposing ourselves to the camera. And as in the Attie set-up in Kiev, we may question the degree of power that the participants in the venture really held. This time they had no mirror in which to check their performance. Again, as part of a queue, they were not free from pressure. They were standing in the street, potentially to be observed by others. And in neither case did they wholly own their pictures. They were each given one, but the camera-owners possessed the negatives, and indeed did later use them for their own ends, albeit benign ones.

From these examples of the self-portraiture venture we can see that the business of ordinary people taking control of the photographic presentation of their own image is more difficult than one might assume. We are all by now socialised into the rules of photography. We cannot just step out of 'the pose' as a social ritual. We cannot forget the power of the camera itself.

If we cannot easily succeed in de-mystifying personal presentation, how much further are we from revealing the structure of society and any of its subsections ? While accepting the hazards of the existing conventions, photography is undoubtedly deeply enmeshed in them. To free it from the present conventions will be as much a result of change as a factor *for* change.

Giving away photography is no panacea. It can no longer be easily accepted by outsiders. Photography has become one kind of formal institution, and the social interaction of photographing is a social ritual. If the act and its resulting pictures, the use to which they are put, the profession of photographer, all became more flexible, they would then involve less inequity and more varied viewpoints. This will come about, as with other kinds of change, through the individual innovator, through political argument, through changes in understanding of the up-to-now passive subjects, and through new people systematically acquiring the technical, social and ideological skills involved.

Handsworth Project, Photographer John Reardon
Cover Ten 8: Stephen

6 Facial maps

The first acknowledged photograph was taken by Joseph Nicéphore at Chalon-sur-Saône Niépce when he pointed his camera out of his window in 1826 and immortalised a pigeon-house and a barn outside. But people appeared on the scene very quickly, to become the continuing central focus of public and personal photography in all three arenas – information, art and emotion.

This in one sense demonstrates our egocentricity. We must capture the rich and the famous, the benefactor and the criminal, our loved ones and ourselves. But, in another, it sadly shows that we understand our own ephemeral existence. We do not last. Neither does our bloom. But the image will.

The photograph shows how people looked.

One of the immediately accepted functions of a photograph was proof of identity:
1 in the legalistic sense
2 in our being able to have a copy of our heroes and heroines and the people we love
3 in giving evidence of our own existential reality.

We can see what we really look like.

The trouble, again, is that paradoxes abound.

> No less than the medieval spectator who accepted as fact the handmade images of Christian characters who enacted their dramas within the holy precincts of church walls, we today have learned to accept as absolute truth these machine-made photographic images of our heroes and heroines.
>
> Robert Rosenblum, critic

He is being clever, of course. At bottom no photograph is as fanciful as the paintings of Noah and his family. But it can be a bit fanciful.

If Rosenblum is at the sophisticated end of the spectrum in 1980, Lady Eastlake in the 1850s had already warned us of another trap:

> What are nine tenths of these facial maps called photographic portraits but accurate landmarks and measurements for loving eyes and memories to deck with beauty and animate with expression, in perfect certainty that the ground plan is founded upon fact ?

Here as everywhere, there are the four components – the photographer, the camera and its image, the person who looks at the picture and the social context in which they all exist. Each has special interests, possibilities and limitation.

Portrait photography spread throughout the Western world in the 1850s, not just for sentimental needs but as a reinforcement of social status, economic class and the institution of the family – more particularly that of matrimony.

The rising Victorian middle class hardly needed photography to cure existential insecurity. What they did want was to own some version of the painted portrait, which was, of course, the prerogative of the gentry. Apart from silhouettes, perhaps, there was no other means of having an image of oneself.

It is hard for us now to image what it must have been like for the vast majority, never to have had their image in their hands.

Mirrors tell us what we look like, but it is too easy to see there what we want to see. A photograph is a harder, tougher version of the truth. It has a concrete existence. It can be passed from hand to hand. It is evaluated not only by our friends but by our enemies. It becomes part of our history.

Similarly, it was rare and expensive to have a picture of a famous person in the house. Indeed, unless one lived in a city and had had an opportunity to see an eminent person in the flesh one would hardly know what they looked like at all.

Evidence for the need for a personal image and a personal record comes most immediately from the history of the enormous commerical success of cheap, standard personal portraiture.

Even Daguerre's single images on highly polished little silvered copper plates (made public in 1839), which had to be held at an angle to catch the light right, were produced in enormous numbers. With them appeared the family icon. But its singularity puts it outside the realm of true photography.

Indeed, although it had its own beauty, the daguerreotype was a dead end because, not able to be multiplied, it could not be used as a means of communication, or to cement social ties.

It was killed by the *carte de visite*, invented by André Desdéri in Paris in 1852. He produced small (2½ × 4 in.) cardboard-backed pictures which were printed as multiples. It was an upstart industry for the celebration of the upstart bourgeoisie, although it must be noted that members of the royal houses quickly appreciated the value of their photographs as democratic public relations exercises. The famous mingled with the family in the private album.

The new medium's success has been documented by Tristram Powell in *From Today Painting is Dead*. Portrait establishments in London increased from three in 1841 to over two hundred in 1861, of which sixty-six were in Regent Street. And we are told that in the week following the death of Prince Albert, seventy thousand photographs of him were sold. *Cardomania* it was rightly called.

The royal family were also consumers of the new art. By the late 1850s Queen Victoria was an enthusiast, and wore a signet ring enclosing a group of five photographs of her family, each measuring about ⅛ in. and magnified by a jewel lens.

The *carte de visite* and other portrait photography have been called a personal talisman for the age of the machine. In common with other photography, they were consonant with the themes of the time. A photograph permits aspects of reality to be acquired, collected, passed around, used in exchange, possessed. It becomes part of one's capital.

In so far as photograpy made popular the genre of personal portraits which had before fallen within the domain of fine art, they should also be discussed as developments of photography – but that cannot be our concern here.

It is worth saying, though, that the uniform 'artistic' backdrops of the Victorian and later photographic studios aped the settings of traditional painters' studios – and this was obviously wanted by the patrons. And however routine the processing of clients, the products were never 'cheap and nasty' in the style of current photo-booth images (of which more later).

Photographers might not hope to capture the full individuality of the sitters, but one suspects that the men and women who presented themselves in the nineteenth century wanted primarily to demonstrate their civic virtue, their respectability and their worthiness to be represented at all.

It will be worth considering some aspects of the evolution that has taken place in formal portrait photography, because it will give us insights into the vision that people have had of themselves over that time.

In the beginning the vision was enormously constrained by the technical limitations and complications of the camera and the chemistry, but there have always been photographers who put their personal style into their work. And, perforce, the demands of clients and the expectations and beliefs of culture have influenced what has been considered a 'good' portrait.

It is no coincidence that two of the earliest portraitists, David Octavius Hill in Edinburgh and Nadar (Gaspard Félix Tournachon) in Paris, both agreed to produce vast panoramic paintings of worthies – Hill for the Free Church Assembly and Nadar for the Panthéon. They were attracted to the camera as a quick and cheap substitute for the sketching which they would have had to labour at. And they used the 'pencil of nature', as Fox Talbot christened it.

Both had the arduous task of collecting many likenesses to be later copied in paint and both produced photographs which have the highest aesthetic power and psychological insight, as well, of course, as historical value.

Hill and the chemist Robert Adamson soon appreciated the camera for its own sake, and they show us Edinburgh people in a straightforward way that properly forsakes the trimmings of conventional painting.

Working within the handicap of the twenty-second exposure and the demands of clear daylight, they allowed their sitters to 'be there' in ordinary settings, posing at least as naturally as a modern photographer a hundred years later would have allowed.

Eventually, in some fifteen hundred pictures, greatly exceeding the original survey of ministers, the collection catches perfectly 'the security and self-confidence of Edinburgh society, unsmiling miniature faces as unsentimental as portraits of Dutch burgomeisters' (Tristram Powell).

> The chiaroscuro imposed willy-nilly by the primitive calotype process, coupled with the bourgeois aura of satisfaction, have further suggested a quality of Rembrandt, while to the German eye of the thirties they suggested an expressionistic blood warmth . . .
>
> David Mellor

What is sure is that the writers, scientists, neighbours, pretty young women, working men and working women are serious and unsentimental, characteristic of Edinburgh people today.

D. O. Hill and Robert Adamson *Jeanie Wilson*

The people are 'alive' and they are seen in their daily lives.

Nadar, too, quickly moved away from the use of the camera as an *aide-mémoire*, to become an enormously popular portraitist who more formally surveyed another subculture.

He planned systematically to 'take' everyone in the new 'republic of the mind' — that is, every member of the radical and cultural scene of Paris. He collected all the people that mattered, and they knew it.

There were to exemplify their roles and their modern, radical style, albeit in their frock-coats, as well as be shown as individuals.

As Nigel Gosling put it:

> he found a way of presenting them — as any good portraitist does in any medium — poised halfway between ephemeral individuality and universal permanence.

That balance between the specific and the universal, even between the person and the role, is an extremely delicate one. And the presentations of the medium of photography and its aims are perhaps more complex than Gosling suggests here. We shall return to these questions more than once.

What we do see is that Nadar, working in a permanent studio and with the fixed trappings of light and tripod, had to grapple with the beginnings of the social rules of the pose.

As early as 1844 Honoré Daumier in one of his Parisian sketches had made fun of the naivety and the sophistication to be found in the photographer's studio. Already then he saw the mistake of showing glum reality, undisguised arrogance, or the simple-minded smile. The right presentation, somewhere between performance and natural sincerity, has always been a difficult matter.

Nadar took great pains to avoid the genre of sentimental photography. He did not take deathbed pictures, a profitable business at the time, although, exceptionally, he made neutral documents of the dead Victor Hugo and the poet Marceline Desbordes-Valmore. This at a time when others were painting wings on to the deathbed likenesses of children.

One must agree with Gosling that his portraits were 'warm, direct and manly'. They show a kind of relaxed gravity. His subjects are animated and at the same time comfortable in front of the camera. This must have something to do with the fact that they were all socially skilled members of their elite, and that they considered themselves equals of the photographer. In the social interaction of the photographing, the exchange was of equal favours between equal protagonists.

We guess that Nadar hoped to achieve a kind of rational account of his republic. There was also the matter of fair negotiation between the sitters who appeared in his pictures and the photographer who got to possess them.

Nadar's naturalism has often been favourably compared with the stiff, self-conscious poetic quality of the pictures of Julia Margaret Cameron.

Cameron, the third of our pioneers here, was a full-blown Victorian eccentric who worked alone, mostly on the Isle of Wight but also in Ceylon, and invented by trial and error her own technique, both technical and artistic.

She has been accused of producing, through feminine hero-worship, a series of English poets, painters and scientists all as Old Testament prophets ! Certainly, the literary painter G. F. Watts had an unfortunate influence on her work, but one has the strong suspicion that sitters like Browning, Tennyson and even Darwin were not averse to playing portentous roles in life, and certainly not in their poses for Mrs Cameron.

Her portraits of children, even when labelled 'Cherub' and 'Seraph' have a chubby earthly quality and appear remarkably self-possessed, considering the conditions of their sitting.

Julia Margaret Cameron *Sir Henry Taylor*

We know little about the experience and feelings of the sitters in those early days, although it has been suggested by Tristram Powell that the experience of the head-clamp and the smell of the chemicals must have reminded them forcibly of a visit to the dentist.

> Dressed in dark cloths stained with chemicals and smelling of them too, with a plump and eager face and piercing eyes and a voice husky and a little harsh, yet in some ways compelling and even charming, no wonder old photographs of us look anxious and wistful. That is how we felt.

If this was the reaction of the children, perhaps the biblical gravity and the distant stare were the men's form of escape from the whole embarrassing affair.

By the end of the century serious photographers clearly believed that the social rules that sitters had evolved – the camera culture of the time – were a barrier between themselves and the good image.

Helpful booklets were published: *Portrait Photography: practical notes for the model* by Carlo Brogi (1895) tries to disclose the techniques and tricks of the trade so that the sitter may co-operate most effectively with the photographer.

> No matter what people say and do, there are certain rules to be observed in portrait photography which now amount to a convention which the public will not readily give up. Except on rare occasions, portraits represent the same lines, and the stance of the model is almost always identical. Should the photographer decide to risk departure from the blue-print, so as to break the monotony and give the portrait a little life and style . . . he is sure to meet with the disapproval of his clientele. This type of portrait is all very well for the shop window, but nobody wants to own one.

One suspects that some sitters are saying that about some of the modern masterpieces of portraiture.

Brogi wanted to achieve a 'normal expression', but for all his tips about not arriving late and breathless and not bringing friends and relations to help with the pose, he cannot give a recipe for it.

Always the picture is the result of the clash between performance and nature. In photographing there is the element of tableau and, opposing it, the fact that we cannot help giving ourselves away to the camera.

On the one side artifice intrudes, on the other mundane reality leaks in.

No sooner had the camera established itself, according to Lady Eastlake, as 'the cleanest and precisest' tool of personal representation, than Hamfstangl in Munich in 1855 invented retouching.

And in 1894, as Gisèle Freund recounts, the following kind of story was being told:

> If someone returns his photograph saying he is 60 and not 30, that he has wrinkles in his forehead and a flat nose that does not resemble the aquiline nose of the portrait – he is certain to receive the following response, 'Oh, you want a portrait that looked like you, you should have told us so. How could we have guessed ?'

On the other hand, the high and mighty were not necessarily fluent in the presentation of their formal persona to the camera, nor the early professionals always skilled in managing role presentation.

The Alinari portrait of King Victor Emanuel II shows clearly that the role of the monarch has suffered some leakage from the person of the short and untidy man. And one must assume that it was not the populist message of 'all brothers under the skin' (or within the baggy trousers) that was intended.

Within the dialectic the camera is a highly conscious eye, setting up and selecting what is to be seen. It is *par excellence* the automatic eye; all mundane reality is there in the image.

Certainly old photographs owe some of their charm and some of their power, making us jump back in time, to unintended trivia, as well as presenting the formal pose and the planned message.

166

Alinari Studio *King Vittorio Emanuele II* Photo Alinari

Kind and cruel portraits

The genre of formal portraits has a highly complex and entertaining place in the development of photography. It is a subject we all have ideas about and are intrigued by. We surely all wish that we could have been 'done' by someone famous – Karsh, Beaton, Bailey, Snowdon.

It seems to us that here are some of the great artists in the field. We don't in general believe that there are any particular political implications in photography. We do feel that we know what a famous person is 'really' like through having seen his or her photograph so often. We surely think that a photograph shows us 'aliveness' as no painting can ever do. In so far as there is an intrusion of artifice, we believe it is on an aesthetic plane, a change for the better in terms of wrinkles.

Serious modern portrait photographers deserve some further study. The contract between the photographer and the sitter and the consumption of the image hang together in complex ways.

In the later part of his life Cecil Beaton used to be rather embarrassed to have to say that one could not really asked to be photographed by him – one had to be chosen, to be deemed worthy of his time and talent.

We have suggested that in all formal portraits there is an element of having achieved the worthiness to be documented. This is an important factor in the power of such picture. Sometimes it is money alone that indexes the worthiness. One can afford this or that photographer. But sometimes – from Nadar through Cameron to Beaton – one must be a special person, a useful person, a clever person, even a beautiful person. But existence is not enough.

In the portrayal the photographer may attempt an *objective* image, may have a *personal view* of the sitter, or may *aid and abet* the identity which the sitter is hoping to present. That is how kind and cruel images result.

In the discussion of radical photography we have seen how August Sander, for example, seriously attempted an objective record of a whole community

through portraits that were self-posed. Logically this seemed a plausible task. From many points of view Sander came nearer to achieving his goal than any other photographer.

Objectivity is not the usual aim, let alone the achievement. It is assumed that professionals will respect the reputation or the aura of their sitter. This is what is paid for.

A kind photograph, then, is one that may produce an aesthetically improved image (dictated by fashion, for example), but most crucially accepts the 'identity work' that the subject has done – be it the projection of probity, wit, sophistication, cynicism, kindliness or simply being 'all right'.

Jane Bown *Mick Jagger, 1973*

Yousuf Karsh – or Karsh, as he prefers to be known – is the past master here. Karsh was acknowledged as the one who could produce the definitive image of the great men (and Eleanor Roosevelt) of the forties and fifties. And indeed his Churchill was more Churchillian, certainly more bulldoggy, than Winston himself. Ernest Hemingway was more boyishly macho, and Albert Einstein more charmingly scholarly in the portraits than they could hope to be themselves.

But in the end his reputation has flagged among the intellectuals, because that collusion with the sitters and, worse, with their reputation, is seen as kitsch. It provided only redundant information. He believed in the postures.

When considering identity work and its acceptance by a photographer, one is tempted to speculate that some people seem almost to have been created by the camera. This is sometimes referred to as 'a media reputation' – being famous for being famous.

One simple example of the power of the photograph, which has been pointed to by Erving Goffman in his book *Gender Identity* – is that of the author on the jacket of a modern book. Today, a far cry from the postage stamp (passport-like) shadows by Elliot and Fry on the old Penguins, we have the glossy full page images which often suggest a strong, outdoor physicality or at least a certain wry charm. This sets the scene for the reader and helps us to hear the voice of the author, reinforcing the strength of his prose or the irony of his commentary. For women authors there is a different creation: Edna O'Brien's face, for example, has been entwined most inextricably with her work. Instead of the usual drawing of the characters on the front of the jacket, her publishers have sometimes put her own beautiful face to gaze wistfully at the potential buyer and reader. She has been produced for us, we know her, she enacts a role which glides mysteriously between heroine and author.

But it is Edith Sitwell whose creation as a persona has been documented most completely, and who has played the most willing partner in her contract with the camera – most often that of Cecil Beaton. Out of the dross left to her by the crazed gentility of her father, she fashioned not only her poetry but also the fanciful, medieval style that was to become her trademark for the media, as well as a work of art in its own right, worthy to stand beside her writings. Beaton took his first photograph of her in 1926, and continued to

Cecil Beaton *This was my first real success. Edith Sitwell on a small strip of linoleum photographed from a ladder by day light*

Cecil Beaton *Edith Sitwell*

work with her until the end of her life. From the earliest vision of her as a tomb effigy, she had to live up to his images, to extend and improve them. The photographs reinforced and confirmed her identity work, and they worked for her, to present her to the public. She contributed her serious artifice. They showed us, and herself, that she was not the ugly duckling her father had assumed, but a strange unique work of art.

Beaton was the man for her. He had always specialised in portraits that enhanced the image of the sitter. He was in this genre a painter with light. His work was art that could be understood by everyone. How could he not succeed ?

So what should a portrait photograph be able to do ? Not produce a definitive verdict – which a painting hopes for – but show a person, a face, a corporeal condition that is alive, here and now, unmasked, or, at least, allowing us to look behind the mask. To show the individual psychology behind the role play.

We now expect that bit of irony, even sarcasm, from any half-clever observer of the social scene, whether sitter or photographer. The image should show the face-work, but also the futility of some of our face.

This suggests a version of the *Verfremdungseffekt* – alienation. That extra distance from the sitter stretches the photographer's task beyond neutral information, beyond aesthetics too, and towards a psychological statement. Into his or her own psychology and that of the subject.

As Cartier-Bresson has written:

> The photographer is searching for the identity of his sitter, and also trying to fulfil an expression of himself.

That is another delicate balance.

Some serious photographers have a signature, a style, that is easily – too easily – recognisable. Their own identity seems to overwhelm that of the sitter. This is an aspect of all art work. The artist is greater than his subject matter.

On the other hand, it is an aspect also of a consumer society. A person's work will become famous (and commercially valuable) if it is not only judged good, but is easily and instantly recognisable. This element of redundancy is of course generally comfortable, and also makes connoisseurship that much easier. We can spot a Penn.

Irving Penn is one of those strong photographers who get in front of their sitters. He seems to create the people he photographs. 'All Penn photographs are first of all Penns,' says Janet Malcolm: 'The eminent from T. S. Eliot to Noel Coward came in all innocence to his studio, and all retreated into the furthest interstices to get 'shot'!'

Irving Penn *Cuzco children*

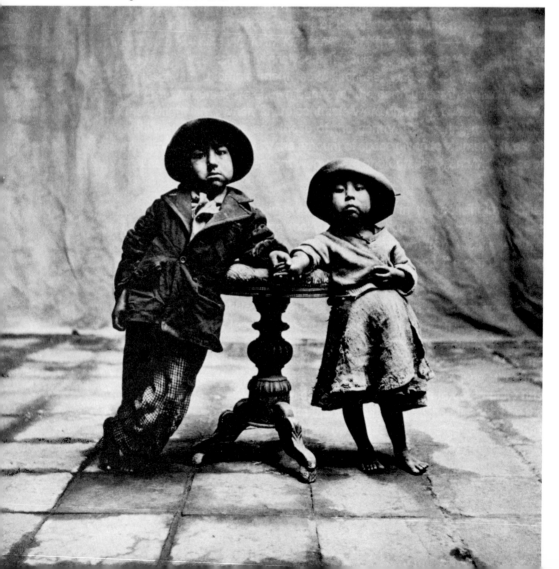

Not only the smart people, but ordinary folk from New Guinea, Morocco and Peru all get Penned, although those outside the camera culture seem to have an edge on him. (In taking the Peruvian children, Penn was surely consciously recreating Riis' *Mott Street boys* – but it is fascinating to see the similarity in the presentation of the two sets of naive children.)

If Penn wins in the identity negotiations, it is in the service of his aesthetic style. Richard Avedon is another master who wields his camera like a scalpel. With it he removes the persona or mask. His recognisable trademark is the 'naked' sitter.

Jacob A. Riis *Mott Street boys*

Consonant with the preoccupations of our time of eroded ideals and deep scepticism, Avedon shows people without their props. He shows them therefore anxious and estranged. Lonely, alienated and afraid. In his analysis the unmasking must always lead to that.

Then, it is suggested, photography will give us true realism and true drama, because it shows us a person as we try not to see them in life. One sees that it makes them suffer, it makes us suffer, and of course it breaks the strictest rule of photography — it goes beyond the fairy-story.

Within camera traditions Avedon's clinical view cannot in any sense be considered the basic, neutral or natural one. It breaks all social rules, even old and hardy ones.

His most dramatic, painful, law-breaking work has been a series of pictures taken of his own father at the end of his life, and during the stages of his dying. They exemplify not only rule-breaking, of course, but also the recording of the human face and the human psyche that extend beyond biology and psychology.

His other, ordinary, portrait work is equally worthy of disentanglement, albeit on a cooler plane.

On the one hand, he has followed the modernist fashion of the other visual arts in commenting on the medium, instead of being enthralled only by content. His famous series of 1976 portraits reveals the black negative edge in each print. There is no hiding the medium. Further, although their style uses the sitter's pose, it also adds in many cases the haphazard quality of the amateur snapshot, and even the accidental off-pose of the photo-booth.

However, the viewer of the portrait gallery becomes a bit suspicious at seeing the image of Joe Babbington the Manhattan caterer, he too caught in a moment of pessimism and dismay (as are Igor Stravinsky, Jean Renoir, Paul Strand and nearly every one else).

The vision of the photographer can flood the pictures.

Cartier-Bresson has always said that the sitter is suspicious of the objectivity of the camera. Avedon and Diane Arbus, who give the appearance of objectivity, in fact expect to show an acute psychological study of the sitter. But seen from the outside, they show us an exciting and complex amalgam of information, aesthetics and emotion that reach a high point of poetic excitement which is entirely within the art fashion of its time.

If Avedon's reality gives us images in a tragedy, some of us will say, that it is his affair. Maybe his life is a tragedy. Is his intelligence too strong, overpowering the camera's own image ?

The egocentricity, the dominance of the serious and fashionable art photographers had to produce a reaction. Coupled with the arrival of minimalism in painting, we see the photographic move towards feckless photography in portraiture — the random snapshot.

If art and personality have intruded too strongly, the retreat has come in the random snaps published by Andy Warhol; although to heighten the artlessness it is put about that he does not necessarily press the shutter himself, and certainly one has the impression that no one necessarily looked through the viewfinder.

This fecklessness parallels fine art movements, but is also an aspect of another more personal or psychological change in values. If, stemming from the alternative culture of the sixties, we so badly want informality, sincerity, spontaneity and 'letting it all hang out', then the formal portraits by Madame Harlip for rich women, Karsh for the captains of industry and commerce, and the high street photographer for the rest of us, must fall from favour.

The status symbol now consists of being caught by the classy *paparazzi* for the pages of *Rolling Stone* or the *New Musical Express*. Sitting for a formal portrait becomes dangerously like a premature embalming.

The new artlessness has its own kind of attraction. It is as if the fascination can never end. The King of Sweden in the Warhol Factory at an unfortunate moment, eyes half closed; Martha Graham with her tights wrinkled; Paulette Goddard just having a happy time — all these make nice pictures. And the capital of artifice of the Beautiful is big enough to have some taken away.

In a sense Warhol's pictures are deliberately arranged to be the kind that would previously have been discarded. 'They didn't come out,' he might have said, but didn't. When we look at them seriously, though, we see a quality, an aura, even, that gives them their own validity.

After all, Norman Mailer's *Marilyn* (1973) derived its power not from the torrent of words but from the selection of images. It reproduced the famous photographs of Monroe from an almost complete roster of contemporary greats (Milton H. Greene and Cecil Beaton to Eve Arnold, Cornell Capa and Inge Morath). In some of them we find the sophisticated alliance between photographer and sitter to show a beautiful woman at her most perfect, polished and vibrant. She was after all one of the icons of her age – through the camera. But the photographic etiquette was sometimes broken. After her death one could publish the pictures where she had let her guard down.

The self may leak out. Then we fell that we see the real person. Photographs also tell the natural truth.

7 Family photography

Photographs of ourselves and our lives are a source of pleasure and of fun. But we also need pictures of ourselves and our loved ones to 'consume' over and over again in our albums. Having a photograph, we have captured some aspect of our world. We have it for keeps.

We have proof that things happened this way. We were like that. In extreme cases of insecurity, the camera almost causes things to exist, including oneself. (In Wim Wenders' movie, *Alice in the Cities,* the hero obsessively snaps with his Polaroid to maintain his tenuous hold on reality.)

Our personal histories are not contained in family albums, but are validated by them. Such proof is most clearly demanded of weddings, of course. And yet never of funerals — not by us, at least.

Elliott Erwitt in an interview has emphasised the central role of photographers here:

> Now very often events are set up for photographers . . . The weddings are orchestrated about the photographers taking the pictures, because it if hasn't been photographed it doesn't really exist.

Some perspicacious priests now agree that the ritual which authenticates the marriage contract is the photographing and not the service.

We select certain people and events to remember in this way. Within the ceremonies of social life, we document certain milestones. Beyond memory, we want a ritual relic – a photograph.

We want relics of occasions when we were in social bloom. Erving Goffman, the sociologist, said that it is a sort of self-worship. So it might be. But a more sympathetic view could be that it involves an important *Dorian Gray* element. We want evidence that even we were once young and comely, successful and desired, happy and carefree.

Within the mode of personal photography, there are three main sets of pictures: photographs of ourselves; family albums; tourist pictures.

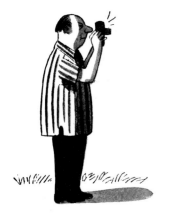

Charles Addams *Drawing by Chas Addams, c. 1980 The New Yorker Magazine Inc.*

Photographs of ourselves

When Goffman wanted to describe the essence of our personal and social identity constructing, he called it face-work. The questions about who is photogenic, who likes their pictures, and what good photographers of people manage to evoke, have as much to do with skilled face-work as with the right physiognomic structure for two-dimensional representation.

All of us in the camera culture have a clear idea that photography demands an effort to present ourselves 'properly', demands that we appear with some grace and, at least from the older of us, demands evidence of some civic virtue.

When young people are asked about the characteristics they would like to show in a good photograph, they have no hesitation in providing lists of attributes. Priority goes to smiling-cheerful-happy, but beautiful-handsome-smart-friendly-kind-nice plus confident-sophisticated-independent come close behind. The most laconic man said simply, kind-rugged-happy – not an unattractive package. Young women give signs of close thinking, for example, 'Dangly ear-rings always look nice'; or, 'Show something about inner self, deep but interesting, slightly mysterious, nice to know but a bit strange.' I'm a bit more dubious about the young man who said only, 'Like Burt Reynolds'.

Eve Arnold *Mrs John F. Kennedy and Caroline*

All this refers to posed pictures within the personal mode. The *posed* and the *candid* snap each have their rules, although the rules become merged as we become more highly skilled within camera culture, and like to think that we take it all in our stride.

We no longer want to submit to the camera. We want to control it. We want to use it to produce the new images that are necessary. The aim of personal photographs is now *naturalism*. We want aliveness most of all. Photographs should look like 'caught' pictures. But really, of course, we want a combination of ourselves and a fairy-story.

Before, both the photographer and the sitter took enormous trouble to present a good person. The work was not hidden – Sunday best clothes and solemn demeanour.

Now it is the work of posing that we find not only uncomfortable, but almost intolerable. That is what makes the studo alarming. Professionals, even, have said that there, although it is the photographer's territory, both the photographer and the customer are 'harnessed'. For the subject everything is false. We feel entirely at a disadvantage. Helpless.

We would like to act and pose to look spontaneous and unposed. As Susan Sontag has perspicaciously put it:

> When we notice someone is about to snap us we must pretend that we are unaware of this. It is good manners not to pose. We must surreptitiously arrange ourselves to best advantage.

While Eve Arnold suggests that professionals can use our implicit awareness of these subterfuges:

> When they know there is a camera about . . . there is studied unstudiedness, self-consciousness-unselfconsciousness going, that makes visual fun.

If such surreptitious work on our identity is the aim, there are contexts in which we pose even for snapshots. In that sense we act ourselves, play the character we aim for. And, as we have seen, the result should be expressive of what we like others to believe we are 'really like'.

If we think, then, that the quality of *sincerity* is highly valued in our society, we begin to see that the act of having our photograph taken is highly complex indeed..

Arthur W. Wang *Roland Barthes*

Roland Barthes, the social philosopher, has described his own conscious-
ness of the feelings involved:

> Now, once I feel myself observed by the lens everything changes; I constitute
> myself in the process of 'posing', I instantaneously make another body for
> myself, I transform myself in advance into an image. This transformation is an
> active one; I feel that the photograph creates my body and mystifies it,
> according to its caprice . . . I decide 'to let drift' over my lips and in my eyes a
> faint smile which I mean to be the indefinable in which I might suggest, along
> with the qualities of my nature, my amused consciousness of the whole
> photographic ritual: I lend myself to the social game, I pose . . . In front of the
> lens, I am at the same time, the one I think I am, the one I want others to think I
> am, the one the photographer thinks I am, and the one he makes use of to
> exhibit his art.

So anything other than the truly stolen candid picture involves a pose. And it
is the challenge to the skill of the photographer to prevent us hiding behind
posing, or at least to soften the stiffness of it.

One method of achieving the desired naturalness is to dazzle the sitter with
many exposures, so that the mask must slip. The success of the cheap and
unskilled technique of the old Polyfoto depended on this. And it was indeed
a rigid person who did not melt once for the sixty stamp-sized images that
were produced.

Among these, as among sets of family snaps, there often appears the odd
anti-pose. In this the subject is overtly reversing the social rules, and glories
in the bad manners of scowling, clowning and 'horsing around'. The paradox
in negation points nicely to the ideal. In the anti-pose sitters look straight at
the camera, they roar with laughter, grimace, put out their tongues, gesture
uproariously, exaggerate nature. They defy all decorum.

Daniel Angeli and Jean-Paul Dousset *Dustin Hoffman and his wife arriving at Nice airport*

Young children have their own anti-pose. They burst into tears. One must surmise that it is the restraints of camera etiquette, coupled with the time involved in getting the party into play, that has been too much not only for their patience but for their acting skill.

On the matter of trust and the relationship between photographer and sitter, we must consider the limiting case of the photo-booth automated self-portrait.

This must be the nadir of artistic photography, and yet it must also be the most common mode of personal photography to date. Statistically the *carte de visite* has been surpassed.

If the function of the *carte de visite* was to reassure the subjects of their personal value, the photo-booth works to two other ends — to prove identity and 'for a laugh'.

The impersonal evidence of personal existence and uniqueness is demanded by the faceless bureaucracy, whether it is to obtain a visa or to apply for a job. Here is produced some mechanical and rigid and partial version of myself that will be processed in a mechanical and rigid and partial fashion. The medium is indeed consonant with the message.

From a different standpoint, is this a process to be compared with computer medical diagnosis ? That, we are assured, is preferred by many patients, as being private and non-judgemental.

The second function (as well as being of commercial value) is to provide entertainment both direct and ironic. Here, where a photo is taken by young people out in a group, as a joke, it is not only the cheapness but also the privacy and the fact that no outsider is witness or judge to the pose or anti-pose, that must be the attraction.

Here then should be a rich vein of data. The psychology of the intimate self-image is preserved. Without the presence of any censor, we could in these negatives have a complete sample of naive 'presentations'. But in fact, the whole phenomenon seems to have been avoided by the critics because it is seen as inhuman and bad. What a pity that its provocative calling the bluff of the role of the photographer has been killed by the quality of the result. The shock of the flash floods out possible freedom and spontaneity.

There has recently appeared a single most apt sign of recognition of the genre in the uncommented collection of anonymous, found, photo-booth photos. Dick Jewel picked up abandoned prints from the delivery slot and from the ground around booths. Again the mode suits the medium. What more appropriate means of making a portfolio of them, sticking the torn ones together, and just allowing them to speak for themselves ?

The Family Album

At one time the Family Bible contained the record of the members' lives. Truthfully, austerely, and without comment, it stated the facts of the rites of passage and the coming and passing of relationships. Each event, christening, confirmation, marriage and death was given equal weight.

For the bourgeoisie, accompanying letters would have documented the style and detail of children's growth, the nuances of love and boredom, status progress and impressions of travel. For others there would have been lost.

Now the Bible has been superseded by the photo album, and the family letter becomes a note justified by the snaps that it accompanies. The family milestones are still recorded, and the arrangements of their photographing in an album brings order and progression to the fragmentary and jumbled impressions and memories of events in daily life. But there is selection. There is the varnishing of truth. There is omission. What is added is liveliness and informality, and a wealth of information and possibilities for memories and nostalgia that was unthought of before.

Few serious analyses of the family album have been made, for publication, at least. *The Camera of My Family* (published in 1976) is such an album, substantiated by diaries, letters, documents and memoirs, put together by Catherine Hanf Noren and recording five generations and a hundred years of her family's history. The pictures start with formal sepia portraits and end with some highly skilled 'informal' snaps. We can follow the same people through the significant stages of their lives, family resemblances through the generations, the same pose struck by different people at different times. We see the achievements, the family advancement, the happiness and harmony of the children. The particular interest of the saga lies in the fact that the family moves from assimilated Jewish subculture in Prussia through the Hilter devastation to new lives in Australia, England and the United States.

Catherine H. Noren *The Camera of my Family*

Catherine H. Noren *Shulamith Stein from The Camera of my Family*

The commentary describes relationships, explains how marriage partners met, and tells us what happened to people at the end. The author's work was motivated by her personal sentiment for this remarkable group of industrious and cultured men and women, who exemplified so well what was good in German middle-class society, and who were disbanded and murdered by that society. In that context we understand that the record functions as a human correlate to the history books.

But in more stable contexts, in more benign circumstances, we may want to consider the family album in a colder light. Then it may be useful to think about drawing the veil, exposing another reality, examining the construction of a family history.

Family documents they are, and ritual relics they may be. But even in this humble context, the process cannot be called *reportage*. Whatever there may be of the informal, the spontaneous and the naive about it, the subculture of the family snapshot and the family album has its personal and social rules and etiquette.

Jo Spence has discussed it bluntly in her *Ten 8* article (1980). We are obliged to show what happiness we have experienced, what friends deserved, what ambiances and positions achieved.

We do not represent ourselves and our relations, neighbours and friends in the more mundane aspects of our daily lives. We do not show work, even if it were available for showing. We do not show the hurly-burly of argument. Boredom, disagreement, preoccupation, sadness – none of these are allowed to exist. They are expunged by two manoeuvres – the narrow focus of events snatched, and the commands of 'the pose'. The latter ensures that the person with the camera may righteously demand *the smile*.

However carefully an album is manufactured, families do not wash up, don't sit around doing nothing; children do not do homework. Instead, there is a kind of half-world of 'the naturalistic pose'. People appear to be engaged in certain activities that are more phoney than real. The mother literally 'shows' the baby to the camera. The children demonstrate the pet, rather like department store assistants. We line up at the front door when the aunt arrives from America. Little girls marshall their dolls like an army platoon in order to have them recorded for posterity.

Vanessa Bell *Angelica and Vanessa at Charleston*

It is this selectivity or, more properly, partiality that makes albums meaning-less and therefore tedious for outsiders. They see the surface uniformity in content and style.

But family members can understand all the implicit information. For them the photographs are not concrete memory. It is not as simple as that. They are hooks on which are caught the 'real' story. The paper square is the 'front' in the Goffman sense. The back region will be revealed, re-evaluated and discussed with more or less honesty by the participants as time goes on.

It takes a particularly sophisticated family to commission a serious pho-tographer to make an album to show us children wrestling, food being pushed away at the table, sprawlings on the floor, and the mother at the end of her tether. What a nice paradox – that it is expensive to record the mundane.

Sean Hudson *Elephant and family*

Sean Hudson *Family living-room*

It is Christopher Musello in Jon Wagner's *Images of Information* who has dissected family snaps and their collection with precision and sympathy (and this section of the present book has been much stimulated by his writings).

We spend time, energy and money and fray our tempers to produce material for such family histories because we want, as was suggested before, to prove that we as a family are worth such a record; that we travelled through those stages and arrived here. We need such a history because then the past, at least, is not as problematic as the present.

We take these photographs fluently. We don't preoccupy ourselves with complicated aesthetic or technical qualities. These are naive, intimate photos that express our family identity, our experience, status and pride. We need them to keep and to use as tools of communication.

We could ask many questions about them. What do they tell us about ordinary family life ? About social structure ? What do they hide ? When are they taken ? When not ? How do we evaluate these pictures ? What do we do with them when we have them ?

They are personal artefacts strongly embedded in the wider culture as well as in camera culture. But they are also a medium of social behaviour.

They are intimate partly because their meaning is fully appreciated only by the people closely involved. That blurred picture is included because the young photographer was trying to be 'arty . This is the grandmother's last visit. This group is noted because of the absence of a particular member. *We* know how the snaps were taken, what the people and events and relations really were.

What we do with a set of pictures is also a socialised activity. We send them off. Grandparents have highest priority. A Christmas card with the whole family harmonious and happy is acceptable in the United States, but problematic in Britain, where it borders on *hubris* or at least showing off.

Musello enumerates the functions of family photography as follows.

Communion

In family photos we show visually our family bonds. With our arms around each other, we stimulate, develop, facilitate the bonds, in acting them out. We do it in the pose of the photo, and most crucially in the sharing of the images. The network of family and friends to whom snaps are sent is validated and reinforced. They want to have us. They will understand this account of us.

Presentation of self

In family snaps members should be presented in that both natural yet complimented way that we have already discussed. Sometimes a more sophisticated amateur photographer within the family will attempt a combination of idealisation and professionalism that turns a snap into an imitation Portrait. More likely there will have been an exhortation to assume a natural pose, which should appear as a 'candid' picture. But ultimately the aim is always to show the family to be healthy, happy and handsome.

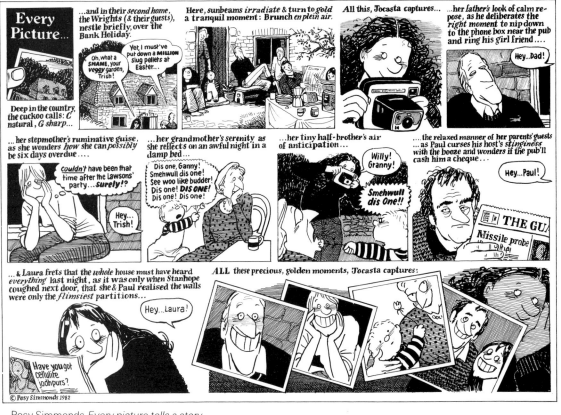

Posy Simmonds *Every picture tells a story*

Anonymous *First day at school: Milestones recorded*

Documentation

We keep family albums to show the history of our family. We capture the important happenings and the developmental stages. These celluloid pseudo-memories we will use to recall, reflect, share, compare.

Within the nuclear family this is, of course, engaged in mostly with pleasure and laughter, notwithstanding some dismay when children are shown pictures of themselves when they were smaller. As adults we have a wider comparison for time past and past images. We become blasé about our childhoods. But children find in their past selves a revelation not only of the power of time for transformation, but sometimes of the love that their parents showed them so much more simply in their baby photos.

What is shown is the past that we can be sentimental about. Photos and reality interact here in complex modes. They may call up – with a sign – what things were really like. That starts another whole story. We evoke time, growth, change, history through the narrow range of possible images.

Although there is no hard survey data, observation suggests that there are clear partialities in the content of family albums. Let us consider the progress of the nuclear family.

One starts with the wedding album.

Then in the formal snapshot mode will come a series of prints of the couple photographing each other, usually on holidays, or at least on excursions.

When children are born, they become overwhelmingly the focus of attention. Here the camera as image-freezing machine comes into its own. With it, we can keep the ephemeral stages for our future pleasure and pride, and for that of the children themselves.

Musello's surveys demonstrate that the frequency of photographing is greatest in the earliest years of the children's lives, with a geometric progression from birth to age six. There also appears to be a geometric decline from child 1 through to child x. Families are often embarrassed by the 'gaps' in the album when they are leafed through by the later-borns in the family.

By the time of adolescence the young people are taking pictures themselves, and there is likely to be a resurgence of documents for the album. They will by this time, of course, have learned the etiquette and rules of photographing, and will show the proper settings and poses – picnics, reunions, smiles and laughter.

Family photographs provide a forum for communication, within the intimate family and in the network of absent friends and relations.

In the technical sense there is not always much 'information' contained in the pictures. (The physical and social development of children does provide this, though.) It is the act of showing the pictures that bind us together, that demonstrates we want that level of intimacy.

We 'edit' these documents. (Hence the feverish first look at the wallet of prints as they come into our hands in the chemist's shop). Some of us are wary of showing our image, others free. Some have a wide tolerance of the range of 'exposure', others must control exposure so that there will be no leakage.

The final editorial process occurs when pictures are mounted into the albums. However, on the way to that point there are a number of stages. We have mentioned the first weeding-out above, but there is also the cardboard box staging-post.) While respectable families will usually have one album, as the children grow, become taken for granted and lose the 'miracle of creation' quality, it becomes harder to spend time to mount them. So the cardboard box comes into its own. However, it is still impossible actually to discard or destroy these pictures.

We have given pride of place to the talisman of the wedding photograph. It can be seen as an index of fashion, personal preference and photographic development, as Barbara Norfleet has suggested in her recent survey, *Wedding,* of both pictures and the professionals who take them.

During the first thirty years of photography it was hardly possible to bring the camera into the celebration. The family status and relationships were documented in the studio. Man and wife came at another time, in their ordinary good dress.

After 1870 we can see the formal portrait in which the couple are seen (the man seated, the wife in attendance) unsmiling and both facing the camera, almost unconnected with each other.

This was formal portraiture at its most solemn and unlived. (We are told that the best results were sometimes achieved by posing the bride in her wedding dress, but with an artificial bouquet, two weeks before the ceremony, in the studio). The bride then was a special kind of still-life. Her pose worked to induce the adjectives feminine, beautiful, demure, soft, radiant, serious, serene, innocent and dignified.

Such picture rules lasted a long time, and reflected the solemnity and permanence of the institution of marriage, as well as the backwash of the tripod, the neck-clamp and the five-minute exposure.

Already in the 1940s in the United States came a reaction, with the inclusion of the 'casual' in the wedding album. This was a 'posed candid' shot which took even the professional beyond stock shots. Aesthetically it was in tune with the time, and socially it was a kind of anti-establishment alternative style. Ostensibly it added liveliness, imagination, spontaneity and individuality to the record.

In the USA and Europe it was the educated, almost the intellectuals, who led the way in preferring informality and, indeed that their amateur friends should take the pictures. But very few are brave enough to refuse to have any photographic record at all. Would it not be tempting providence too rashly ?

Before we leave the family album, one note.

The ultimate impropriety by contemporary Western rules would be picture-taking at a funeral. However, we know that photographs of the dead in their coffins, and even in their beds, were popular in the nineteenth century. In the black community of New York, at least, such pictures provided a flourishing trade with living memory. Soldiers and spouses were dignified in the funeral parlour, and even little children, in apparent peaceful sleep in their parent's arms, providing a comforting *memento mori*.

James van der Zee in his book *The Harlem Book of the Dead* says that the dead were posed, with their dearest around them, for the benefit of absent ones: 'Sometimes the family wanted to show the other relatives just how the deceased had been put away.' From the evidence of his photographs – with fine pomp and artistry.

It has been suggested that the Harlem rituals of the dead have links with those of ancient Egypt. Certainly we see a kind of hieratic formality, not only in the laying out of the corpse but in the bearing of the mourners. They maintain full social and emotional control.

It is surely the fear of showing our lack of dignity and of emotional flooding, that underlies our modern taboo on photographing. That, coupled with a kind of proper modesty. The survivors do not want to put their own ego, their persona, forward at this time. We begin to see there reasons that have proper social validity.

James van der Zee *Black and white mourners*

James van der Zee *Dead child in her father's arms*

Tourism

Tourism – the use of leisure time to seek out new experiences in strange places for their own sake – is, with existential philosophy and science fiction, a specifically modern phenomenon. Photography and photographs are an integral part of it.

In the nineteenth century, one of the most successful artistic and commercial photographic endeavours was that of supplying beautiful 'concrete memories' of the important landmarks that early tourists visited. The Alinari Studio in Florence and Francis Frith in Britain excelled in this work.

They produced pictures of the sites that were worthy of visit and appreciation more cheaply and more accurately than the earlier engravers had been able to do.

The sociologist Dean McCannell in his analysis, *The Tourist* (1976), has categorised the essential stages that a site (and a sight) undergoes during its 'sacrilisation'.

It must be named. It must be framed and elevated – whether by a little stone kerb round the floral clock in Edinburgh or by the hushed darkness round the *Night Watch* in the Rijksmuseum in Amsterdam. It must be enshrined. And finally, mechanically and socially reproduced.

The last is obviously the phase of particular interest for us. It has two aspects. First, and most simply, miniatures and pictures of the sight must be propagated, in order that it become famous. The Brooklyn Bridge has lent itself most finely to geometrically complex photographic images, and the Eiffel Tower to the pocket-sized metallic miniatures. Second, that very reproduction paradoxically creates tourism. Knowing the reproduction, we are unsatisfied and frustrated. It compels us to have the real experience, to travel and see it for ourselves, and to make our own reproduction.

As has been suggested, the tourist as he is deployed around the world is worthy of study not only as an actual person, but as a fine model for post-modern woman or man in general. If today's society leads us to experiences of instability and inauthenticity, and if, inevitably, we therefore yearn for naturalness and real things, then travel to beautiful and old and wild sites will satisfy us more dramatically even than wholefood.

Photography here plays a crucial role in the transformation (and manufacture) of natural, cultural and technological sites into sights. Again, it is a matter of validating their worthiness. It is the image that informs the wider public of the existence and form of the original. But that is not enough. The reproduction persuades us that seeing it 'for real' will enhance our own lives.

Smoothly and easily potential travellers learn the loving duty, both to place and to their own positions as more sophisticated persons, that tourism implies. They assume, in evaluation, the correct ritual attitude of more or less awe, plus a measure of cynical, experienced distance. The camera has an important part in the whole role play.

Originally when photography was a complex and arduous process, tourists had to buy their 'travel documents'. They all came back with the same ones.

Now it is possible for all traveller's to 'personalise' their trip, to make it authentic in their own right.

> Amateur photography permits the tourist to create his own touristic imagery with himself and his family at the centre, or just off the side of the great sight or monument.

as McCannell writes, adding that the possession of such relics is a clear status sign.

The style of the relic itself develops with experience and skill in touring. Children start simply by snapping 'what is there'. That is how they demonstrate that they understand its value. Experienced tourists will want an 'art version' – emulating the *Time/Life* books of cities and countries.

Sophisticated travellers will want now to include aspects of the natural or real life of a place. Considering the short time at their disposal, this must be a vain hope. It brings one into all kinds of ethical problems about the intrusion into privacy, which the here-today-and-gone-tomorrow tourist will hardly worry about.

At the centre of the tourist photograph, and of the question of proof of experience, is the picture of ourselves – out there – for the family and friends on our return. One of the simplest photographs that anyone ever takes is that of companions in front of an interesting place. We've come to this spot; now we complete the experience by showing ourselves with it, there. In alliance with that worthy sight, we become worthy. The picture of ourselves, there, proves that we made the journey. Its interest value enhances our interest value. In communicating that evidence, we justify sending our image to our friends and relations. In showing the slide version, we entertain and also educate our companions. In pasting the photograph into an album, we continue the record of lives and times. Without such a document of ourselves feeding the pigeons in the Piazza San Marco, we have only the private and ephemeral memory of it. That fades, that can hardly be communicated with much persuasive power, that cannot be stored in the public domain.

Young children certainly need evidence that they were in that place during that summer, and they were only that high. But adults too find comfort and strength in seeing and not just knowing that they were there.

The problem is that all benefits have costs. Records and documents of touring, when they are entrance tickets to the Brera Gallery in Milan, are psychologically free, but the taking of photographs removes us one step from the spontaneous experience.

Photographers of any pretensions beyond the most simple-minded Instamaticer's must look with the camera eye. They must judge the image value, the light and shade, the completeness of the view, the aesthetic composition. They must be at work and technically on the *qui vive*. It is often said, therefore, that one can travel and enjoy oneself – or take photographs.

Some travellers now act on a higher plane of tourism and refuse to take a camera. They buy books of art photographs, send black and white photographic postcards to their friends (or reproductions of art work in museums) and drink in their new experiences with their own eyes.

They have no barrier between themselves and the world around them, they believe. They have not distanced themselves. They are part of the scene, naturally. In a sense, therefore, they wish *not to be tourists*. A tourist has a camera – by definition.

So the personal mode is highly selective, but also regularly predictable. It is patterned and restricted in order to give a positive account of important and seemingly appropriate family subjects.

The mode produces fragments, not through incompetence or neglect, but because shared goals, needs and intentions of a kind that are vital for the maintenance of well-being, indeed for the existence of the family, are at stake.

This is the humanistic account. But B. F. Skinner might well say that such evidence of health, harmony and success are necessary rewards for the costs of family life and the workaday round demanded of its members.

The fragments can be studied in their own right or as tools for finding a truth.

8 Click: the act of photographing

The complexities, the ambiguities, the conflicts within photography all come together at the moment in which a photograph is being taken.

Professional photographers have spoken and written about it, and the people in front of the camera implicitly know that there are customs that surround the camera. We will see how far we can make them explicit, to understand them more clearly.

In this chapter we will bring together into sharp focus many issues that have appeared under different headings before.

Photography as a process, in both public and personal use, is one of the customs of our society. Any custom, in any community, is surrounded by rules. As we have said earlier, the set of social interactions that come under the heading of photographing have the quality of a ritual. As a ritual they can be the subject of a kind of social-anthropological study. But beyond these, as

Susan Sontag has written:

> Even when photographers are most concerned with mirroring reality, they are
> still haunted by tacit imperatives of taste and conscience.

Taste and conscience will have to be our concern here.

The rules of the ritual

What must you photograph ? What can't you photograph ? Where can't you
photograph ? What kind of warning must be given to the subjects ? Who
owns the rights of the photograph ? What is photographic space ? What are
the rules of the pose ? What about the power of the 'smile' rule ? Do all
photographers obey the rules of the camera ritual ? What do they feel when
they don't ? What do subjects feel when they are broken ?

We will consider some aspects and examples of rules, and we will go further
into the ritual – that of the pose, especially. We will attempt to explain the
ethics of taking photographs, for some contexts at least, and we will suggest
that photography should ideally be considered as a form of social exchange.

We shall not be surprised to see that the concept of social rule here, as in
other social interactions, refers not simply to a statistical mode, or even to a
convenient guide-line. Rules within photography have the quality of moral
imperative and contain the concept of righteous demand. Although this does
not mean they cannot be broken, there are costs involved in breaking them.
The pictures resulting from broken rules have a special effect, too.

The simplest example of an implicit rule is that of *photographic space*.
Stanley Milgram first drew attention to this phenomenon that we have all
experienced.

When we stand in a public place, preparing to take a photograph of a friend
or indeed just a monument or scene, people tend not to walk between us
and our subject. It is a 'photographic courtesy' that the territory between
camera and subject for that time belongs to the photographer.

Milgram himself explored the point further, and discovered that the rule is applied more rigidly or systematically when the subject of the camera is a person rather than a statue. This suggests that a rational kind of social calculation is being made.

By walking through, then, we will hold up the photographing for two people instead of just one. And the pose of the person may be spoiled if it has to be maintained for too long. The inanimates will last.

A student, checking out the New York findings in Edinburgh, was able to confirm their extension, if not their universality. But more than that, he was shown the force of the rule.

While he was photographing a friend on the steps of the Central Post Office, a man running out, obviously in a great hurry, stopped at the photographic space as if it had been a sheet of glass, then continued his run around the partners in photography. He was willing to pay a price in order to obey the rule. Serious respect is paid to the privileged space.

There are some rules that apply to the public domain and that concern the use of photographs as special kinds of records.

Art galleries and museums generally do not allow photographing, as they presumably want to sell their own reproductions. Similarly, performances in theatres forbid cameras, not only because it would disturb other members of the audience, even without flash, but because they want to retain the copyright on the look of the event. (At rock concerts, the challenge to steal an image is eagerly taken up by the fans.)

The identifying function of photographs is clearly at stake in those restaurants in the United States and Canada that do not allow any photography of the social occasion by customers. The other guests fear to appear on any resulting photograph. They may not wish there to be evidence in this place with this partner, in case it is used against them. And who knows whether the 'informal' photographer does not hide some other motive ?

It is often good to test out the covert rules implicit in any activity by engaging in an unusual version of it.

What happens, for instance, when a photographer walks around the streets of a city, rides on the buses, takes photographs which include the passers-by ? And what does it feel like for him ?

In such an exercise we hope to follow the maxim that the power of a phenomenon may often be best studied in its absence. What would happen here, if we assumed that there were no rules ? From tentative explorations, some preliminary conclusions can perhaps be drawn.

In the centre of Edinburgh there seems no particular note taken of, or objection made to, street photography. It is as if the many tourists have justified the activity, and it is taken for granted that people will appear as adventitious 'noise' or as simple accessories to the architectural 'sights'.

Outside the tourist environs, different assumptions are made.

While collecting a systematically random sample of 120 architectural photo-graphs in the city limits of Edinburgh, more than once it happened that elderly men, finding themselves in camera range, turned away while simul-taneously giving the young woman with the camera 'verbals'. Although it was highly doubtful that they had anything to hide, they clearly felt that their privacy was being in some way invaded, and that the photographer would now in some way 'possess' them. (As indeed she would, however incidental their image might be to her concerns.)

A more dramatic example of the disturbance of the flow of ordinary life occurred when Roderick Taylor, the student, on his explorations, used a camera on the top of a bus. To take a picture of the panorama outside is understandable and justifiable. When he turned the camera on to the interior and the passengers, there was dismay, and certainly some level of general objection. That being the case, he made an exit at the next stop.

While, again, it is unlikely that any passengers were engaged in illicit activities during their bus travel, they believed that their presence there was no one's business but their own and the fare collector's. To photograph there was worse than to stare at them, although one would hazard a guess that that would be an analogous kind of rule-breaking.

Even in a public place, where we are open to the casual scrutiny of our fellows, photography breaks the rule of self-possession, as one might call it. Only in tourist contexts is the function of the camera clearly accepted as non-noxious. The tourists go away; we are clearly only part of the scenery. There is nothing personal.

We shall come later to the complexities of reportage, but even on this informal level, it may be useful to see what the photographer feels like when working outside the usual amateur track.

The rules of the pose

We have already considered the central fact that photographs are not taken at funerals, which indexes the point that the rules of the pose must allow us to show ourselves in some socially correct manner. Loss, grief, and the expression of unsocialised emotion are outside the pale of the positive aspect of our correct persona.

Similarly, in chapter 6 we have discussed the arguments surrounding the unposed pose, and the performance of sincere and natural informality. We commented then on the arduousness of such performances.

It was George Bernard Shaw, the patron of Alvin Langdon Coburn, who saw the dilemma and devised a method of overcoming the problem. As he said:

> though we have hundreds of photographs of Dickens and Wagner, we see nothing of them except their suits of clothes with their heads sticking out; and what is the use of that ?

He had himself photographed in the nude. Did that reveal more of the true Shaw than simply the skin and a typical Shavian 'pose' ?

The distinguished professionals have attempted many styles for allowing the natural person to 'come out', or even, of course, of producing an improved version. Some, like Karsh, seem to encourage the straightforward *gravitas*. By the time Karsh takes you as a world leader, or top Canadian industrialist, the fact of the sitting means that the role is presented, accepted and printed.

Arnold Newman, who has taken on the mantle of Karsh, shoots the all-time greats now – witness the unabashed *The Great British* (1979). He works hard to enable people to lose their self-consciousness and 'become what they are'. But, of course, they decide what they are.

Alvin Langdon Coburn *Le penseur: George Bernard Shaw*

Arnold Newman *Sir Freddie Laker* Copyright Arnold Newman

Other photographers, as we have seen, must use a variety of distractions and ruses to avoid the roles and the presentations. Only then will they have done their job. Their paradox is that they must break the rule of the pose, or at least arrange for the sitter to circumvent it.

Cartier-Bresson, as we would guess, even in the portrait wants to take the sitter unawares, and so exclude both the sitter's presentation and his own personality from the interaction. He explains:

> Above all the sitter must be made to forget about the camera and the man who is handling it. Complicated equipment, light reflectors, and various other items of hardware are enough, to my mind, to prevent the birdie from coming out.

> The sitter is suspicious of the objectivity of the camera, while what the photographer is after is an acute psychological study of the sitter.

Certainly it is the presumed objectivity of the camera that leads us to work so hard on all the rules of presentation that we have discussed in chapter 7, and which indeed are designed to shield us from 'the acute psychological accounts'. Which one of us has a psyche that could bear that ?

Cartier-Bresson's own practice of 'hiding' his camera and distracting his sitter in the studio by using a myriad of cameras clearly achieves its object.

Paul Strand, on the other hand, approached his 'plain people of the world', as well as the eminent French cultural figures he portrayed, like objects in a still-life. We know that he often didn't speak to his sitters at all, not even the famous ones like Pablo Picasso and Jean-Paul Sartre. He wanted to deny the axiom that a photographer must 'know' his sitters in order to reveal them. One may surmise that this ploy disconcerted the subjects so seriously that they did indeed drop their guard.

We have already commented on the rule of 'the smile', which is faithfully followed in the family album. There a serious (i.e. non-smiling) picture will be carefully evaluated, commented upon and interpreted before being included.

Arnold Newman *Mary Quant* Copyright Arnold Newman

But the smile is found even in collections of professional portraits. One might speculate that it is employed by famous sitters in order to ingratiate themselves, for even they wish to communicate to the powerful 'master' photographer. One might further speculate that the absence of the smile in such collections is an index of the artistic integrity of professionals.

A cursory inspection suggests that there are great variations. For example:
Arnold Newman *The Great British* 33 out of 111 smile
Richard Avedon *Portraits* 11 out of 82
Peter Huja *Portraits in Life and Death* 2 out of 31
Jonathan Williams *Portrait Photographs* 10 out of 40
Rosalyn Banish *City Families London* 95 out of 154, *Chicago* 112 out of 140.

Jo Spence herself has been at pains to point out the element of lying that is involved. In her explication, or dissection, of her own family album, she has discussed her photographs as statements that she must translate. Her pictures aren't documents. Or rather they are documents of a brave front. It is what is going on behind the front that only she can now tell us about. The photos are just buoys above the true stories in the deep.

Certainly one has the impression that it is children, particularly, who have an obligation to follow the smile rule. It is adults that impose it, for their own comfort. Then – 'The children are all right,' think the adults.

Perhaps it is here that one begins to understand that photographic rules change, as do all social rules. Early photographs of children allow them to be serious if they so choose, either singly or in groups. Long exposure times – clearly a problem – interact here with both natural inclination and social expectation, but the mode of the smile has become increasingly powerful.

Is it because earlier life was more serious, even for the children ? Is it because we are now more anxious that they should be having a happy life ? Is it that, as we become more anonymous and dishevelled in the complexities of modern life, we need the external reassurance that all is well ?

What is certain is that the rule is strongly enforced, and accepted; and that it has worked against the sort of photograph that is more than a mask and that attempts a psychological study.

The moral rules

At one level the problems of taste and conscience must depend on the use to which a photographer's work is put – art, journalism, 'concerned' investigation, personal pleasure. But there are some common questions of privacy and of ownership of the image, about control of the act.

The problems arise from two sources:
1 A photograph is a kind of clone. Although we hold ourselves open to all kinds of inspection, both on our own territory and when we enter a public space, a photograph of us is different. It is a visual clone that is permanent, portable, reproducible, public and saleable.

2 Photographers work towards more than possessing the appearance of the world. They want to understand life. They are a species of social scientist. Therefore the rules governing respect, intrusion, openness of purpose, and that exchange of benefit which social scientists aim to follow, should apply to photographers too.

And yet the piquancy of life might then be lost – and photographers would become as pedestrian as social scientists.

Imogen Cunningham in an interview said:

> Once a young woman who does street work said to me, 'I've never photographed anyone I haven't asked first.' I said to her, 'Suppose Cartier-Bresson asked the man who jumped the puddle to do it again – it never would have been the same. Start stealing.'

In fact, photographers have been both ruthless in their stealing and tactful in their approaches. They themselves have offered justification and expressed ambivalence and guilt about what they do.

But even the stealing of anonymous people for purposes of pure art is not always an easy thing to do.

At the end of his working life Paul Strand discussed in detail the various tactics he had used for avoiding being 'found out' during his portrait work in New York and in Mexico. By means of a shiny brass lens barrel attached to the side of the camera, or a prism attachment, he deceived observers about the focus of his interest. He faced one way and shot another.

In New York this was necessary so that people would not pose, and in Mexico because they did not like to have their photograph taken. 'I never questioned the morality of it,' he said. But, of course, he did later, or he would not have brought it up at all.

Robert Frank married not only style, but also tactics, to the ethos of *The Americans* (1978). In America there was no need to pussy-foot – not by the 1950s. You poke your camera and you shoot. In the country of the machine, the camera is acceptable. It does the work. The fine aesthetic has no place. Composition would be anachronistic. Although the artefacts of his places are new, gimcrack and ephemeral, they have their own strength and interest. So do the people. But perhaps the niceties of diplomatic relations were also seen as obsolete by Frank.

The bus-riders, the black nurse with the white baby, by their lack of indignation show that they do not object to being 'taken'.

Is this because the camera culture has indeed become ubiquitous, affecting them as much as anyone else ? Or is it an index of their low place in the hierarchy ? Or was Frank simply acknowledged as another alien presence, who had no connection with them, and was therefore harmless ?

In the Old World, questions of tact and diplomacy and fine tactics loom larger.

Taking Henri Cartier-Bresson as an example of an independent European photographer, here certainly is one who wants to comprehend the social scene, not shoot recklessly. 'He is not making art but taking life,' as Lincoln Kirstein said in his tribute for the 1963 exhibition in New York. He wants to know what is true, he is interested ultimately in the behaviour of man. In order not to disturb reality, his raw material, he works unobtrusively.

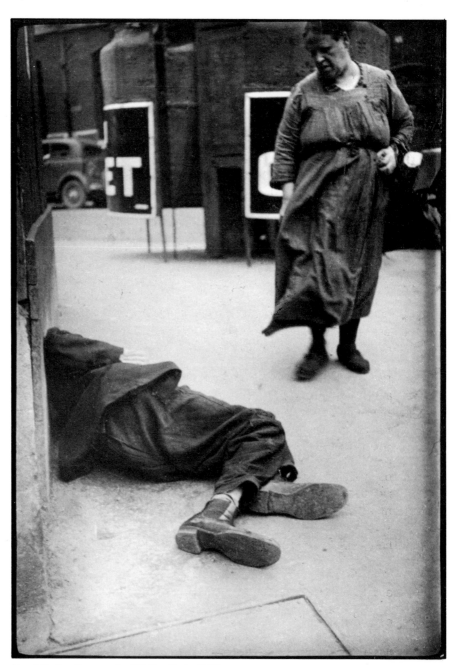

Henri Cartier-Bresson *La Villette, Paris, 1929*

It is said to be through respect for his subject that he has developed a way of working without intrusion. He has covered his Leica with black tape to make it less conspicuous. It is in his hand or the crook of his arm ready for instant action. Around his neck, it would be too conspicuous too.

Is this tact or deceit ? Diplomacy or lying ? It is both.

We do not find his work repugnant, though. On the contrary, he is acknowledged as the most popular independent photographer, and pundits consider him to have produced the *principia photographica,* as Kirstein calls it.

The point is that whether the pictures show a knowledge of the subjects or not, they are all suffused with Cartier-Bresson's humanism, his warmth and sympathy.

His pictures of the liberated concentration camps are perhaps alone in showing anger and hate. Otherwise his *oeuvre* is concerned with the charm of the everyday, the beauty of what is natural and hand-made, the ebullience of children, the mystery and the humour in our lives. Even in his *clochards* we are comfortable in being able to identify with his charitable eye.

In the most clichéd sense, Cartier-Bresson captures his famous decisive moments in the blatant 'voyeuristic' manner. But because what he shows us is so clearly a beautiful, witty, and even elegant picture, we know that it is all perfectly safe. He has no purpose other than to show that life is good if only we can share his humanism. In fact his photographs help to 'raise' us to his level.

Is this the only way in which a student of people works ?

Is this the only goal, and the only strategy ?

Are the problems of ethics always apparently so easily resolved ?

No.

For Cartier-Bresson the problem of ethics seems to be overcome through his modesty and his goodwill.

He sees what is good, nearly all the time.

He shows that we can live with our funny little ways, and as long as we have a sense of humour and a sense of empathy with others, that us as it should be.

In the north he shows our foibles, in the south he shows that life has a traditional serenity that more than compensates for the total lack of modernity.

Photographers rage against the status quo because they see in it the iniquities that bring ethics to a dramatic crisis. They want to show what is bad and ugly.

Where does that leave the people in their pictures ?

What kind of objects do they become ?

What is the photographer doing, then ?

It is Don McCullin who has been most perceptive and outspoken about his own position and his own feelings:

> Although I go down dark tunnels, I don't want to be thought of as a ferret.

While we have considered McCullin in some detail in chapter 4, we must again make the point that he is using his photography to make statements about his own social attitudes.

> My photography's an expression – of my guilt, my inability to make a protest in any other way. It's an expression of something in front of me that doesn't look too good.

Although he has also said, 'When I was younger I did it to become famous.'

In one sense, as John le Carré, in his introduction to McCullin's *Hearts of Darkness* collection, has rightly written, of McCullin's appeal to the people he photographs:

> the elusive amount of connection with his subject – the *yes* . . . The moment of naked affinity, when he or she sees him, and forgives him, at death's edge, starving, inconsolably bereaved, when their own child lies dead on the hall floor, bombed in the attack: still *yes*.

But he himself has put it more laconically and has certainly admitted that the 'yes' is a complex process, adulterated with 'no'.

It is his comments on the portfolio *Coming Home* that provide the best illustrations, if only because we can identify more closely with the people involved.

After he had followed an old and confused woman in the street, and finally photographed her, she realised what was going on:

> in the end, of course, the safety valve in her released a great river of abuse; she went off looking behind her, as if I'd physically abused her – an accusation which I know I deserved.

> The camera's become an object for assaulting people; they know what you're doing now, and they resent it deeply.

> Photography has become a sinister eye. The simple Victorian photographers were the last to make images of the English people with their consent. I came too late; I'm hanging on to the last of the goodwill around, and there isn't much.

> Bradford's the last remaining place in England where people aren't offended by having photographs taken of them. They're not fully aware of photography's power. They think something important is happening when they see a photographer, and they're quite tickled. It's the way England was when I was a child, when people had a certain respect for and were ready to demand sympathy from, each other.

Yet, when we wonder how it is that the Bradford woman with her Indian child ever allowed McCullin into that kitchen and agreed to be shown there to the world, he tells us:

> I was wandering round the street one day and I saw a woman standing with two men. I said, Good afternoon.
> She said, What are you doing ?
> I'm a newspaperman.
> And she immediately dragged me into her house and showed me the conditions under which she had to live.

She had one understanding of the function and power of photography. She believed that McCullin could not only show, but ultimately change, her life. We have discussed the limitations of this belief, but in this particular case the woman worked on the assumption that a photograph would not do something *to* her, but *for* her. McCullin was not using her, but she him.

The balance in the relationship was at least more equal.

McCullin himself, of course, understands perfectly the matter of balance. One has the impression that even the possibility of physical assault is to him a risk that he must take. Without that price on his part, it is all unfair.

> I spotted a man had collapsed. Very quickly I stopped the car. I had the right lens attached to the camera, and I thought, Now what am I going to do ? This is very embarrassing. Do I photograph, or do I let it go?
> He always photographs, one has the impression. This imagery thing isn't worth spoiling my character for.

> It's not important that I record every tragedy that goes on in the world. But I decided to try a couple of shots. And I did something despicable. I wound the car window down and took the photographs from inside. Then I hated myself for not having the decency and courage to at least get out and do something . . .

We have already discussed the impotence, or at least passivity, of photographs. It isn't McCullin's role to 'do something'. Surely his guilt this time concerned the fact that he was not even *in* the street. He was in the armour of the car, removed, protected, incurring no cost at all to himself.

Yet, again, we don't find his pictures repugnant. We don't resent his intrusions. We do not class his activity as cold exposure of the underbelly of our society, as cynical purveying of horror for profit. We do not consider his behaviour unethical.

Partly we return to the argument already advanced, about believing that 'knowing' is somehow good. We may be better for it. But partly we can see intuitively that he himself does not have an exploitative, cynical, cold attitude. Through the vaunted reality on his film comes his own identification with his subjects, the wonder that we can exist like this at all, and the anger that we have to exist like this.

Finally, for anyone of the humanistic persuasion, the very fact that he is aware of his own moral position, the very fact that he has a bad conscience, excuses a good deal. Albeit that that does not recompense his 'victims'.

In the issue of ethics we cannot possibly come to any firm conclusions. In an already thorny field, photography raises more questions than it provides answers to.

The ends seem to be closely connected with the evaluation of the means. Self-consciousness seems an important factor. Consent, informed consent, even, is a desired goal, but might defeat the purpose of the venture. The character of the individual photographer seems to need to be taken into account.

There is perhaps one model for social interaction that has been tacitly referred to and that we should explore further – the concept of social exchange.

Social exchange

If we follow the model of social interaction applied to photography, it becomes obvious that one way of considering the problem of morality, contract, ethics, relative status of photographer and subject, relative power, must be in terms of social exchange.

This is a simple metaphor in which social interactions are viewed in terms of the costs and rewards which any interaction brings to the parties involved.

A simple social algebra then occurs, and the fairness of any outcome can be 'calculated'. The finesse in the equation will take into account the status (or reward value) of the individuals involved, as well as the value of the outcome, or product which follows the interaction.

From our earlier discussion of the contracts that are made with photographers playing various roles in the repertoire, we know already something about this kind of approach.

When we consider a photograph as any kind of reporting or documenting we see that there is a dimension of exchange. At one end the photographer has all the power and all the benefit; at the other, the subject is in control and the photographer his or her servant.

At the subject pole, the photographer and subject are allies with the same goals, which have been openly negotiated between them.

At the photographer end, he comes in with his own undiscussed aim. A camera is used, simply, like gun, to shoot a picture which will conform to his idea, his style, and in which the image is possessed by him in every sense. He will use it or sell it for his profit, in either financial, career, or political terms.

Every shade of subtle difference between these two extremes is possible.

Consider portraits. Our high street studio must for our money produce a picture that is to our liking. But Snowdon may publish a picture of even an eminent person which expresses his own vision, without needing to satisfy the simple *amour propre* of the sitter. A compromise outcome may be deemed acceptable because a picture by Snowdon is an accolade in itself.

Those 'stars' of the Western social world who appear in the most glamorous poses and the most flattering lights may indeed have been manufactured as stars by photographers.

As Anthony Burgess has commented apropos of Angeli and Dousset's stolen pictures:

> If you are sufficiently well known and you are thus worthy of the attentions of press photographers, then you are a star. You are different from the rest of us, you possess glamour. . . . you belong to a pantheon, you are a myth.

224

But then, on balance, you are also fair game for the *paparazzi* who 'are tough and wish to teach sharp lessons'. They will show the private moments too, 'the moments of gracelessness', which prove that the stars are human too. Like us, they are mortal.

In one version of the equation there is no inequity in this. If the camera has worked *for* you so well, it must also be allowed to work against you. It is morally fair, and good for the body politic, to show 'the extraordinary as terribly ordinary'. As Anthony Burgess understands, such divine punishment is right and good.

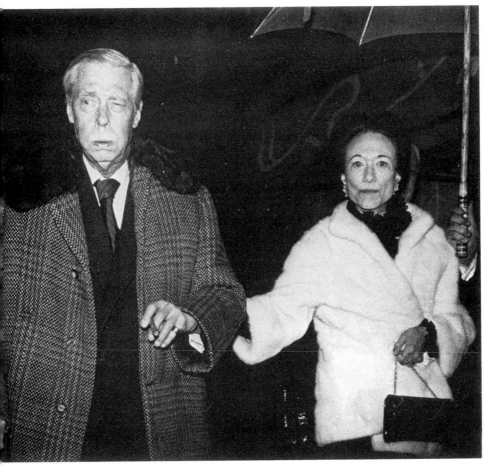

Daniel Angeli and Jean-Paul Dousset
Having dined at Maxim's, the Duke and Duchess of Windsor

The current controversy centres, then, on the applicability of such an equation to public figures who have not chosen that role – members of the royal family, for example. But the basic terms in the exchange are tacitly accepted.

Leaving this drama for a moment, it is worth looking at the views that different photographers have taken of their moral obligations in terms of cost and benefit for everyone involved.

Sociologists and anthropologists understand well the price that they must pay in order not only to study, but to capture, their participants for their work. The very fact that they now use the technical term participants, rather than subjects, shows that they at least aim and hope for a more balanced and more equal relationship between members of the study.

Bill Aron, who has documented the disappearing group of orthodox Jews in New York, as well as Doug Harper and Phyllis Ewen (see chapter 9), all describe the reticence that they feel in photographing the people whom they are trying to describe and understanding in their research. They can see how easy and cheap it would be to catch them and mount them, as if they were species of insects.

Either they say that they simply felt 'unable' to take the pictures, or, at least, they knew it would completely spoil the relationship that they had made during the account-gathering. Photographing would have asserted their power so blatantly.

What they had to do was somehow to earn the right to take the pictures. This could be done by simply sharing the life of their informants. For Doug Harper, that meant riding the freight trains for many months. Then, as one of them, he could try to extend his documentation. Even at that point it was difficult for him to take out the camera.

For Phyllis Ewen, the beauty parlour was a more natural habitat. All women have a right to be there. She earned her right as a social scientist, by simple openness. She explained her purpose of seriously studying the beauty ritual as it was seen and understood by the individual customers, and justified her work by the fact that each person approached could 'manage' her own sitting.

For Aron, his straightforward purpose of documenting a dying subculture, the noble losers *par excellence*, was a pass for collecting their biographies, describing their beliefs and customs, and photographing their look and the look of their world.

Either the cost to the photographer is high, or the benefit to the subject is high. In any case there is a balance in the relationship. That makes a fairer exchange.

Mrs Cameron truly 'used' her servants and their children in her original photographic experiments. For their half-crown payment they had to sit, fixed, for minutes at a time, for reasons that must have seemed mysterious indeed to them. But she tells how exultantly that first successful print she made, of Annie in 1864, was immediately given as a present to her father. She understood intuitively the rules of social exchange.

At a very different level of complexity, we may consider the example of Brassai and his innovative forays in *The Secret Paris of the 30s* (1976). He saw that the camera was the obvious tool for exposing the night world – not only the beauty of Notre Dame by moonlight, but the gangsters, burglars and pimps who somehow held such romance for the bourgeoisie of that time.

He describes in some detail how he gained access to that closed world. Although he admits to using some mixture of 'trickery and diplomacy', essentially he honestly admitted to wanting to take pictures. Of course, with the equipment of the time and working at night, he had little choice.

A colleague in the film world, an electrician, introduced him as a friend. He showed some of his previous photographs, to provide his bona fides, and to attract them to the idea of being photographed. He paid actual money to photograph them, and he entered their world.

On one occasion he had all his exposed plates stolen. Two of his cameras were broken in altercations. And in the end, one of Albert's gang stole his wallet: 'Even though I had already paid them handsomely for their favours. I didn't lodge a complaint, however. Thievery for them, photographs for me. What they did was in character. To each his own.'

Again, he is not explicit, but there is a kind of acceptance that the benefits to the photographer are so great that he must be willing to accept high costs too. It is almost as if he wants us to see that there are two kinds of stealing going on.

In all our discussions we have assumed that the camera gives a kind of power. The camera in the hand makes the photographer a kind of manager of a scene. He may become the possessor of that visual clone. He may publish it, either among relations or among the world press. He can make us look good or bad.

Potentially he may help us or harm us. He may agree to share his power, or not.

At its least, fairness in the exchange is a level of sharing in which the photographer should consider whether he can show his work to the subjects. At another level he would show it, at least first, to the subjects. At a still higher level, he would give his subjects the power of veto over the propagation of their own images. And at the highest level, as we've suggested, the people involved in a picture negotiate the act and the outcome together.

Interacting with this kind of bye-laws in the rules of the ritual is the purpose to which the pictures are to be put.

If the purpose is benign rather than malicious, if the interests of the photographer do not override all others, then fairness may include terms beyond those of the individuals shown.

As we have seen, if the aims of the photographer are to document a certain social wrong, we have allowed him to show degradation. The motive of reform is enough to excuse showing individual men and women in circumstances that show not only their dirtiness and unhappiness but also the hopeless failure of their attempts to join the society of 'worthy' people.

Yet why is it the victims who have so much more often been portrayed, rather than the dominant agents in the community who are either responsible for their fate or at least allow it all to happen ?

The usual answer is that sympathy must be aroused, so that it may be marshalled to wreak the social change that is necessary.

In our present terms, the victims' reward comes in the amelioration in their condition that will eventually result. That balances their present costs of appearing so 'nakedly' in the photographs.

However, we might consider alternative interpretations of the exchange.

Is it not also that *vis-à-vis* the victims, the photographer has all the power ? It is his status that allows his work to cost him little and to offer him much potentially rewarding power.

Consider, alternatively, photographing, say, the chairman of the housing committee of a local authority in the comfort of his home. Then the power balance is changed. Although it might be a provocative comparison, it is rarely made. For the chairman there would be no benefit (to say the least), and compared with him, the intrinsic status of the photographer is not high enough to persuade him. The balance is against the venture.

It is perhaps such considerations of power balances and the cost/reward outcome of the social exchange that determine who gets photographed, where and when, more often than we previously thought.

Photography is a fact of life.

Implicity, if not yet explicitly, social rules surround the institution and the ritual of taking photographs.

The process and the pictures may raise or lower the quality of social interaction and social representations in our culture.

As Don McCullin said, at one time people thought something was happening when they saw a photographer. There are still vestiges of that feeling. A camera need not have just a sinister eye. Social rules have evolved that permit us, as subjects, to be taken seriously, so that we are not reduced to anonymous objects used by someone wielding yet another machine.

229

9 New uses of photography

The central question in our discussion so far has been about the use of photography and of photographs. The issues about aesthetics and economics, art and politics, even, have been considered from that point of view. We have concentrated on the function of photographs for people: what are photographs for ?

We have also tried to see how far such a social analysis could add to the analysis of photography theorists and art critics. Is there a social psychology of photography ? How far can photography add to our understanding of people and their social lives ? Here we will consider studies of social issues that have used the tool of photography, or have based themselves on photographs as samples of human activity.

Because of the general popular interest in photography, not many such studies have been carried out by social scientists. Indeed, arguments against such work have been advanced in terms of its lack of scientific and professional respectability. However, at this stage of our argument I shall try to show that the camera has provided us with a means of studying people that is spontaneous, although rule-governed; acceptable to our participants, although fraught with ethical obligations on our part; objective, although including subjective variance; natural, although also highly technical. In short, it is as difficult and rich as people themselves.

Although for a considerable time photographs have flooded the popular means of communication, have documented mundane life as well as that of the high and mighty, and have brought the image of all the world into every corner of civilisation, even so, the work of students of human life has remained firmly embedded in the culture of the word and of print. Marshall McLuhan himself was ignored as a sociological upstart pandering to popular taste, when he first discussed the power of any picture over that of words. He was seen as confirming the simple-minded prejudice for the direct and easy medium. If research and conceptual ideas were to maintain their seriousness, they must eschew popular preferences and therefore remain distant from the visual image.

One has the impression that the simpler the mechanical process of photography becomes, and the more popular photography is in ordinary life, the more is the phenomenon to be shunned by experts in the human sciences. An interest in something so straightforward will contaminate the scientist with its apparent simplicity, with its apparently uncomplicated link with the real world and ordinary life.

In fact, sociologists and social anthropologists made a good start when they accepted early photography as a way of collecting raw data. Photographs both illustrated and constituted their research findings, and were used in communicating analyses and interpretations.

So what were the bad marks against photographs ? For a start, one might say that photographs were too real. They show vividly and completely the matter in hand. So they might show up for what they are, the vague abstractions and high-flown interpretations that social scientists are prone to. Photographic evidence would be subversive to their teaching.

They show particularity. Perforce even a large sample of evidence is the sum of small parts. Such particularity is antithetical to the idea of science. But perhaps most important on a professional level is the point that they are not 'serious'. They need no lengthy training, no expertise to appreciate. Anyone can understand them. They communicate directly. In so far as all these arguments have weight, photographs constitute information which easily lends itself to analysis.

Where could photography extend the study of psychology ? The most cursory survey would suggest in the study of social skills, child development, aspects of psychopathology (one thinks of the problem of anorexia nervosa), environmental psychology, analyses of subcultures, social interactions in general and all aspects of the self and its presentations, as we have continually suggested.

Where has it been used up to now ? At one extreme is the venerable Szondi test (and its revision by Michael Balint), where a series of portrait photographs (of a quality that would have shamed a *carte de visite* shop) is presented for a preference selection. If you like the face of a manic-depressive, for example, you are thought to have some special relationship to that disorder. Unfortunately all the photographs are of poor quality and the images, therefore, all unsympathetic. Apart from the unaesthetic aspect of the task, its validity is poor.

At the other extreme, American social science textbooks use photographic illustration extensively, to inject some element of attraction, liveliness and naturalism for its possibly reluctant readers. The pictures do bring to life the more abstract ideas about social distance, the contrariness of adolescents, social conformity to fashion, the loneliness of the old. It is said that readers can by this means relate to the issues discussed; they can bring the problems within their own experience, or at least observation. This must be true, or publishers would not continue to bear the extra cost. However, it must be admitted that at times the illustrations add little but a break in the text, and it is this sugaring-the-pill function that reinforces the serious social scientist's contempt for images.

In environmental psychology, one of the most striking uses of photographs appears in the work of Colin Ward (who is an architect) describing the uses that children make of the city. In his analysis he relates the capabilities of children, as interpreted by psychologists, to the ways in which, in all kinds of cities, they use streets, courtyards, alleys and concrete jungles for their games, their secrets, their collective and individual 'concrete' and fantasy activities. Sometimes the pictures simply illustrate, but at other times they demonstrate complex relationships useful to psychologists and town planners.

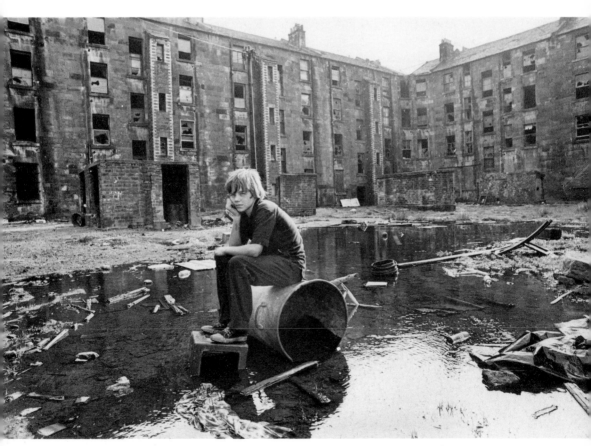

Peter Dunne *Boy in Glasgow*

Research into cultures and subcultures that are strange to the investigators would always have used visual material as part of their data, one would have thought. However, even in the field of ethnography, Margaret Mead and Gregory Bateson's study of Bali in 1942 was alone in its use of photographs as evidence rather than mere illustration.

Doug Harper, a sociologist from the State University of New York, has described the crucial role photography played in his understanding of the skills, the nuances of behaviour and the social categorisation among the homeless men he studied in *Life on the Road* (1985). The men's accounts and his participation in their life amply demonstrate the independence and self-expression that their life afforded. Particularly, it was the subtleties of proper 'riding behaviour', the neat and functional arrangement of belongings in the freight cars (no less ritualised, as he tells us, than the journey of the royal household from Windsor Castle to Balmoral), that he caught in his photographs. They persuasively testify to the reader against any interpretation of desperation, and for the men's control over their space, their own class stratification and their positive presentation of self.

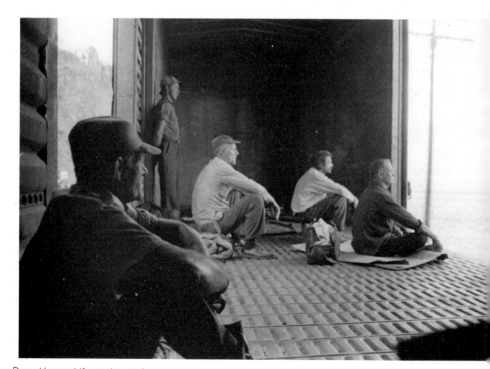

Doug Harper *Life on the road*

Ethologists – Desmond Morris, in the popular domain – use photographs as raw data, as index illustrations of symbolic gestures, showing distance between interlocutors, universality of facial expression, signs of erotic display and the functions of gaze, etc. Unobtrusively captured in public spaces, they are slices of frozen interactions.

In some instances, the use of photographs within psychodynamic psychology has had negative effects. Robert Akeret, in his *Photoanalysis* (1973), has interpreted character and relationships from single photographs in great detail. His point would be that here we have a time sample which must demonstrate the adjustment of the subjects to each other and to the world, and that the privileged moment of a posed photograph must indeed bring to fine flowering the preoccupations and the needs of each one of us. In this way, he suggests, we can see Hitler's megalomania from his top central position in his school photograph and in his masterful stride on the running-board of his car. He sees, too, the loneliness and alienation of a member of a posed family group who seeks the touch and gaze of an indifferent sister. Such interpretations are hard to deny, but hardly have the backing of rational validation. Other images of those people will lend themselves to other interpretations.

In general terms, images are used in society as a direct, quick and persuasive means of communication. As we have seen, we need photographs in order to possess a moment, a place, a person. A message and a surrogate reality are both there. It is the amalgam of these themes that provides the material for this chapter, at the same time presenting for solution the problem of disentangling reality and association.

Here we will introduce a number of research studies which address themselves to the use of photographs: as samples of social and political images, as evidence of others' lives, as opening up hidden social constructions, as tools for understanding. In each case, the construction, definition and perpetuation of a social image will be analysed and dissected. Sometimes existing pictures will be used, and at others we will consider how making new photographs will help us see new alternatives. This sort of work should demystify both photographic practice and the subjects represented.

Sampling social and political images

The sociologist Erving Goffman's book, *Gender Advertisements*, large in format and featuring on the jacket two erotic young women, with its coffee-table associations might well have confirmed, again, the speptic's view of photography as frivolity. However, his essay and the survey sample of some five hundred commercial photographs extends Goffman's previous work concerning social ceremony. It concentrates on the particular social ritual of identity displays, especially in so far as these are made of and by women. Famous for his clever use of anecdote as social data, he now samples visual images for meaning.

The title of the book is to be taken literally. The sample of photographs is culled from newspaper and magazine advertisements that feature women. Goffman is studying, therefore, a set of visually accessible behavioural styles. They are expressions of gender as presented by advertisers in the service of making goods attractive in order that they shall be bought. We must accept the images of versions of gender, gender displays and gender relationships. They are illustrations of an ideal social structure. They are true, accepted ideas because otherwise they would hardly be commercially viable.

They are artful. But then gender styles are always artful. These are supposed to be 'natural' representations of presentations that we know are *not* natural. They are learned rituals, which may here be said to be hyper-ritualised. Advertisers draw on the same corpus of displays as we all do, 'they render a glimpsed reaction readable'. Advertisers conventionalise our conventions; stylise what is already stylised, as Goffman put it.

So what do we see ? 'With the vast social competency of the eye', we discover in the game of presentation between the men and women a list of ploys:

1 Differences in relative size: men are shown bigger.
2 Women more than men using their fingers to touch things; the 'feminine touch', using their faces to touch, touching themselves.

Bruce Weber *Easy country*

236

3 Function-ranking – in occupational settings the man is shown in the higher function. Even at leisure, the man builds the sandcastle. Body-addressed help is carried out by the man, who feeds the woman. There are differences in space elevation, with the man higher and standing rather than sitting.
4 Women shown with bashful knee-bend, in canted posture, smiling more often, in Puckish style (with turned-in feet) and in generally unserious poses, clowning.
5 Women given the arm lock, shoulder hold, hand hold.
6 Women are licensed to withdraw. They are allowed to 'flood out', express-ing their emotion freely. They are shown with hand covering the mouth, finger held to mouth, finger to finger position, with head or eye averted, mentally drifting away, behind another person, snuggling for comfort, nuzzling another.

We are shown rituals of subordination. The interpretation of the demography of photography is that women are seen essentially as children.

They have the rights and privileges of children, and pay the same price as children for that position. This means a women is not a fully mature person. She has her basic needs satisfied by others, and is in a sense on holiday, not just for now or still, but for ever. She has a certain orientation licence, she can drift into a daydream. It is expected that she will be ineffective in achieving her goals. She does not cope, but hides and escapes. Others – men – intercede for her in difficult, heavy, dirty jobs. She is given indulgence priorities – for example, through doors. Her offences are erasable.

If these are her privileges, she is therefore subjected to control. And she is subjected to various non-personal treatments; for example, she is talked about as though absent. Her privacy may be invaded and her information rights violated. The man's power, his coercion, hostility, distance, are covered, justified and sugared-over by that parent-like relationship. It is mystified.

Such patterns may be thus expressed fleetingly, but they are consistently there and are entirely consonant with the basic characteristic of the trad-itional relationship between women and men in middle-class Western societies.

If all this concerns psychologically expressive characteristics, Goffman would insist on the political message too. A genre like advertising must present an ideal, comfortable stereotype in order to evoke a favourable reaction from a significant proportion of the 'readers' of the images.

However, the work of interpretation need not stop there. Further speculation may be provoked. If the child–woman is one version of the social structure, we are quickly drawn also to a diametrically opposite conclusion. Thinking of our own experience of a real family and the interactions, skills, needs and coping strategies of its members, most women would inexorably be drawn to the conclusion that it is the men who in fact, though not in fiction, are the babies. It is men who are practically and socially inept, if not helpless. It is men whose *amour propre* must be carefully and artfully maintained. It is they who need the comfort of escape into fantasies of macho integrity. It is men who are inflexible and who crumble in crisis. The experience of women is that their subordination is indeed a game in fact, and not just in metaphor. That game assumes that they are weak, in order to give the men their much needed illusion of strength. (This paradox will be further explored when we consider women taking their own photographs in the last section of this chapter.)

Opening up hidden social constructions

As we discussed in chapter 1, photographers have been able to show more powerfully than any painters the secret places in our society, its people and their affairs. Secret and purely private settings have been exposed.

In this genre, combining photography and account-gathering, Phyllis Ewen has given us a paradigm, in the uncovering of a mundane activity, that extends our understanding not only of a commercialised part of what we might call identity services, but of self-construction and respect for self.

Her study of hairdressers has opened up a hidden view. Hairdressers' shops used to be hidden behind a shuttered front, and even in the so-called salon, again one was hidden in a tiny cubicle. Now the operation is more open to hazard, and everyone I know has hoped at one time or another that no friend, enemy, spouse even, will be walking by in the street while one (man or woman) is 'under the towel'.

Phyllis Ewen *Female appearance and the beauty ritual*

Women have always felt apologetic and self-deprecating about the beauty operation. Instead of seeing it as a pleasant tribute to the visual aesthetics of the social scene, we have accepted its assignment as another example of our vulnerability, weakness, gullibility and even lying.

Phyllis Ewen has studied with empathy this presentation work of women, and also the bonds between women, that are asserted in the beauty shop. (Ninety per cent of the workers, in the USA, are still women. In Britain also they form the big majority.) She simply went to the salons, talked to the women there, and asked if she could take photographs. She worked with a camera that had an especially loud shutter, so that there should never be any question of her stealing an image from people unaware.

Phyllis Ewen *Female appearance and the beauty ritual*

The camera for her was not just a recording machine, but contributed to the work in that it took the women seriously. It valued their efforts. The women themselves arranged their pose. They presented themselves during their presentation work. They could, in a new sense, see themselves in the midst of the process. This kind of distancing helped them to express their ideas in words more clearly, too.

What do we see in the resulting photographs ? Young women experiment-ing with what they might be. But also old women. They are not grotesquely aping the young and desirable, or feverishly re-creating their previous selves; but we appreciate that going to the hairdresser is a serious and important sign of self-respect. They do not experiment with images, as the young ones do, but have settled on a compromise with the style of their prime and attempt to maintain it. That is effort enough. They go to retain their dignity. They may even admit, towards the end of their lives, it is a false pride. But their going is a mediation with death. Not yet, they say.

In her images of image-making, Ewen has caught the women in a state of undress, but they can pause a moment to compose themselves. They confront the camera in their own way. As we see, they are formal portraits in a strange ambiance. They have the quality of icons. They open up the formalised aspect. They shown the women at ease, in ceremonial robes, anointed, in ritual headdresses. They are genuine, honest and beautiful. Ewen and her subjects paid respectful attention to each other. They are of the place and looking at it. It is that nexus that is rich material for our study.

Self-portraits are different

Although we have seen that simply 'giving the camera away' does not automatically lead to a new and stronger truth, there is a tenacious belief that this is a way to circumvent the cultural rules of the camera and to come directly to a more honest picture of personal reality. That is, we believe that people themselves will be able not only to show us how they really look, but thereby to show us what they really are.

Even if ordinary people are often too closely locked into the conventions of the portrait, perhaps professional photographers are so skilled in the practice of the rules that they could, if they wanted, leave them aside. Clearly we are not discussing here the coy and self-congratulatory pictures that photographers sometimes produce for their own commercial use. Those only appear to remain behind the scenes.

Let us look, rather, at a group of professional women photographers that Joyce Tenneson Cohen asked to produce themselves.

By her account (in *In/Sights*, 1979), they had both the highest skills and the greatest interest in this kind of job. Professional women photographers have an appetitive eye. As women they are used to doing ostensible identity work; this they will peel away. It has been suggested that such images as the women produced do not in themselves create ideas, but illustrate the concepts and perspectives of the 'authors'. While logically one might agree with this, it seems to the outside observer that the portraits are such strong entities in their own right that the point becomes merely academic.

In fact, when women's self-portraits have been exhibited, critics have denigrated them by saying that they are not 'art' and that the work is just a sort of therapy. They have acknowledged their place in the domain of psychological study – as a final 'put-down'! And while that very characteristic makes them attractive to us here, we see that they could also have a political purpose. They can be used in the discussion of change. In terms of struggle for change, the danger is that the staging of such exhibitions will connect them too closely with the structure of formal photography. They will become part of 'the shock of the new', part of the Arts Council Archive. The context defuses the ammunition. They could become just more cultural artefacts. Within our analysis, we can still see how they communicate without the conventional code.

Around pictures of ourselves there are many challenges and possibilities for psychological study. I could work on and for myself, or on and with you. As Jon Wagner has asked in *Images of Information*, if I were to make a photograph of you, in a familiar room, in your ordinary clothes, your hair no better combed than now, your teeth not especially brushed, would it be an accurate datum of you, of what you are ? If not, what is missing, how might it be made good ?

We could make more photographs, in pairs perhaps, of ourselves and of each other. Talk about them. Ask each other questions about them. We could make pictures of important places, other people. We could talk about the things that we wouldn't want to photograph. Things we would find hard to shoot. We could try forcing ourselves to take them. We might want time-sample pictures. We could make sets of photos and sort them into categories. We could interpret our existing albums. Try to fill the gaps in them. We could start slowly and casually. We could, if we wanted, become more formal and objective.

We could begin to see what is the matter-of-fact part of our selves and our lives, and what is ambiguous, what sham. But this kind of question, about the whole of social life, has been implicit throughout our discussion.

Why has the genre of self-portraits seemed to interest women most ?

We have gradually collected reasons at various levels. Women seem to have some extra skills in self-presentation. They acquire these perhaps because the rules of presentation are so narrowly defined for them. The camera rules, certainly, are obeyed even in casual snapshots. Women have been particularly constrained by their objectification in the popular visual media. Now it is seen that visual images can be used to undo that oppression.

Jo Spence has formally stated what half the Western world has privately always known, that women hate their photos. However we hold our head and body to comply with the ideal models, whatever faces we pull, even if we hurriedly improve our hair, we don't manage to look as we should. She is brave enough to say that she saw from her repertoire of photos that her life had been full of shame. Then she reclaimed her image. At the age of 44, she called all our bluffs. She showed herself as her parents had been happy to document her, according to the traditions of camera culture, at the age of 8½ months, and again at 536½ months — naked and unashamed.

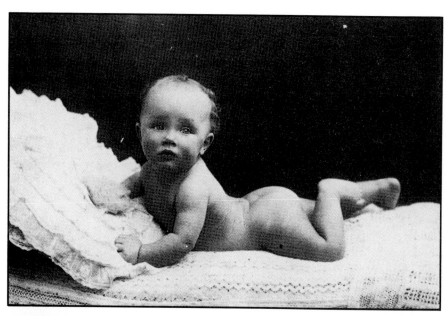

Jo Spence *Me at 8½ months, me at 44 years 9 months*

Following the simple scientific principle that a phenomenon can be most directly understood when we see what occurs in its absence, she parodies our performances by their absence. And the parody is not a joke. We see rather that we in sight are the site of all the contradictions of our society, the up-market striving, the sexual competing, the claims to sincerity. We must disguise our flaws, our shiny nose, our insecurity, so that we can look proud and happy, and our friends and relations can be glad to know us.

But perhaps, finally, we should also ask, why have the men kept away ? It has not been vanity that has lured women into self-portraits, but the wish to understand their true state. Do men not need to know theirs ? Perhaps they have been conditioned even more successfully to hide what they are ashamed of. Is it because they have been taught most forcefully that to be manful is to be uninvolved in the concern for psychological realities ? Is show enough for them ? Because a show it is.

Bibliography

Abbot, Berenice, *Photographs*, with foreword by Muriel Rukeyser, introduction by David Vestal. Horizon Press, NY, 1970.

Adams, William Howard, *Atget's Gardens*, with introduction by Jacqueline Onassis. Doubleday, Garden City, NY, 1979.

Agee, James and Evans, Wal, *Let Us Now Praise Famous Men: Three Tenant Families*. Peter Owen, London, 1965.

Akeret, Robert U., *Photoanalysis: How to Interpret the Hidden Psychological Meaning of Personal and Public Photographs*. Simon & Schuster, NY, 1973.

Angeli, Daniel and Dousset, Jean-Paul, *Private Pictures*, with introduction by Anthony Burgess. Viking, NY, 1980.

Arbus, Doon and Israel, Marvin (eds), *Diane Arbus, An Aperture Monograph*. Millerton, NY, 1972.

Arts Council of Great Britain, *The Real Thing:* An Anthology of British Photographs 1840–1950, 1975.

 Hockney's Photographs, 1984.

Atget, Eugène, *A Vision of Paris*. Photographs by Eugène Atget, words by Marcel Proust. Macmillan, NY, 1963.

Attie, David, *Russian Self-Portraits*. Thames & Hudson, London, 1978.

Bailey, David and Evans, Peter, *Goodbye Baby and Amen: a Sarabande for the Sixties*. Conde Nast, 1969. Corgi, 1970.

Banish, Rosalyn, *City Families: Chicago and London*. Pantheon Books, NY, 1976.

Barthes, Roland, *Camera Lucida: Reflections on Photography*. Hill & Wang, NY, 1981.

Beaton, Cecil, *Photobiography*. Doubleday, NY, 1951.

Beaton, Cecil and Buckland, Gail, *The Magic Image: The Genius of Photography from 1839 to the Present Day*. Weidenfeld & Nicolson, London, 1975.

Benjamin, Walter, A Short History of Photography. In: *Creative Camera Yearbook*, 1977.

Berger, John, *Ways of Seeing*. BBC and Penguin Books, London, 1972.
 About Looking. Writers and Readers Publishing Co-operative Ltd., London, 1980.

Bosworth, Patricia, *Diane Arbus*. Heinemann, London, 1985.

Bown, Jane, *The Gentle Eye*. The Observer and Thames & Hudson, 1980.

Brassai, *The Secret Paris of the 30s*. Thames & Hudson, London, 1976.

Bruce, David, *Sun Pictures: the Hill-Adamson calotypes*. Studio Vista, London, 1973.

Burgin, Victor (ed.), *Thinking Photography*. Communications and Culture Series, Macmillan, London, 1982.

Caldwell, Erskine and Bourke-White, Margaret, *Say, is this the USA?* Da Capo, NY, 1977. Duell, Sloane & Pearce, 1941.

Callaghan, Sean, *The Private Experience*. Alskog with Petersen Publishing Co., LA, 1974.

Cartier-Bresson, Henri, *Photographs*, with introduction by Lincoln Kirstein and Beaumont Newhall. Grossman, NY, 1963.
 Archive of 390 photographs from the Victoria & Albert Museum, with an essay by Sir Ernst Gombrich. Scottish Arts Council, 1978.

Cohen, Joyce Tenneson, *In/Sights*. Gordon Fraser, London, 1979.

Cunningham, Imogen, *After Ninety*, with introduction by Margaretta Mitchell. Univ. of Washington Press, Seattle and London, 1977.

Danziger, James, *Beaton*. Secker & Warburg, London, 1980.

Danziger James and Conrad, Barnaby, III, *Interviews with Master Photographers*. Paddington Press, London and NY, 1977.

de Ville, Nicholas (ed.), *The Art of Society Photography* (Lenare), with introductory essay by Anthony Heden-Guest. Allen Lane, London, 1981.

Diamondstein, Barbaralee, *Visions and Images: Photographers on Photography*. Travelling Light Photography, London, 1982. Rizzoli International Publications Inc, NY, 1981.

Ewen, Phyllis, The Beauty Ritual. In: John Wagner (ed.), *Images of Information*. Sage Publications, London, 1979.

Frank, Robert, *The Americans*, with introduction by Jack Kerouac. Aperture, NY, 1978.

Freed, Leonard, *Leonard Freed's Germany*. Thames & Hudson, London, 1971.

Freund, Gisèle, *Photography and Society*. Gordon Fraser, London, 1980.

Gernsheim, Helmut, *Julia Margaret Cameron: Her life and photographic work*. The Fountain Press, London, 1948.

Gernsheim, Helmut and Alison (eds), *Photographer: an Autobiography* (Alvin Langdon Coburn). Dover Publications, NY, 1978.

Goffman, Erving, On Face-Work. In: *Interaction Ritual: Essays in Face-to-Face Behaviour*. Allen Lane, The Penguin Press, London, 1967.

Gender Advertisements. Macmillan, London, 1979.

Gosling, Nigel, *Nadar*. Secker & Warburg, London, 1976.

Green, Jonathan (ed.), The Snapshot. *Aperture* Vol. 19, No. 1. Aperture, Millerton, NY, 1974.

Hansberry, Lorraine, *A Matter of Colour*, Documentary of the Struggle for Racial Equality in the USA, with introduction by Ronald Segal. Penguin Books, Harmondsworth, 1965.

Hardy, Bert, Collected photographs with introduction by Tom Hopkinson. Gordon Fraser Photographic Monographs: 5, London, 1975.

Harper, Douglas, *Good Company*. Univ. of Chicago Press, 1983.

Haworth-Booth, Mark (ed.), *The Golden Age of British Photography, 1839–1900*. Aperture Books, 1984.

Hiley, Michael, *Seeing through Photographs*. Gordon Fraser, London, 1983.

Hill, Paul and Cooper, Thomas, *Dialogue with Photography*. Farrar Straus & Giroux, NY, 1979.

Hine, Lewis, '*I wanted to show the things that had to be corrected*' *1874–1940*. Arts Council of Great Britain, London.

Hockney, David, *Cameraworks*. Thames & Hudson, London, 1984.

Hopkinson, Tom (ed.), *Picture Post*. Penguin Books, Harmondsworth, 1970.

Jewel, Dick, *Found Photos*. No publisher, Dec. 1981.

Jussim, Estelle, *Slave to Beauty: The Eccentric Life & Controversial Career of F. Holland Day. Photographer, Publisher, Aesthete*. David E. Godine, Boston, 1981.

Karsh, *A Fifty-Year Retrospective*. Secker & Warburg, London, 1983.

Keller, Ulrich (ed.), *Menschen des 20. Jahrhunderts* (Sander). Shirmer/Mosel, München, 1980.

Klein, William, *Photographs*. Aperture, Millerton, NY, 1981.

Kozloff, Max, *Photography & Fascination*. Addison House, Danbury, NH, 1979.

Lartigue, Jacques Henri, *Diary of a Century*. Penguin Books, Harmondsworth, 1978.

Leslie Charles, *Photographer*, a brief introduction to the life and work of Wilhelm von Gloeden. Soho Photographic Publishers, NY, 1977.

Lomberg, John, Pictures of Earth. In: Carl Sagan *et al.*, *Murmurs of Earth*: The Voyager Interstellar Record. Random House, NY, 1978.

London Photography Workshop, *Photography/Politics: One*. 1979.

Lucie-Smith, Edward, *The Invented Eye: Masterpieces of Photography, 1839–1914*. Paddington Press, London and NY, 1975.

Luskacova, Marketa, *Pilgrims*, with introduction by Mark Haworth-Booth. Victoria and Albert Museum, London, 1983.

Lyon, Danny, *Conversations with the Dead*: Photographs of Prison Life with the Letters and Drawings of Billy McCune #122054. Holt, Rinehart & Winston, NY, 1971.

McCartney, Linda, *Linda's Pictures*. Jonathan Cape, London, 1976.

McCullin, Don, *Homecoming*. Macmillan, London, 1979.

Hearts of Darkness, with introduction by John le Carré. Secker & Warburg, London, 1980.

MacLeish, Archibald, *Land of the Free*. Da Capo, NY, 1977. Harcourt Bros., NY, 1938.

Maddow, Ben, *Faces: A Narrative History of the Portrait in Photography*. New York Graphic Society, Boston, 1977.

Malcolm, Janet, *Diana and Nikon: Essays on the Aesthetic of Photography*. David Godine, Boston, 1980.

Martin, Rosy and Spence, Jo, New Portraits for Old: The Use of the Camera in Therapy. In: *Feminist Review*, Spring, 1985.

Mazaroli, Oscar, *One Man's World: Photographs 1955–84*. Third Eye Centre and Glasgow District Libraries Publication Board, Glasgow, 1984.

Meiselas, Susan, *Nicaragua*. Writers and Readers Publishing Co-operative Ltd., London, 1981.

Mellor, David (ed.), *Germany: The New Photography 1927–33*. Documents and essays. Arts Council of Great Britain, 1978.

Milgram, Stanley, The Image Freezing Machine. In: *The Individual in a Social World, Essays and Experiments*. Addison-Wesley, London, 1977.

Museum of Modern Art, *Walker Evans*, with introduction by John Szarkowsky. NY, 1971.
Dorothea Lange, with introduction by George Elliott. NY, 1966.

Musello, Christopher, Family Photography. In: Jon Wagner (ed.), *Images of Information*. Sage Publications, London, 1979.

Newhall, Nancy (ed.), *The Flame of Recognition*: Edward Weston's photographs accompanied by excerpts from the Day Books and Letters. Gordon Fraser, London, 1975. Aperture, 1971.

Newman, Arnold, *The Great British*. Weidenfeld & Nicolson, London, 1979.

Noren, Catherine Hanf, *The Camera of My Family*. Alfred A. Knopf, NY, 1976.

Norfleet, Barbara, *Wedding*. Simon & Schuster, NY, 1979.
The Champion Pig: Great Moments in Everyday Life. Penguin Books, NY, 1980.

Orkin, Ruth, *A Photo Journal*. Secker & Warburg, London, 1981.

Ovenden, Graham (ed.), *Clementina, Lady Hawarden*. Academy Editions, London, 1974. 1974.

Owens, Bill, *Our Kind of People: American Groups & Rituals*. Straight Arrow Books, San Francisco, 1975.

Parker, Rozsika and Pollock, Griselda, *Old Mistresses: Women, Art and Ideology*. Routledge & Kegan Paul, London, 1981.

Penn, Irving, *Worlds in a Small Room*. Secker & Warburg, London, 1980.

Powell, Tristram (ed.), *Victorian Photographs of Famous Men and Fair Women*, with introduction by Virginia Woolf and Roger Fry. Hogarth Press, London, 1973.

Riis, Jacob, *How the Other Half Lives: Studies among the tenements of New York*. Dover Publications, NY, 1971.

Rodger, George, Collected photographs with introduction by Inge Bondi. Gordon Fraser Photographic Monographs: 4, London, 1975.

Rosenberg, Harold, *Portraits: a meditation on likeness*. The Noonday Press. Farrar, Straus & Giroux, NY, 1976.

Salomon, Erich, Collected photographs with introduction by Peter Hunter (Salomon). Gordon Fraser, London, 1978.

Sander, August, Collected photographs with introduction by John von Hartz. Gordon Fraser, London, 1977.

Scharf, Aaron, *Art and Photography*. Pelican Books, Harmondsworth, 1974.

Sizner, Zvi and Sened, Alexander (eds), *With a Camera in the Ghetto*. Schocken Books, NY, 1977.

Smith, W. Eugene and Smith, Aileen M., *Minamata*. Alskog-Sensorium Book. Holt, Rinehart & Winston, New York, 1975.

Snowdon, *Snowdon, A Photographic Autobiography*. NY Times Books, 1979.
 Sittings: 1979–1983. Weidenfeld & Nicholson, London, 1983.

Sontag, Susan, *On Photography*. Farrar, Straus & Giroux, NY, 1977. Penguin Books, Harmondsworth, 1979.

Spence, Jo, Body Talk – A dialogue between Ros Coward and Jo Spence. In: *Photography/Politics: Two*, Commedia, London, forthcoming, 1985.
 Beyond the Family Album. In: *Ten 8*, No. 4, Spring, 1980.
 'Public Images, Private Functions', Reflections on high street practice. Ed. Barber talks to Jo Spence. In: *Ten 8*, No. 13.
 and Corrigan, Philip, *Family Album Work Book: Snaps and their uses*. London, Routledge & Kegan Paul, forthcoming.

Steichen, Edward, *The Family of Man*, with prologue by Carl Sandburg, introduction by Edward Steichen. Museum of Modern Art, NY, 1955.

Stern, Bert and Gottleib, Ann, *The Last Sitting*. Orbis Publishing, London, 1982.

Szarkowski, John (ed.), *Storyville Portraits: Photographs from the New Orleans Red-Light District, circa 1912*. Museum of Modern Art, NY, 1970.

Tomkins, Calvin, *Sixty Years of Photographs*, Profile of Paul Strand. Aperture, Millerton, NY, 1976.

Vaizey, Marina, *The Artist as Photographer*. Sidgwick & Jackson, London, 1982.

Victoria and Albert Museum, *'From today painting is dead'. The Beginnings of Photography*. London, 1972.

Wagner, Jon (ed.), *Images of Information: Still Photography in the Social Sciences*. Sage, London, 1979.

Ward, Colin, *The Child in the City*. Architectural Press, London, 1978. Penguin Books.

Warhol, Andy and Colacello, Bob, *Andy Warhol's Exposures*. Hutchinson, London, 1979.

Weaver, Mike (ed.), *Julia Margaret Cameron: 1815–1879*. The Herbert Press, London, 1984.

Webster, Frank, *The New Photography; responsibility in Visual Communication*. John Calder, London, 1980.

Whitney, David (ed.), *Portraits of the 70s* (Warhol), with essay by Robert Rosenblum. Random house in association with the Whitney Museum of American Art, NY, 1980.

Williams, Jonathan, *Portrait Photographs*. Coracle Press, London, 1979.

Wise, Kelly (ed.), *Lotte Jacobi*. Addison House, Danbury, NH, 1978.
 Portrait Theory. Lustrum Press, NY, 1981.

Zee, James van der, Dodson, Owen and Billope, Camille, *The Harlem Book of the Dead*, with foreword by Toni Morrison. Morgan & Morgan, Dobbs Ferry, NY, 1978.

Zevi, Filippo (ed.), *Photographs of Florence, 1852–1920* (Alinari), with introduction by John Berger. Alinari Edizioni and Idea Editions in association with Scottish Arts Council, 1978.

Zille, Heinrich, *Photographien Berlin 1890–1940*. Winifried Ranke Schirmer/Mosel, München, 1979.

Acknowledgements

Sir Benjamin Stone The Benjamin Stone Collection, Birmingham Public Libraries

Mathew Brady Library of Congress

Brassai By kind permission of Mrs G. Brassai

Margaret Bourke-White MGT. BOURKE-WHITE/LIFE © TIME INC. with thanks to Roger Bourke-White

Heinrich Zille Schirmer/Mosel Verlag GmbH

Irwin Klein The Museum of Modern Art, New York. KLEIN, Irwin B. *Minneapolis Fire*, 1962. Gelatin-silver print, 9 × 13⅜". Collection, The Museum of Modern Art, New York. Purchase.

George Hoyningen-Huene Reproduced by kind permission of *Vogue* © The Condé Nast Publications Inc. Photographer George Hoyningen-Huene

Lewis Carroll By kind permission of Graham Ovenden

Wilhelm von Gloeden Reproduced from Charles Leslie *Wilhelm von Gloeden: Photographer* (New York: Soho Photographic Publishers, 1977)

Dorothea Lange Reproduced from *Dorothea Lange* with an introductory essay by George P. Elliott (New York: Museum of Modern Art, 1966) and from Archibald Macleish *Land of the Free* (New York: Da Capo Press, 1977)

Mendel Grossman Reprinted by permission of Schocken Books Inc. from *With a Camera in the Ghetto* by Mendel Grossman

Nadar Bibliothèque nationale, Paris

Leonard Freed Magnum/The John Hillelson Agency Ltd

August Sander By kind permission of Günther Sander

Cecil Beaton Courtesy of Sotheby's, London

Family of Man Page 187 from the exhibition catalogue; *The Family of Man*. Published by The Museum of Modern Art, New York, 1955. Courtesy, The Museum of Modern Art, New York.

Jacques Henri Lartigue Viking Penguin Inc., New York

Lewis Hine Breaker Boys in a Pennsylvania Coal Mine (1911) (Printed 1945) Gelatin-silver print, 4 ½ × 6 ⁹⁄₁₆″ (11.4 × 16.6 cm). Collection, The Museum of Modern Art, New York. Gift of The Photo League. Courtesy of George Eastman House

Roslyn Banish Copyright Roslyn Banish and Pantheon Books, a division of Random House, Inc.

Julia Margaret Cameron National Museum of Photography, Bradford

Imogen Cunningham The Imogen Cunningham Trust

Berenice Abbott By kind permission of Berenice Abbott

Gertrude Käsebier George Eastman House, New York

Lady Hawarden Victoria and Albert Museum

Eve Arnold Magnum/The John Hillelson Agency Ltd

Paul Strand 'Blind Woman, New York, 1916' Copyright © 1971, 1982 The Paul Strand Foundation, as published in Paul Strand: *Sixty Years of Photographs*, Aperture, Millerton, 1976.

Antonioni Lorrimer Publishing Ltd

Eugène Atget Museum of Modern Art, New York. The Abbott-Levy Collection. Partial gift of Shirley C. Burden.

Nancy L. Rexroth By kind permission of Nancy L. Rexroth

Fred Holland Day George Eastman House, New York

Chuck Close The Pace Gallery, New York

David Hockney By kind permission of David Hockney *George, Blanche, Celia, Albert and Percy, London, January 1983* Photographic collage 44 × 47 inches Copyright David Hockney

Christo Courtesy: Juda Rowan Gallery, London. Photograph: George Meyrick

Danny Lyon Magnum/The John Hillelson Agency Ltd

Henri Cartier-Bresson Magnum/The John Hillelson Agency Ltd

Jacob A. Riis The Jacob A. Riis Collection: Museum of the City of New York

Horace Nicholls Imperial War Museum, London

Don McCullin Courtesy of Abner Stein

Ben Shahn By kind permission of Mrs Bernarda Shahn

Bill Brandt By permission of Noya Brandt. Photograph courtesy Marlborough Fine Art (London) Ltd.

Erich Salomon Bildarchiv Preussischer Kulturbesitz and by kind permission of Peter Hunter

Arbeiter-Fotograf from *Der Arbeiter-Fotograf – Dokumente und Beiträge zur Arbeiterfotografie 1926–1932* By permission of Prometh Verlag, Köln

Humphrey Spender By kind permission of Humphrey Spender

Index

(Page numbers of plates are in italic)